IMAGES
of Sports

BALTIMORE'S
BOXING LEGACY
1893–2003

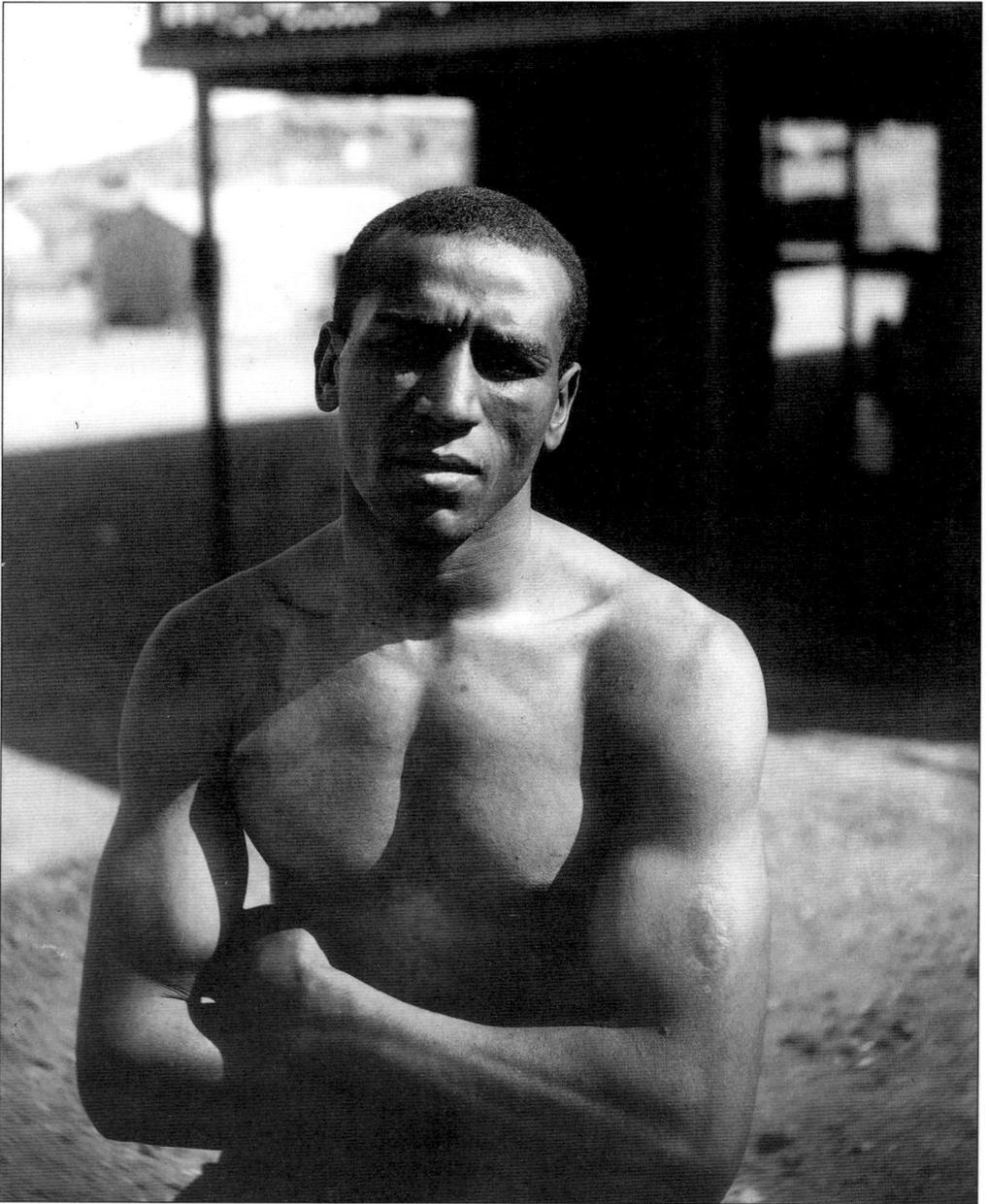

BALTIMORE'S FIRST WORLD CHAMPION. This photo of Joe Gans was taken in Goldfield, Nevada, sometime during August of 1906. The town, as the name implies, was a mining camp during the gold rush days. All interested eyes watched on September 3 when Joe successfully defended his lightweight crown as a result of referee George Siler's decision to stop the bout in the 42nd round when challenger Battling Nelson struck low.

IMAGES
of Sports

BALTIMORE'S
BOXING LEGACY
1893–2003

Thomas Scharf

ARCADIA

Published by Arcadia Publishing
an imprint of Tempus Publishing Inc.
Charleston SC, Chicago, Portsmouth NH, San Francisco

Printed in Great Britain

Library of Congress Catalog Card Number: 2003107785

For all general information contact Arcadia Publishing at:
Telephone 843-853-2070
Fax 843-853-0044
E-mail sales@arcadiapublishing.com
For customer service and orders:
Toll-Free 1-888-313-2665

Visit us on the internet at http://www.arcadiapublishing.com

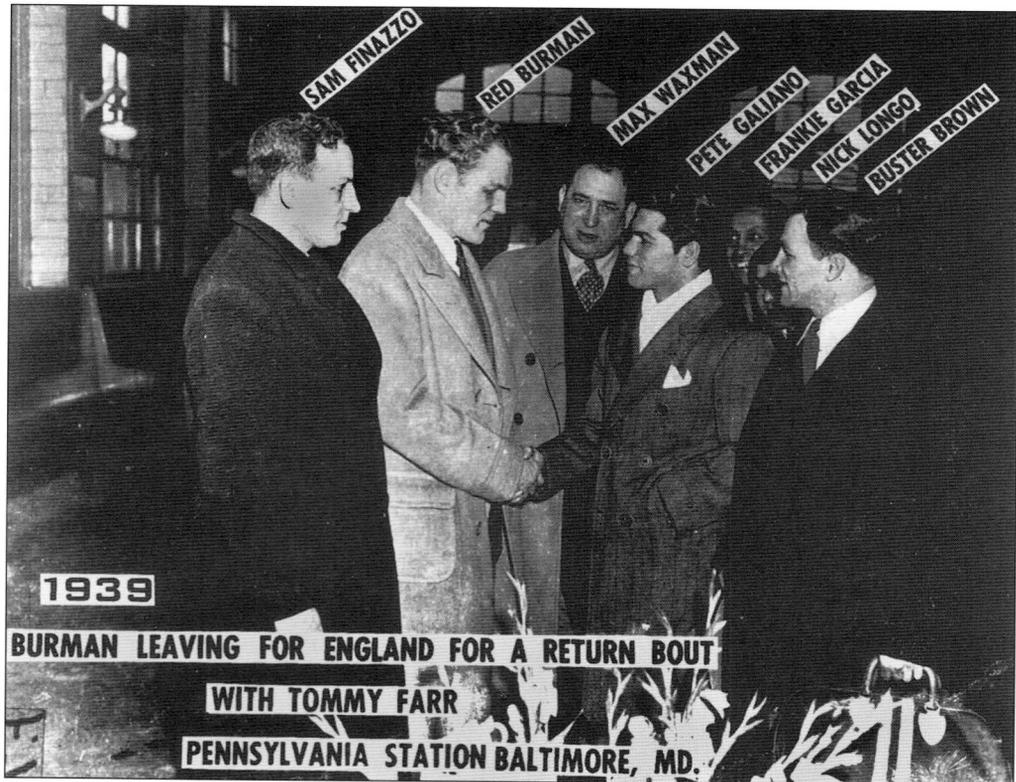

A SLEW OF LEGENDARY BOXING FIGURES. Several local boxers and managers wish Clarence "Red" Burman best of luck for his return match with Welshmen Tommy Farr. Red previously won a 10-round decision on January 13 in New York City but was not as fortunate in London on April 13, losing via a 12-round decision.

4

CONTENTS

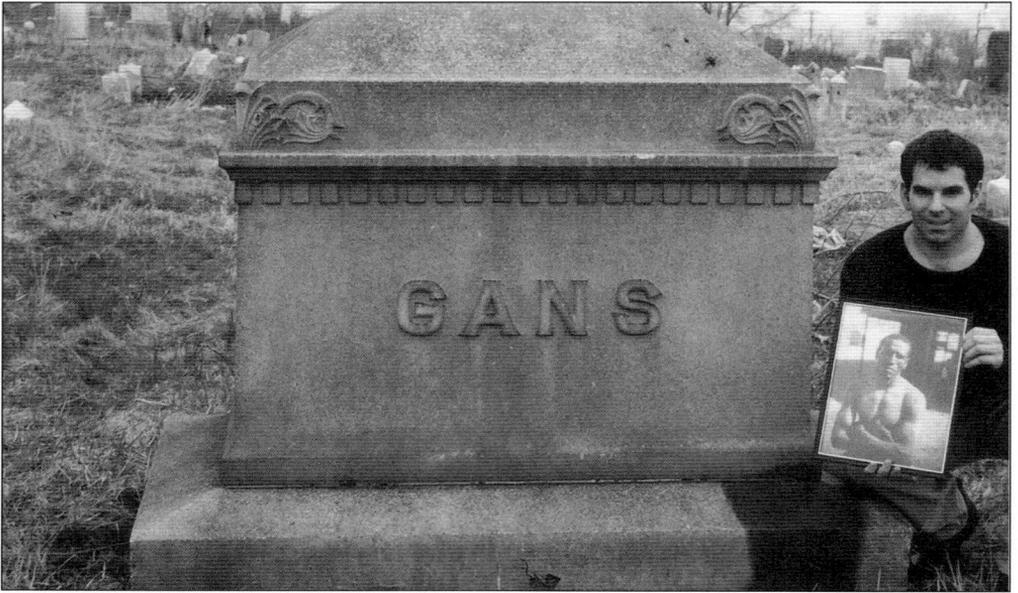

AUTHOR THOMAS SCHARF AT THE GRAVE OF JOE GANS. Buried at Mount Auburn Cemetery in Baltimore, Maryland, Joe's headstone simply says "Gans." Joe is the most famous Baltimorean boxing figure of all time, despite dying prematurely from tuberculosis on August 10, 1910.

ACKNOWLEDGMENTS

The author wishes to recognize John Gore, Robert Carson, Leo Dymowski, Harry Shaffer, Mack Lewis, Tank Hill, Tracy Callis, Johnny Bos, Jerome Shochet, James J. Johnston, Gary Phillips, Buddy Ey, and Joseph Poodles Sr. The latter two I never had the privilege of meeting but are considered Baltimore's first two boxing historians and founding members of Maryland's Boxing Hall of Fame. Their pioneering hard work, meticulous attention to detail, and wonderful collection of photographs are spread throughout this book. I especially want to thank Buddy for proofreading the manuscript and supplying me with records of fighters. Many of them he received from Laurence Fielding. Over the years, newspaper scribes Rodger Pippen, John Steadman, Jesse Linthicum, Paul Manton, and Alan Goldstein must be recognized for their contributions to Baltimore boxing. I thank my family and Nikeyta for their patience and support throughout this endeavor. I also thank God because without Him nothing would be possible.

INTRODUCTION

Baltimore, the Monumental City, has been a boxing mecca since the 1890s. Along with Philadelphia, Boston, and New York, most early boxing matches on the East Coast occurred here. All of Baltimore's early history was written in the old East End. All things began there, even the city itself. Boxing, too, began here, for the men who came from various countries. The manly art of self defense could not be denied its place, and its exponents wrote their history along with that of statesmen, financiers, and the rest. The whole world knows of Baltimore's Fistiana because eight world champions and numerous famous contenders were drawn from this melting pot. From the old East End neighborhood, of which Fleet Street is the center, came Baltimore's first two world champions, Joe Gans and Kid Williams. It was here that Gans, the first African American ever to win a world title, in 1902, learned his boxing science, which earned for him the title of "The Old Master." Just around the corner, on Fleet Street, then called Canton Avenue, was the inn of Al Herford. It was Herford who made the old inn a rendezvous for sporting men, and it was he who guided Joe Gans to the lightweight championship of the world.

However, Herford was not a pioneer in the boxing game. Long before Gans' name was spread throughout the world Jake Kilrain was known to all followers of pugilism. On the northeast corner of Fleet and Dallas Streets, Kilrain trained for many of his fights. Many sporting men regarded him as the world's champion due to the fact that John L. Sullivan failed to meet him at the time. However, when John L. met Jake at Richburg, Mississippi, on July 8, 1889, the Boston Strong Boy knocked all championship notions from the Baltimorean's head. Even before Kilrain's day there, another man, who fought for the world's heavyweight championship, walked up and down the streets of Baltimore. He was Yankee Sullivan. Tom Hyer knocked him out in 16 rounds at Rock Point, Maryland on February 7, 1849.

On Bond Street, just around the corner from Fleet, stands the building where Johnny Gutenko became Kid Williams. In a small room behind a confectionery store—run by Tom the Greek—Williams learned to box with the help of local boxer Young Britt. It was there that one of the greatest of all bantamweight champions shaped his career during the 1910s. George Chaney, the Knockout King, walked the same back room to the roped arena. In the Roaring Twenties, many of Baltimore's elite fighters trained in Klein's Gymnasium—a melting pot of Italian and Jewish fighters. Among those were brothers Joe and Vince Dundee, who would become Baltimore's third and fourth world champions, respectively. They were followed by Harry Jeffra, 1937 bantamweight and 1940 featherweight; Dwight Braxton, 1981 light heavyweight and 1985 junior heavyweight; Vincent Pettway, 1994 light middleweight; and Hasim Rahman 2001 heavyweight.

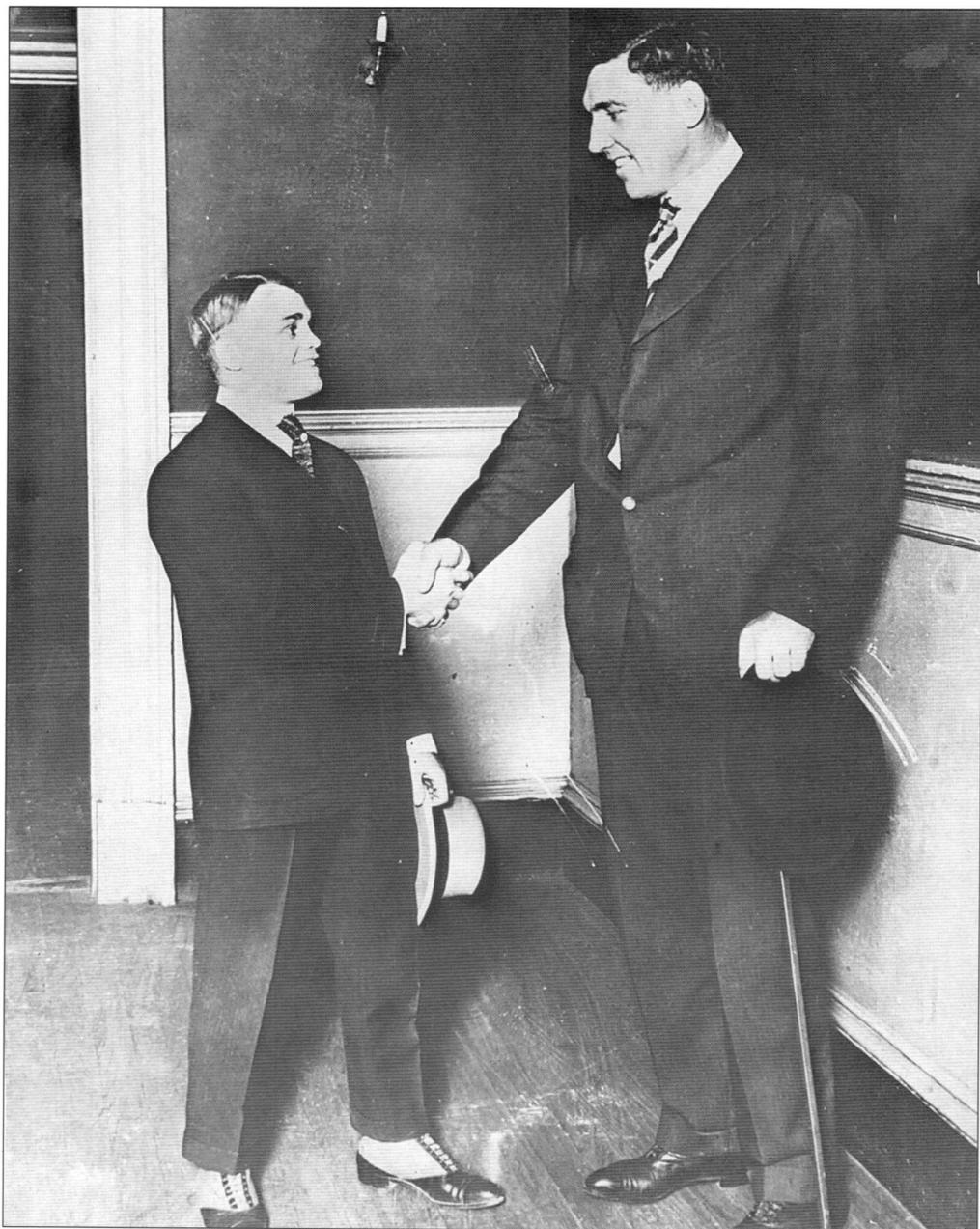

JUST A TAD DIFFERENCE IN SIZE. Baltimore's second world champion, bantamweight Johnny Kid Williams (left), shakes the hand of world heavyweight champion Jess Willard (right). Both of their careers were predominantly active in the 1910s when this picture was taken.

One
1893–1902

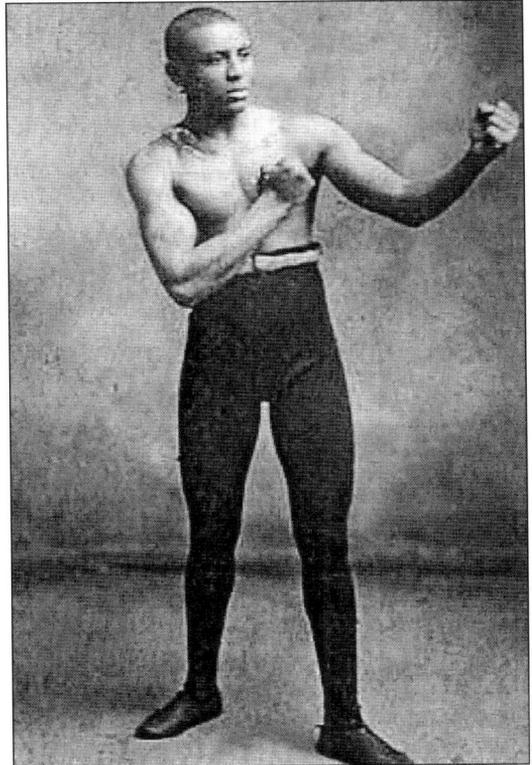

THE OLD MASTER. Joe Gans (Gant), christened Joseph Butts and raised by Mrs. Maria Gant in the 1000 block Argyle Avenue, boxed from 1891 to 1910. Gans was the first Baltimorean and African American to ever win a world championship. He won the title when he knocked out Frank Erne in Fort Erie, Ontario, on May 12, 1902 for the lightweight crown. His footwork, his speed of hand, his brilliant boxing ability, and his punching power all made him an immortal prizefighter, perhaps the best lightweight ever.

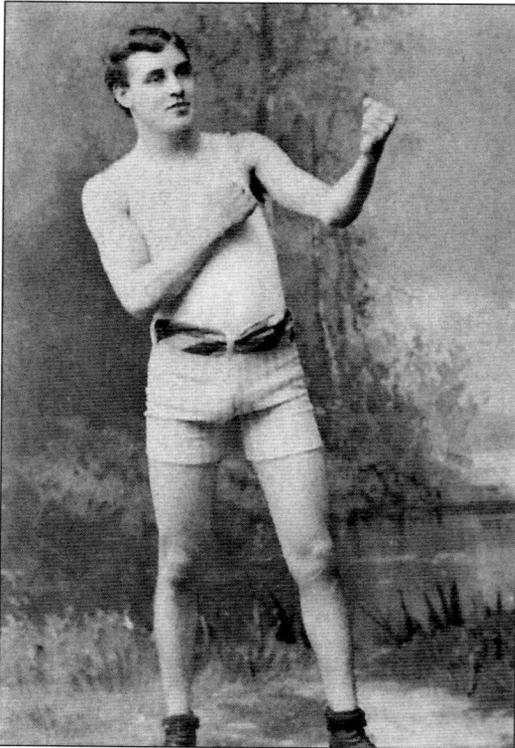

THE PROFESSOR. Frank Farley boxed from 1894 to 1898 when he was appointed boxing coach at Johns Hopkins University on March 18. Farley battled such good men as Herman Miller, Eddie Lenny, Spike Sullivan, and Elwood McCloskey.

THE BLACK DEMON. Jim Janey fought in both the 142 and 150 weight classes—mostly out of Baltimore and Washington, D.C., from 1894 to 1909. Among the opponents he boxed were Billy Payne, Jim Watts, Charley Johnson, and Frank Childs.

BARE KNUCKLE PIONEER. John Joseph Killion, better known in pugilistic circles as Jake Kilrain, trained on the corner of Fleet and Dallas Streets for his Baltimore fights in 1895 and 1896 with Abe Ullman and later Frank Slavin.

JOE ELLIOTT. A capable ring technician at 128 pounds, fought from 1894 to 1908, but only has 22 bouts on record among them Eddie Lenny, Billy Whistler, and Marty McCue. He has the distinction of being one of Joe Gans early knockout victims in 1895. (Photograph courtesy of Harry Shaffer.)

EDDIE DALY. He was a trial horse with a soft chin fighting as a bantamweight and later featherweight. Most of his losses from 1893 to 1905 were by way of knockout including among them Joe Tipman, Eddie Gardner, and Willie Fitzgerald.

HE CAME TO BALTIMORE TO SETTLE A SCORE. George Siddons (Ambrose Smith), inundated by the many challenges of Joe Gans, arrived in Baltimore in 1895 to see what this youngster was all about. On July 15, they finally met at the Eureka Athletic Club and boxed to a 20-round draw. Not satisfied with the outcome, Siddons met Gans once again, on November 28, and this time was knocked out in only 6 rounds. Gans burst into the national limelight with this bout and the previous one versus Young Griffo.

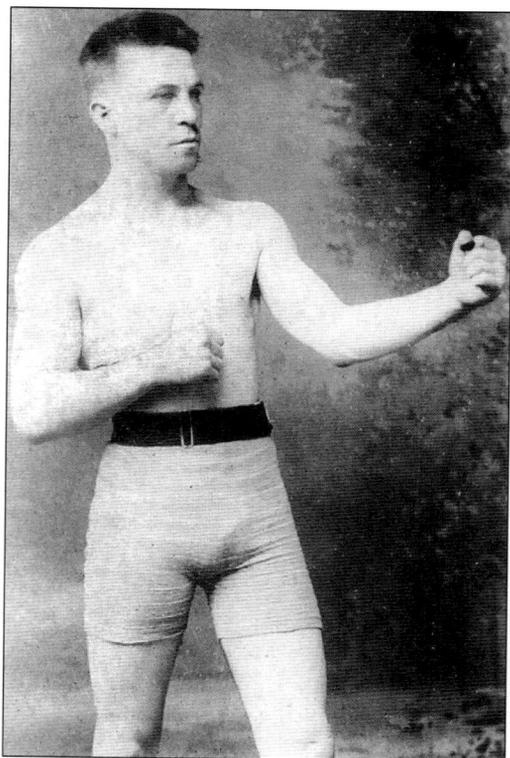

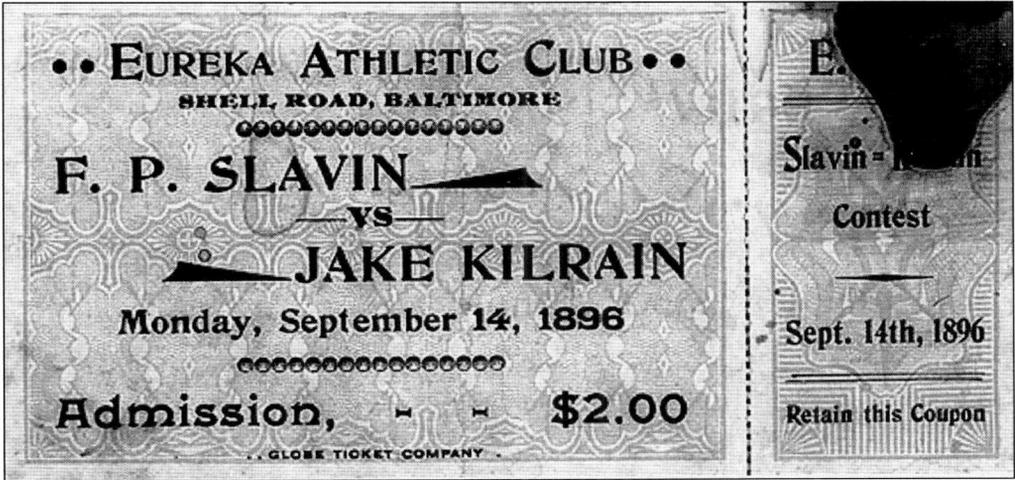

AN EARLY FIGHT TICKET. The most famous boxing venue in Baltimore from the 1890s to the 1910s was the Eureka Athletic Club on Shell Road. It attracted some very popular pugilistic stars throughout the country, such as Frank Paddy Slavin and Jake Kilrain. (Photograph courtesy of Jerome Shochet.)

BIG SIX. Alf Walker, originally hailing from Birmingham, Alabama, participated in many fights in the Baltimore and Washington, D.C. areas. Big Six, which was his ring name, had a short stocky build at 5'10" but carried a lot of muscular weight on his 240 pounds frame. His great strength won him fights against Mervine Thompson of Washington, D.C., and Jack McCormick, whom he fought at the Eureka Athletic Club in Baltimore. That fight occurred on March 11, 1898, and Big Six was winning the fight when the police intervened and stopped the fight in the fourth round. He ended his career by being knocked out in the third round by the much lighter Baltimore legend Joe Tipman on July 4, 1901.

13

SPARRING PARTNER OF JOE GANS. Herman Miller was a topnotch lightweight contender from 1898 to 1908. Most of his fights were in Baltimore rings where he tangled with Eddie Lenny, Elwood McCloskey, Joe Gans, Frank Farley, Bobby Dobbs, and Terry Martin. He later became a referee in Baltimore. (Photograph courtesy of John Gore.)

A NIGHT OUT ON THE TOWN. A good 108 pounds fighter, Jimmy Farren boxed the majority of his fights out of Baltimore from 1899 to 1909. He fought former world bantamweight champion Casper Leon to an eight-round draw on April 4, 1904, in Baltimore; he also tangled with Griff Jones, Kid Murphy, Al Delmont, and Young Britt. (Photograph courtesy of Harry Shaffer.)

FOUGHT TWO WORLD CHAMPIONS. Harry Lyons, a featherweight, fought many top men of his day, including past world champion George Dixon in Baltimore on February 8, 1901 in a 20-round draw and future champion Eddie Santry in 1897 in a six-round draw. He also met Elwood McCloskey, Eddie Lenny, Tim Callahan, and Joe Bernstein in Baltimore rings during a career that lasted from 1895 to 1904. He was often the chief second of Joe Gans in the ring and was also managed by Al Herford. (Photograph courtesy of Harry Shaffer.)

A GREAT WELTERWEIGHT. Baltimore's Billy Payne fought most of his fights out of Philadelphia, which was a very common practice for fighters from both cities. Payne fought from 1895 to 1912 and included among his opponents four world champions: Tommy Ryan, Philadelphia Jack O'Brien, Matty Matthews, and Joe Walcott. (Photograph courtesy of Harry Shaffer.)

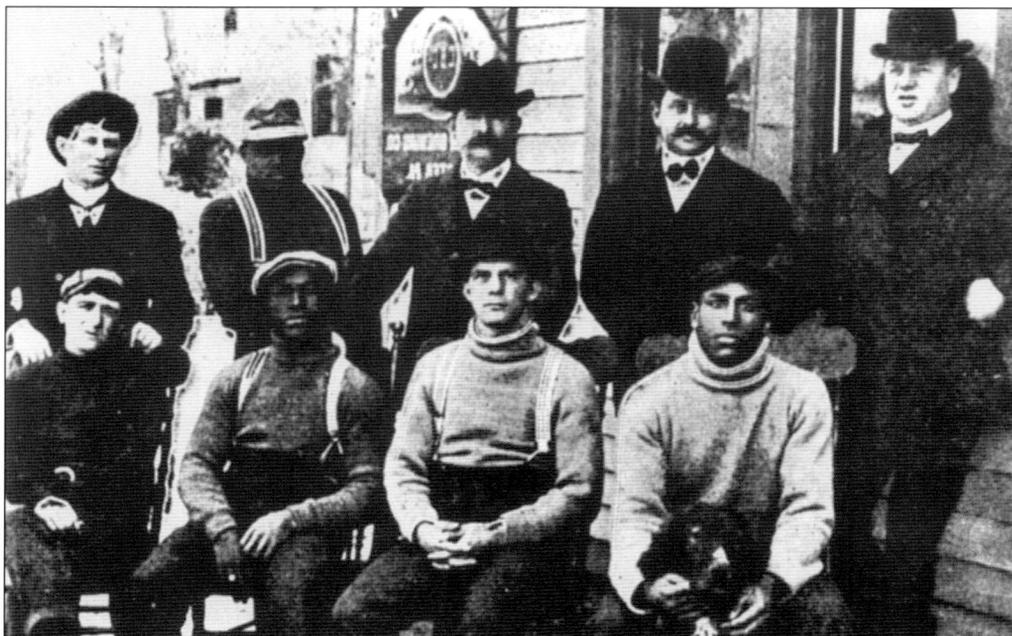

A STRONG BALTIMORE CONTINGENT. This photo was taken *c.* 1899 in Chester, Pennsylvania. The men pictured from left to right are the following: (seated) Eddie Lenny, a good featherweight from Philadelphia; Young Peter Jackson, a top contender from Baltimore; Herman Miller, a good boxer who later became a top referee in Baltimore; and Joe Gans; (standing) Jimmy Dougherty, manager of Lenny; Raymond Coates, boxer and trainer; Ed McLaughlin; Gus Coblens; and Al Herford, manager of Gans, Jackson, and Herman.

ELBOWS. George McFadden's foes faced four weapons in the ring. McFadden, a Brooklyn lightweight, was considered one of the greatest blockers, hitters, and defensive fighters of all times. Baltimore's Joe Gans could attest to this as Elbows knocked him out in 23 rounds in 1899. Elbows fought Charlie Seiger and Jimmy Murray in Baltimore rings. Long after his career was over, he lived in a Naval Home in Washington, D.C., during the 1940s.

16

Two

1903–1912

THE PRIDE OF ROCK STREET. Born Irvin Tieperman, Joe Tipman (right) was a Baltimore icon first as a boxer from 1899 to 1905 and later a saloonkeeper until 1946. He died in 1966 at the age of 82. His last fight was on October 27, 1905, in the old Germania Maennerchor Hall against Young Corbett II. Tipman later said it was the toughest fight of his career and it was the only one in which he received a major injury, a broken jaw. His friend Barney Sullivan is on the left. (Photograph courtesy of John Gore.)

HARRY SCROGGS. An active featherweight and lightweight from 1904 to 1911, Scroggs fought such men as Joe Tipman, Tommy Feltz, Kid Sullivan, and Joe Bernstein. He lost a 15-round decision to former world featherweight champion Young Corbett II on May 11, 1909, in Baltimore.

YOUNG PETER JACKSON AND JOE GANS. Two of Baltimore's best fighters train for Gans's fight with Jimmy Britt, which Gans won on a foul in the fifth round on October 31, 1904, in San Francisco. Gans fought the important fights of his career in other cities, but at least half of his matches were staged in Baltimore. Jackson, a welterweight and middleweight, fought world champions Jack Johnson, Joe Walcott, and Philadelphia Jack O'Brien all in Baltimore.

18

HE FOUGHT MANY GOOD ONES. Tommy Feltz of Brooklyn, New York, met many stars in Baltimore rings, including former world bantamweight champion Danny Dougherty on January 15, 1904, in a 15-round draw; Joe Tipman on October 14, 1904, in a 15-round win; and former world featherweight champion Abe Attell on February 3, 1905, in a 15-round loss.

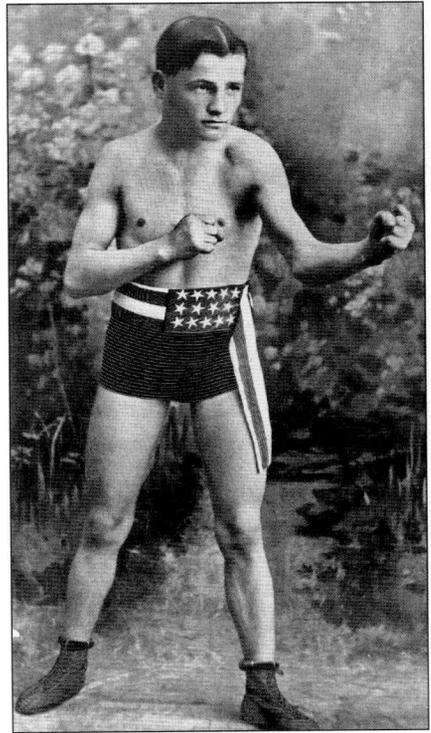

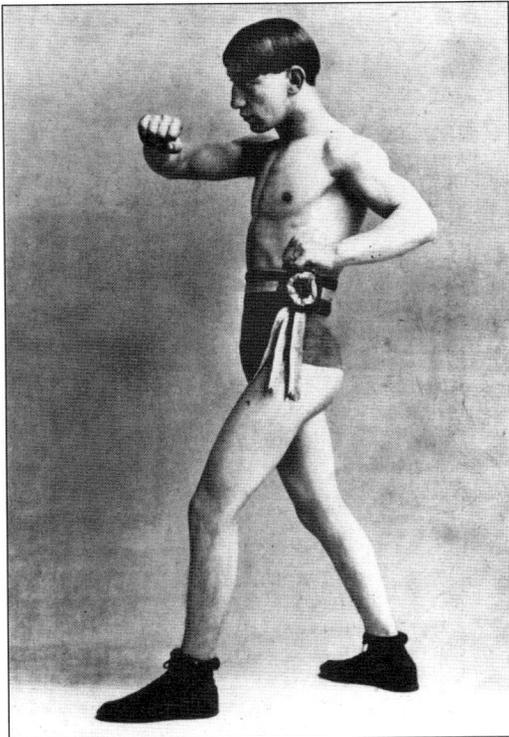

FLYWEIGHT KID MURPHY. Peter Frascella, a native of Trenton, New Jersey, had numerous fights in Baltimore from 1904 to 1908 and met the likes of Benny Franklin, Young Britt, Jimmy Farren, Kid Egan, and Tommy O'Toole. He claimed the Paperweight title, as it was known then, in 1906 but quickly outgrew the class and claimed the bantamweight championship, which he eventually lost to Johnny Coulon on January 8, 1908. (Photograph courtesy of Harry Shaffer.)

19

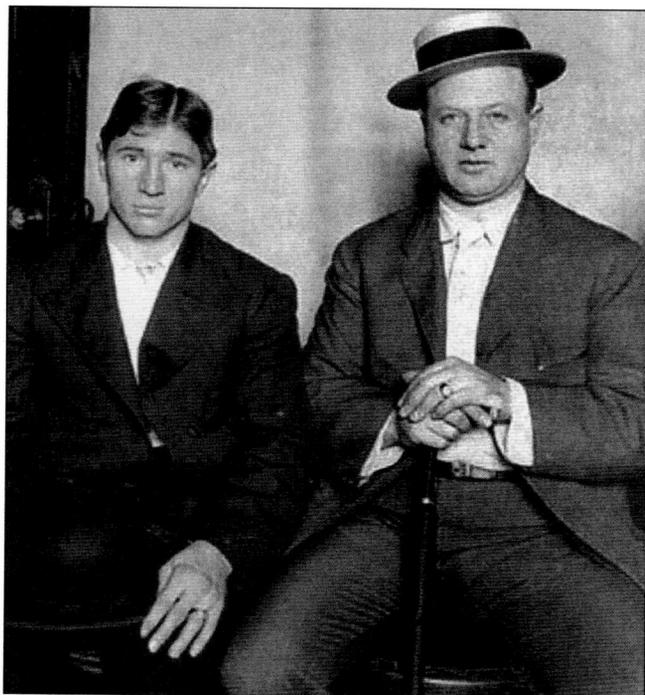

MENTOR AND PUPIL. Abraham L. Herford—known as Al—(right) was a Pimlico bookmaker, Fleet Street restaurant manager, and prizefight promoter of the Eureka Athletic Club on Shell Road. Herford also managed Baltimore's best fighters from 1895 to 1910, including Joe Gans, Young Peter Jackson, Joe Tipman, Herman Miller, Harry Lyons, and Kid Sullivan (pictured). The year 1905 was a busy year for Sullivan (Harry Sheehy) as he fought five past, reigning, or future world champions: Young Corbett II, Jimmy Britt, Abe Attell, Battling Nelson, and Harry Lewis. Sullivan was active from 1903 to 1908 with more than half of his fights taking place in Baltimore.

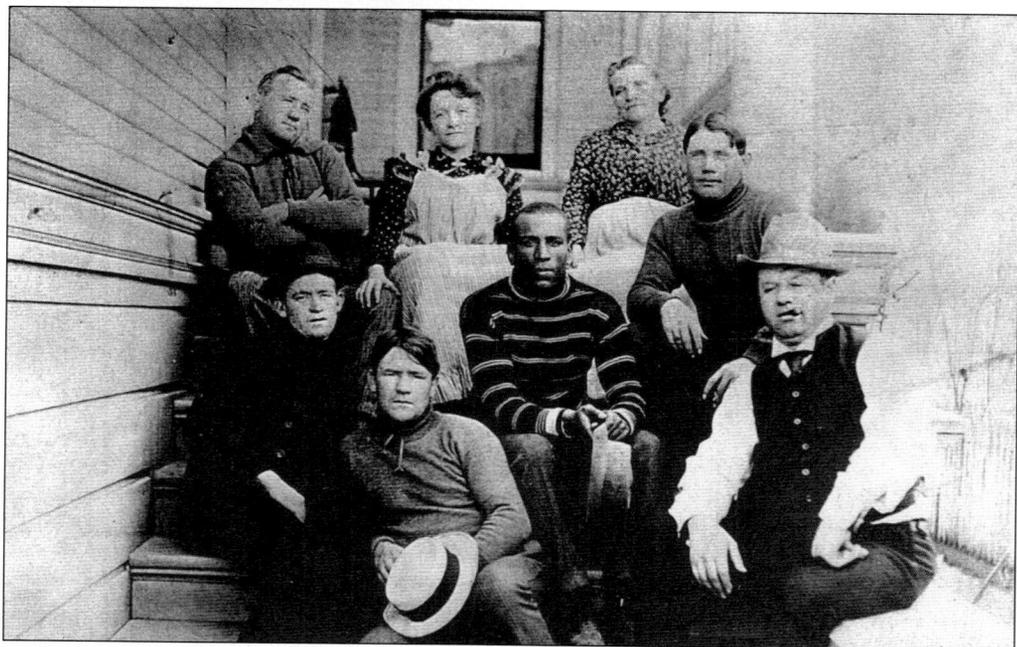

TRAINING BREAK. Joe Gans (center) was training at Billy Shannon's in California as was Featherweight champion Young Corbett II (to Joe's right) during the fall of 1904. Seated with the hat is Al Herford, Joe's manager. At one time, Joe referred to him as "crooked" after he was told to take a fall in a bout with Terry McGovern in Chicago in 1900. (Photograph courtesy of Gary Phillips.)

TERRY MARTIN. By way of Philadelphia, Terry often made the short trip to the Monumental City to fight any welterweight willing to step into the ring. On June 26, 1907, Herman Miller accepted the challenge and regrettably was knocked out in the fifth round. Others Terry fought in local rings included Harry Lewis and Eddie Chambers.

DOWN GOES SULLIVAN. Squaring off prior to their second of three meetings in less than one year, Joe Gans (right) knocked out Mike Twin Sullivan in 15 rounds in San Francisco, California, on January 19, 1906. Gans often took on heavier men such as Sullivan, Barbados Joe Walcott, and Sam Langford. Standing behind Gans is his "second" Willie Fitzgerald, whom he called one of his toughest opponents.

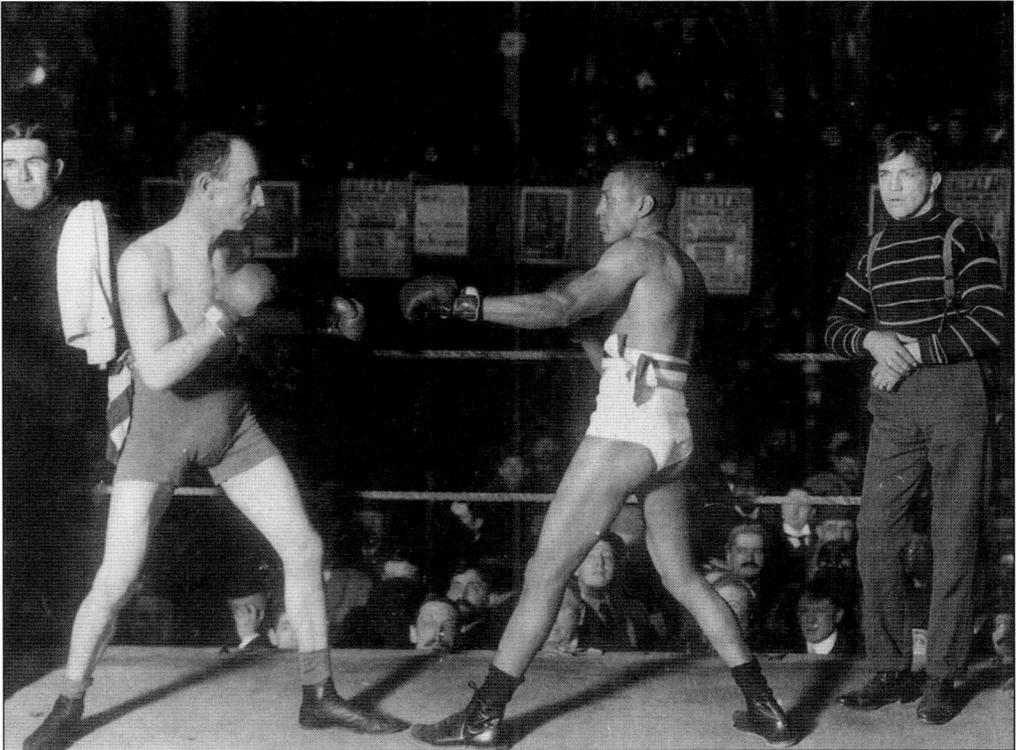

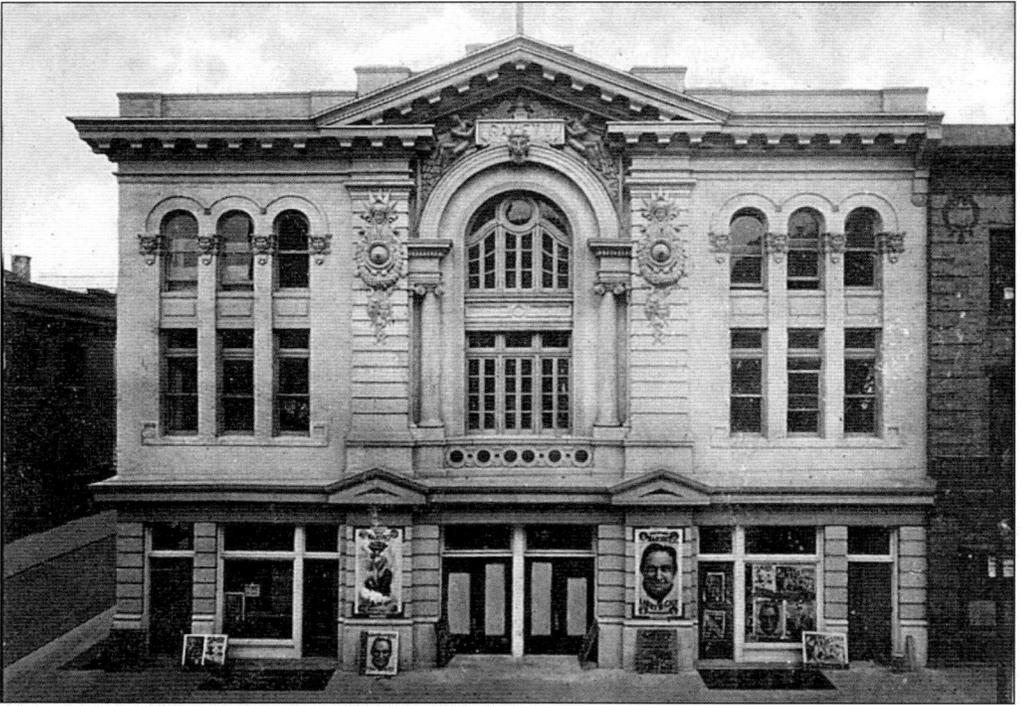

THE GAYETY THEATRE. Built in 1905 and still located to this day on 405 E. Baltimore Street, the Gayety hosted several important matches from 1909 to 1933, including Kid Williams vs. Charlie Holman in 1923 and Harry Jeffra's first professional bout vs. Angelo Brocato in 1933.

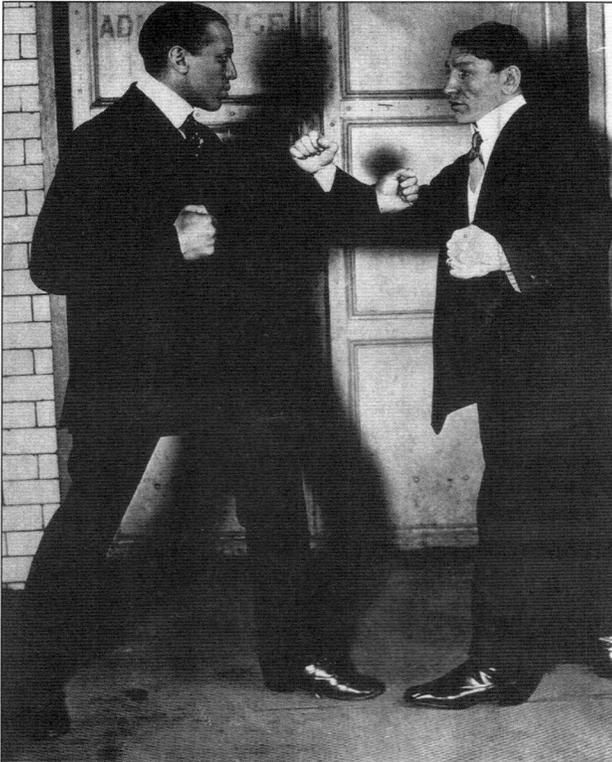

CAN'T WAIT UNTIL I SEE YOU IN THE RING. Squaring off outside the Coliseum before their May 14, 1908 fight, Joe Gans (left) and Rudy Unholz (right) look more like they were going to the theatre—instead of engaging in a scheduled 20-round bout. San Francisco was the sight of this battle in which Gans would knockout Rudy in the 11th round to retain his world lightweight crown. This would turn out to be Gans's 4th last bout. (Photograph courtesy of Leo Dymowski.)

A MAN OF TRADES. Benjamin Harrison Franklin was born in Baltimore to Jewish-Irish parents. He began boxing professionally at the age of 14 in 1901 at 114 pounds. He went on to engage in some 187 fights losing only 7. His fights with Kid Murphy, the bantamweight title claimant, were held in Baltimore on March 31, 1904—a 25-round draw—and in Bel Air, Maryland on May 10, 1904—a 15-round loss. Benny also met Charley Goldman, Irish Patsy Callahan, Young O'Leary, and Leach Cross. After his boxing days, he joined partnership with the renown Sammy Harris in 1920. After the death of Harris, Benny started the Olympia Athletic Center on Franklin and State Streets with the assistance of matchmaker Lou Fisher. Benny brought two world championship fights to Baltimore, the Pancho Villa versus Benny Schwartz flyweight match in 1923 and the Harry Greb versus Fay Keiser middleweight match in 1924. Both were held at the Fifth Regiment Armory.

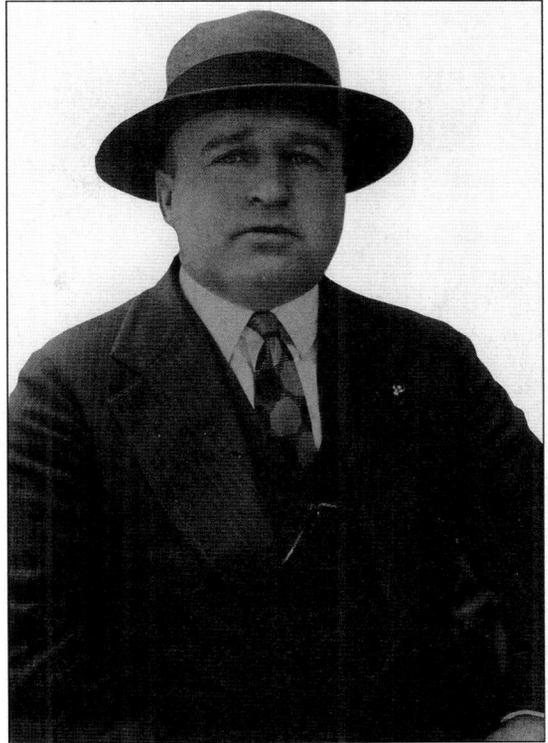

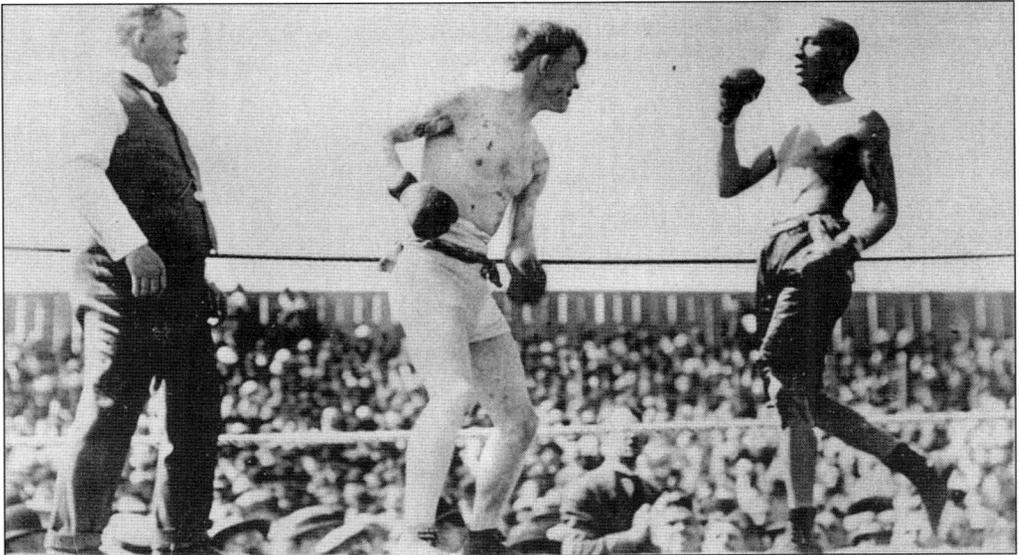

THAT NELSON AFFAIR. The site is Mission Street Arena in Colma, California, on July 4, 1908, an epic battle between Battling Nelson (left) and Baltimore's lightweight champion Joe Gans (right). This photo was taken in the 12th round by famous photographer Percy Dana, which clearly shows Nelson covered in blood. The bout would end in the 17th round with Nelson stripping Gans of his crown by a knockout. Famous referee Jack Welch looks on. (Photograph courtesy of Gary Phillips.)

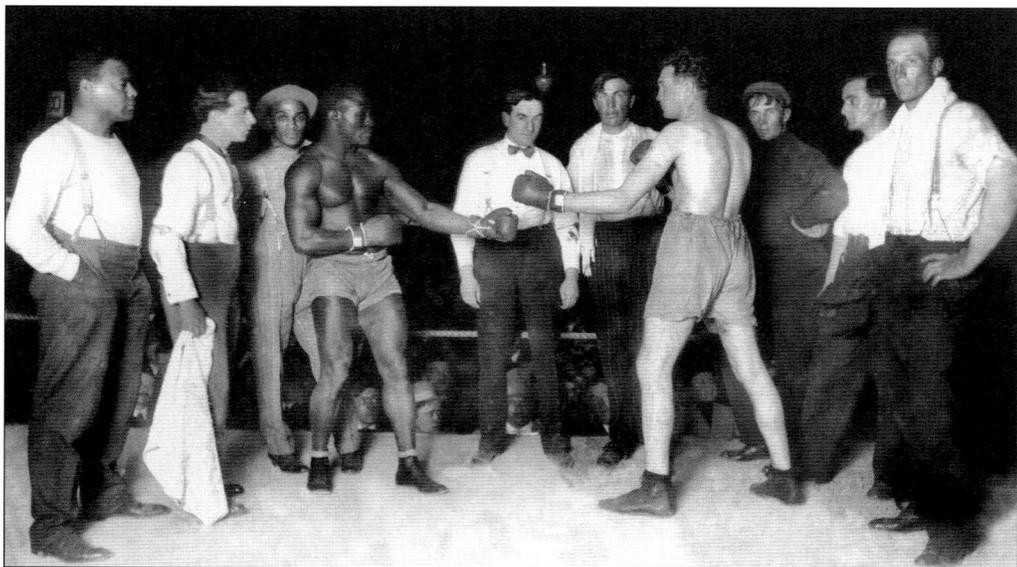

QUICK WORK. Young Peter Jackson (left) of Baltimore, christened with the name of Sim Thompkins, knocked out Billy Burke in the second round on September 9, 1909, in San Francisco, California.

JOE GANS GAVE HIM A SET OF HIS BOXING GLOVES. Raised in the Little Italy section of Baltimore, Rock Joseph Scala—a.k.a. Willie Rock—learned his skills at the gym in the back of Tom the Greek's confectionary store on Eastern Avenue. In this same gym, Kid Williams honed his skills that later allowed him to become a world champion. During his seven year professional career, Willie tangled with two world champions, Kid Williams and Kid Murphy. While working as a youngster around the fish market at Lombard and Market Place, he became friendly with the all-time great lightweight Joe Gans.

THE 1910 BANTAM AND FEATHERWEIGHT
CHAMPION OF THE SOUTH. Harry Treffinger,
better known as Young Britt, was one of the most
popular boxers in the South during the teens.
The Monumental City lad fought many top-
notchers, including Charley Goldman—a future
trainer of Rocky Marciano—and world
champions Jimmy Walsh and Frankie Neil. He
was also influential in teaching future world
bantamweight champion Kid Williams how to
box before he burst onto the scene.

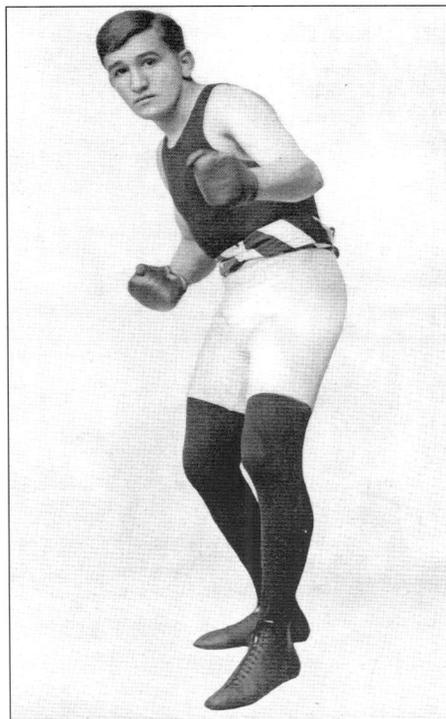

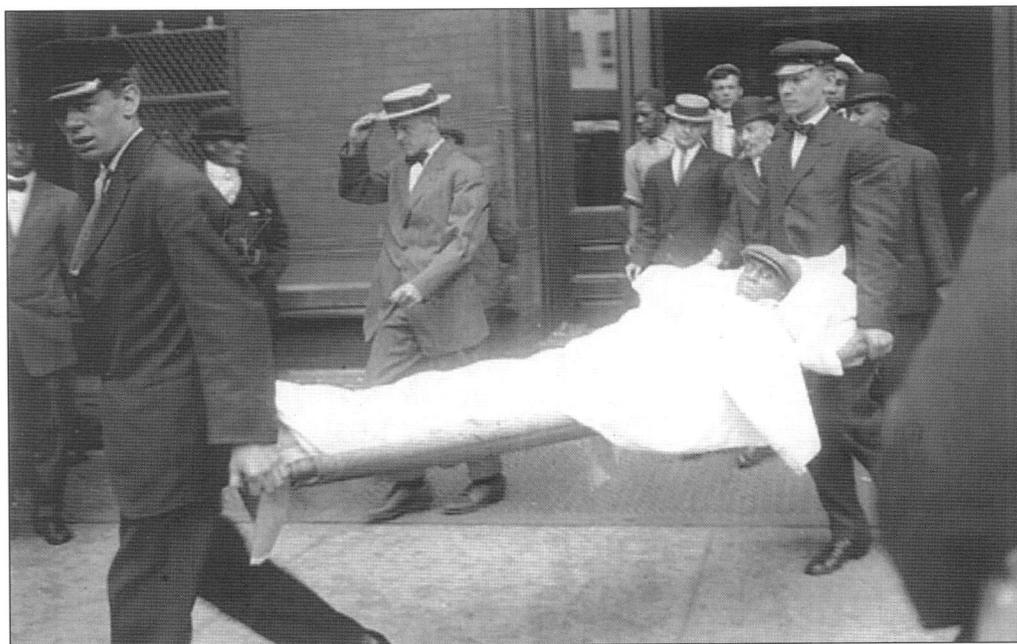

A SOMBER 1910 SUMMER. Already feeling the effects of advanced tuberculosis, Joe Gans is
carried out of a building in Chicago, Illinois, awaiting a train on his way home to Baltimore.
Gans wished to die in his foster mother's home and did so on August 10, 1910. He was only 35
years old.

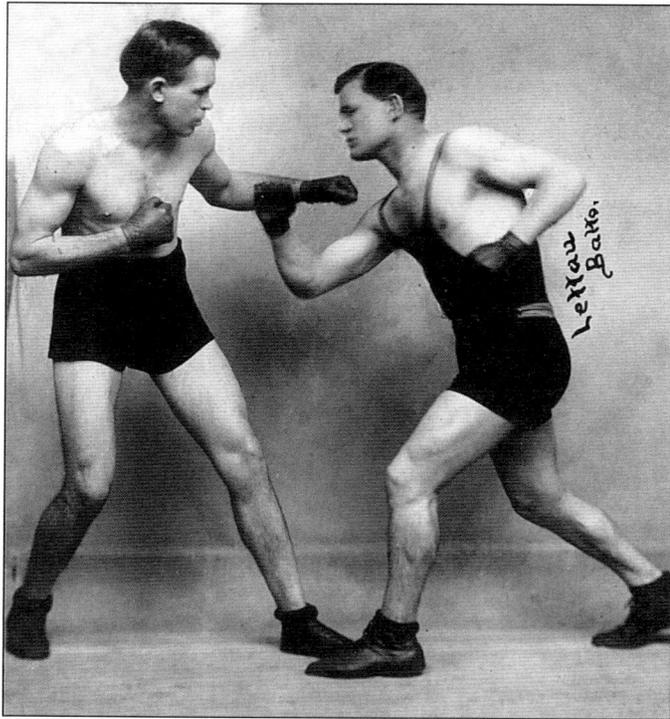

STILL MIXING IT UP. Joe Tipman (right) helped boxers hone their skills even after retiring from the ring in 1905. Here he is with Ford Munger in preparation for Munger's Baltimore bout with Joe Borrell, held on March 11, 1912, in which Borrell knocked him out in 15 rounds. Munger has the distinction of being world champion Jock Malone's first opponent in 1916.

GEORGE KID ASHE. A fine middleweight from Philadelphia, he ventured down to Baltimore during his rookie campaign to tangle with Jimmy Glavin on June 5, 1911, and earned a 15-round draw. The following year on February 8, he was amidst much tougher competition in the name of Battling Levinsky. Again, George fought a 15-round draw against the future light heavyweight champion.

Three
1913–1922

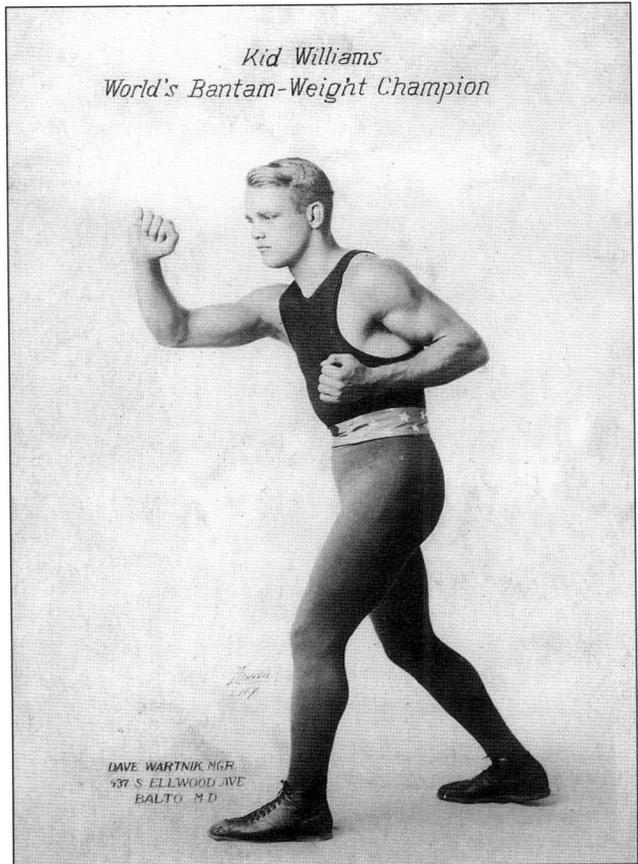

Kid Williams
World's Bantam-Weight Champion

DAVE WARTNIK MGR.
437 S ELLWOOD AVE
BALTO M.D

WORLD'S BANTAM CHAMP, 1914 TO 1917. Kid Williams, christened John Gutenko, was a fighting machine with over 200 recorded bouts from 1910 to 1929. He was Baltimore's second world champion. His managers were Sam Harris, Dave Wartnik, and Phil Glassman. He was often called "Dutch" by his friends and admirers.

THE KNOCKOUT KING OF FISTIANA. George Henry Chaney started boxing in Baltimore in 1910. In his first fight, he scored a one-round knockout over Willie Williams. His final fight was 16 years later—he was kayoed in one round by Danny Kramer. Upon retiring, he held the record for most knockouts with 102, which was later broken by Young Stribling. KO Chaney fought three times for the world championship, but he failed to win the title in all attempts. His bout with Rocky Kansas at old Oriole Park in 1920 was judged the most brutal and bloody bout ever held in Baltimore.

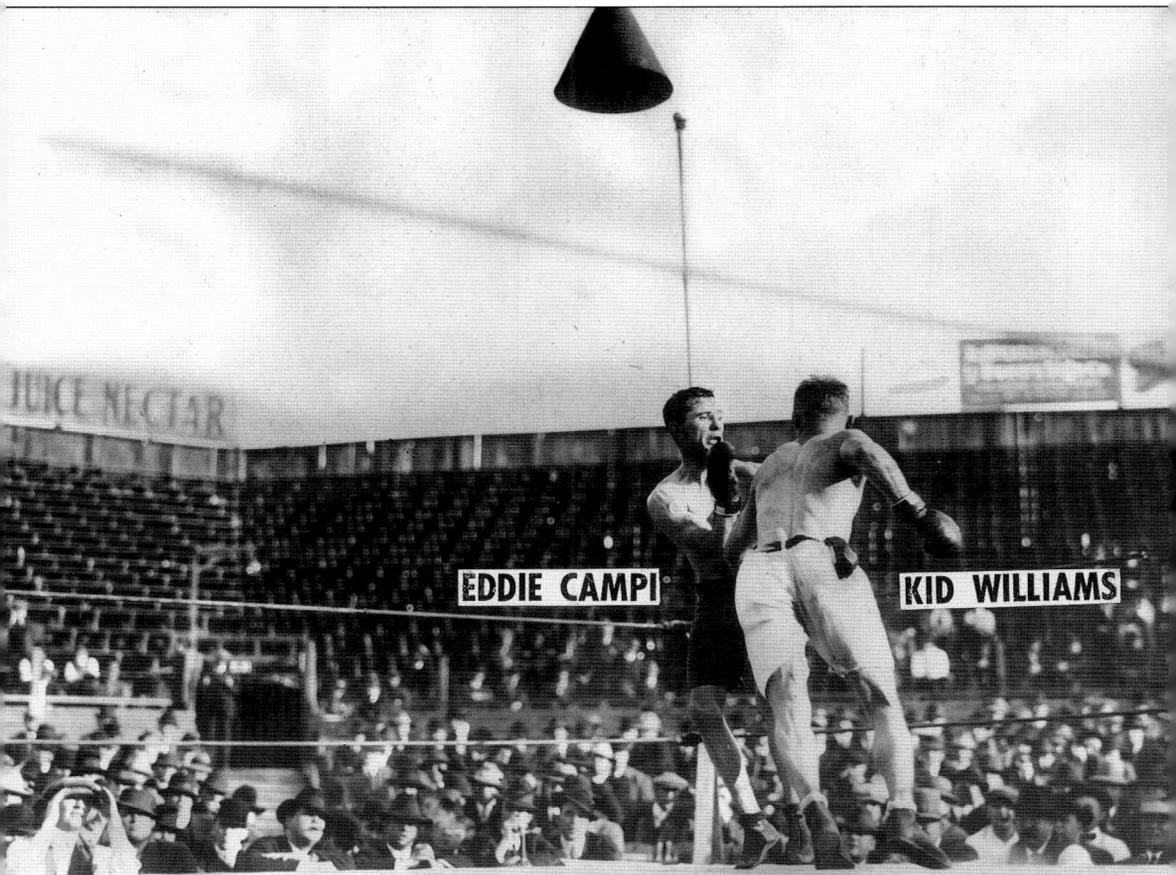

WILLIAMS SCORES 12 RD. KAYO OVER EDDIE CAMPI, VERNON, CALIFORNIA

TUNE UP FOR WORLD'S BANTAMWEIGHT MATCH. In a torrid 12-round match, Kid Williams knocked out Californian Eddie Campi on January 31, 1914. Five months later in the same ring, William's knocked out Johnny Coulon in three rounds for the world bantamweight title.

THE THIRD FIGHTING CHANEY. The man known as Andy Chaney was born Andrew Kwasniewski. Upon turning professional in 1914, he assumed the ring name, Young Chaney, out of admiration for his fellow Baltimorean boxing buddies, Joe and George K.O. Chaney. His bantamweight career lasted until 1925. His career was lengthy and included touching gloves with the following: Little Jack Sharkey, in a 15-round draw; world bantam champ Pete Herman, battling for 10 rounds no decision; world feather champ Johnny Kilbane, fighting for 8 rounds no decision; ex-world bantam champ Kid Williams, in a 10-round battle win; future world welter champ Joe Dundee, an 8-round knockout; future world feather champ Louis Kid Kaplan, a 12-round loss; and world lightweight champ Jimmy Goodrich, a 10-round loss. (Photograph courtesy of Harry Shaffer.)

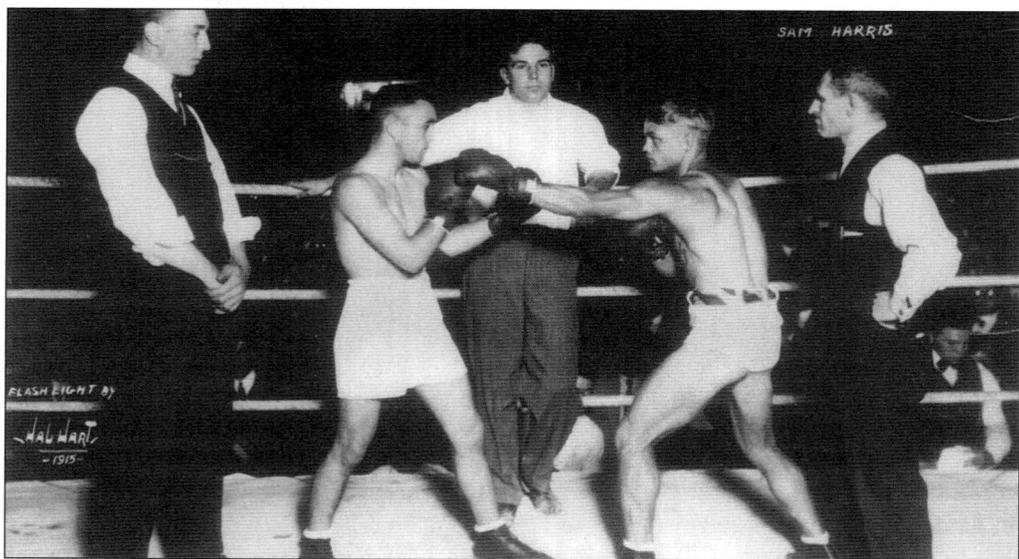

KID WILLIAMS FIRST TITLE DEFENSE. In St. Paul, Minnesota, hometown of Johnny Ertle (left), Williams (right) dished out a severe beating. It was in the fifth round when Ertle sank to his knees claiming he was hit low. George Barton (center) allowed the claim and named Ertle the winner and new world bantamweight champion. However, uproar ensued from the public over the referee's decision, thus Ertle was never generally recognized as champion. Sammy Harris managed Williams for most of his career. (Photograph courtesy of J.J. Johnston.)

American Athletic Association,

ARTICLES OF AGREEMENT.

EUREKA ATHLETIC CLUB (Inc.)

OF BALTIMORE, MD., U. S. A.

SAMMY HARRIS, Manager.

BALTIMORE, MD., March 21st, 19 16.
American Athletic Association,

These Articles of Agreement, entered into between **THE EUREKA ATHLETIC CLUB (Inc.)** of Baltimore, Md., of the first part, andAl. Britt of Baltimore, Md..

.. andKid Whitten of Baltimore, Md..........................

of the second part, whereby the parties of the second part agree to box.......fifteen...............rounds, with five-ounce gloves, according to Marquis of Queensbury Rules and the By-Laws and Regulations of the Club, before the above named Club, on..Thursday night April 4th,............19 16.

The party of the first part agrees to award to the parties of the second part...

..of which the party who the referee designates as the winner is to

receive ..and the loser..as and for

their and each of their services in giving the above exhibition of boxing.

The parties of the second part shall not weigh over......pounds at....xxxxxxxxxxxx........
.........................., and each of the parties of the second part shall post a forfeit of

not less than........$ 50 ..dollars as a guarantee to their being to weight and at

the Club house in good physical condition, ready and willing to perform their part of this agreement not

later than......nine.........o'clock, on the............night............of contest.

Both contestants must be in the city...twenty four hours......before the day of the contest; if not, they forfeit money posted.

Neither of the parties of the second part will be allowed to take part in a boxing exhibition either in private or public for points, or in any other capacity, until he has fulfilled his agreement with this Club.

Each of the parties of the second part shall be examined by the authorized physicians of the Club, and shall present certificates showing them to be in good physical condition.

The official Referee of THE EUREKA ATHLETIC CLUB (Inc.) to act in that capacity. Tony Geiger

It is also agreed that the contestants may wear soft cotton bandages for the hands, the bandages to be approved by the party of the first part.

Each of the parties agree that the Referee shall stop the contest if it should go beyond a fair boxing bout; and in case either man should be disqualified on account of deliberately fouling his opponent he shall forfeit the amount called for in these articles for weight and appearance.

Al Britt to receive twenty percent of the gross gate receipts for giving the above exhibitionxxg of boxing.

...

In case contestants do not agree on Referee 24 hours before contest, Club reserves right to select Referee. It is also agreed that parties of second part will allow Club one-half of Referee's charges.

In Witness Whereof, THE EUREKA ATHLETIC CLUB (Inc.) have hereunto set their Corporate Seal, by the hand of their Secretary, and the parties hereto have hereunto set their hands.

WITNESS:

THE ARTICLES OF AGREEMENT. The Eureka Athletic Club was still going strong in the 1910s under new management of Sammy Harris. Sammy took over the club from Al Herford. Here is a contract between Al Britt and Kid Whitten for their April 4, 1916 bout. (Photograph courtesy of John Gore.)

31

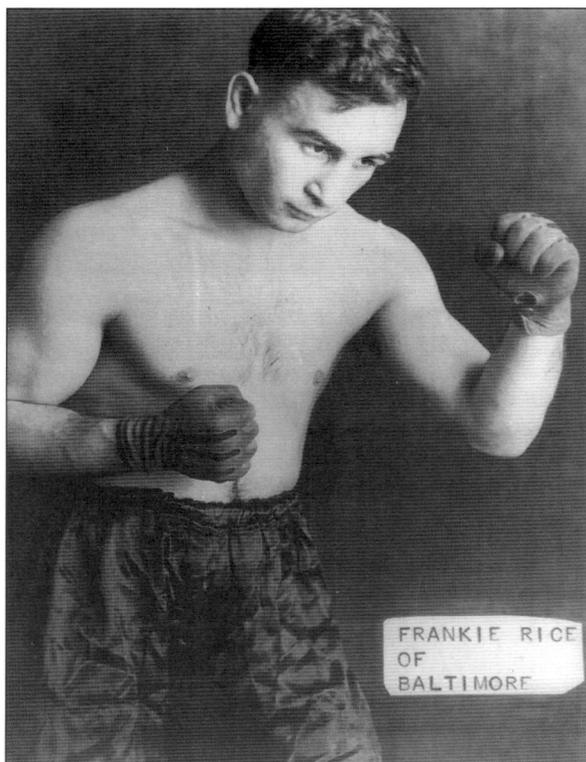

THE BALTIMORE CAVEMAN. Benjamin Lipsitz—a.k.a. Frankie Rice—was a top-notch featherweight whose career lasted from 1917 to 1926. This included approximately 150 fights. In that time, he fought the following: world champion Johnny Dundee, Joe Tiplitz, Andy Chaney, Bobby Garcia, Joe and George KO Chaney, Danny Kramer, Willie Jackson, and Sid Terris. After his boxing days, Rice trained and managed fighters like Jack Portney, Burt Whitehurst, and Tony Ross. Benjamin also ran several shows at Carlin's Park in the 1930s. (Photograph courtesy of Robert Carson.)

HE FOUGHT THREE CHAMPIONS IN BALTIMORE. Dick Loadman, hailing from Buffalo, New York, enjoyed boxing in Baltimore during the 1910s. On November 27, 1916, he met title claimant Johnny Kewpie Ertle and won a newspaper decision in 10 rounds. The following year on October 1, he tangled with world champion Kid Williams only to lose the 12-round decision. On February 6, 1918, he was on the losing end of a 15-round decision over title claimant Memphis Pal Moore.

LEN (YOUNG) MAHONEY. A great all around boxer he was very agile and had a good left jab and hook. At 128 pounds, he debuted at the Gayety Theatre in 1917 and racked up some 60 bouts during his career that lasted until 1926. His greatest local rival was none other than future world champion Joe Dundee, whom he fought three times. The first two bouts were split and Len took the 15-round decision in the rubber match on February 5, 1923. Other contenders he met were Danny Frush, Eddie Kid Wagner, Nick Bass, Frankie Rice, Eddie Burnbrook, Battling Willard, and future champion Vince Dundee—this would be his last fight.

THE GLOBE TROTTER. Jeff Smith, a middleweight champion claimant from Bayonne, New Jersey, fought over 185 battles during his 18-year career. He fought four times in Baltimore during the 1910s. On November 6, 1916 he knocked out Herman Miller in three rounds. In 1917, he won 15-round decisions over past middleweight claimant Frank Mantell on New Years Day and Zulu Kid on July 21. On May 10, 1919, he won a 12-round bout with past middleweight champion George Chip.

HE FOUGHT HARRY GREB FOR THE WORLD MIDDLEWEIGHT TITLE. Prior to World War I, Fay Keiser fought Pittsburgh's Harry Greb an incredible seven times. Greb took most of the newspaper decisions. When war broke out, Fay volunteered his services. He even took a bullet in his shoulder during action in France. Hailing from Cumberland, Maryland, Fay returned and was matched against Bob Martin, whom he beat in 12 rounds. On March 24, 1924, Fay met his old nemesis, now world champion, Harry Greb for the title. He was knocked out in 12 rounds. A week later he met future light heavyweight champion Jimmy Slattery. During his career Fay also battled future world heavyweight champion Gene Tunney twice (one time knocking him down in the second round), future light heavyweight champion Tommy Loughran, Young Stribling, Leo Houck, Joe Chip, George and Billy Shade, and Young Bob Fitzsimmons.

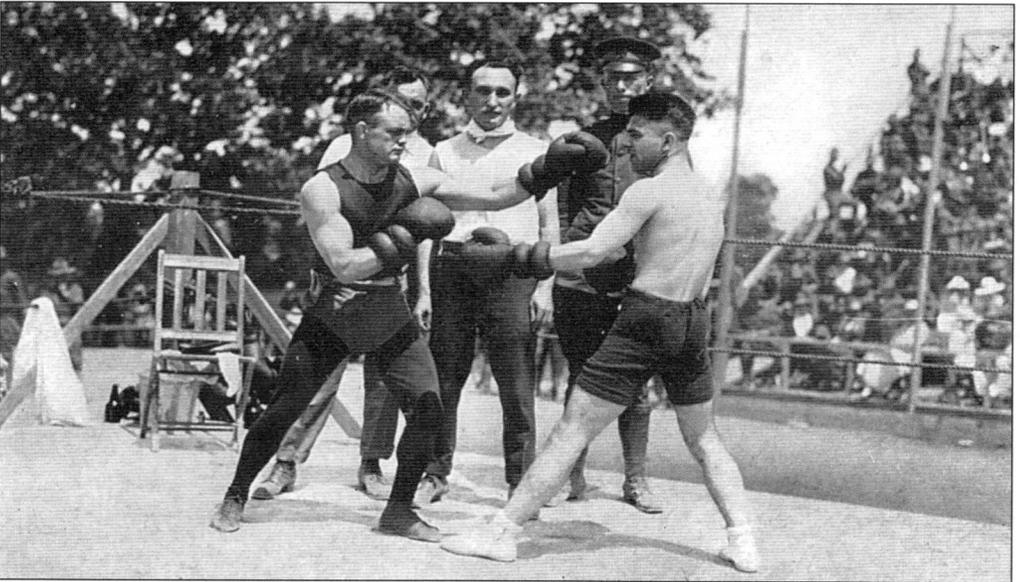

BALTIMORE TIGER. Kid Williams (left), like many other boxers during World War I, donated his time to instructing Uncle Sam's Dough Boys. The Kid, only 5'1", was one of the strongest bantamweights of all time. He had a relentless, aggressive style that he carried to the end of his career in 1929.

PROUD TO SERVE OUR COUNTRY.
Monumental City lads—from left to right,
Bobby Burns, Larry Cohen, and Baltimore
(Young) Dundee—were fixtures in Baltimore
rings during the 1910s. This photo was taken
in 1918 during the First World War when the
men were stationed in the Navy at Norfolk,
Virginia. On April 15, 1917, Dundee (Samuel
Ranzino) won a six-round decision from
Burns (Chester Webb) for the bantamweight
championship of Maryland at Holliday Street
Theatre. Larry Cohen trained both men.
Dundee, managed by Sam Harris, grew up in
Little Italy on East Lombard Street. He
learned to box there at the ripe age of 16. He
took the ring name Young Dundee in honor
of fellow Italian champion Johnny Dundee.
Tragedy struck both fighters. The Great Flu
Epidemic of 1918 struck Baltimore very hard
and Dundee, one of the epidemic's many
victims, died on October 11, 1918 at the age
of 17. Burns, two weeks earlier, died of
shrapnel wounds aboard the ill-fated
transport, Ticonderoga.

WORLD BANTAMWEIGHT TITLE CLAIMANT.
Young Pal Moore of Memphis, Tennessee,
won a 15-round decision from Johnny Ertle
on April 10, 1918 in Baltimore. However, this
was not universally recognized and Kid
Williams still held the crown. Moore boxed
numerous times in Baltimore from 1918 to
1921, meeting the likes of Dick Loadman,
Earl Puryear, and Roy Moore.

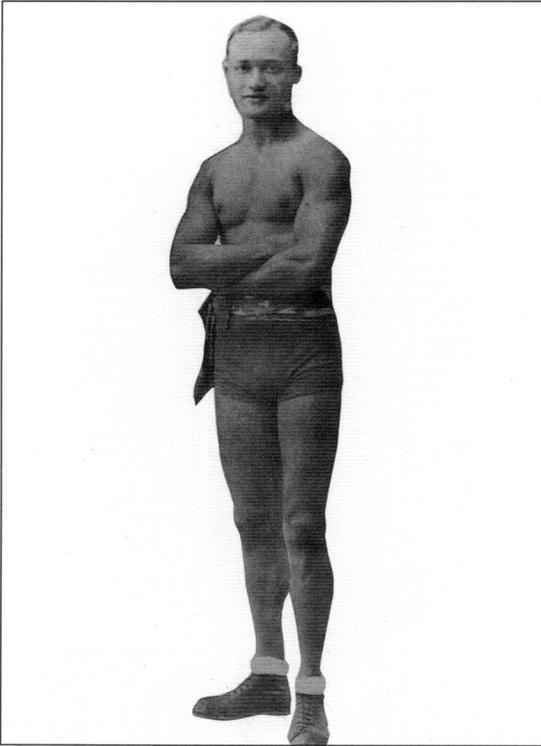

HE FOUGHT JOHNNY KILBANE FOR THE WORLD FEATHERWEIGHT TITLE. A true globetrotter Danny Frush was born in England and settled in Baltimore. Sam Harris managed him when he arrived in 1920. He did not waste anytime in testing his strengths against the proven Andy Chaney. Frush won 11 of the 12 rounds and was on his way to the featherweight title. His big chance came against champion Johnny Kilbane on September 17, 1921. Kilbane, on the verge of defeat, fouled Frush. The foul was not called and Kilbane won by a seventh-round knockout. In his career, Frush also met champions Johnny Dundee, Eugene Criqui, and Louis Kid Kaplan.

DEBUTED AGAINST YOUNG PAL MOORE. Michael "Kid" Julian, a flyweight tipping the scales at 112 pounds, earned a draw against the seasoned Moore in 1920 (not Memphis Pal Moore). During the early 1920s, Benny Schwartz and Lew Mayrs were his biggest rivals. He entered the ring with them at least four times each.

Four

1923–1932

BALTIMORE'S THIRD WORLD CHAMP. Samuel Lazzara, better known as Joe Dundee, was welterweight champion from 1927 to 1929. His two brothers, Carmelo (Battling) and Vince, as well as cousins Phil, Joey, and Lew Raymond, made boxing history in Baltimore a fond memory. Joe started boxing at an early age, fighting in the streets. He decided to make boxing his profession and at the age of 13 took to the gym. His hard work paid off when he won the world welterweight title from Pete Latzo in New York City on June 3, 1927.

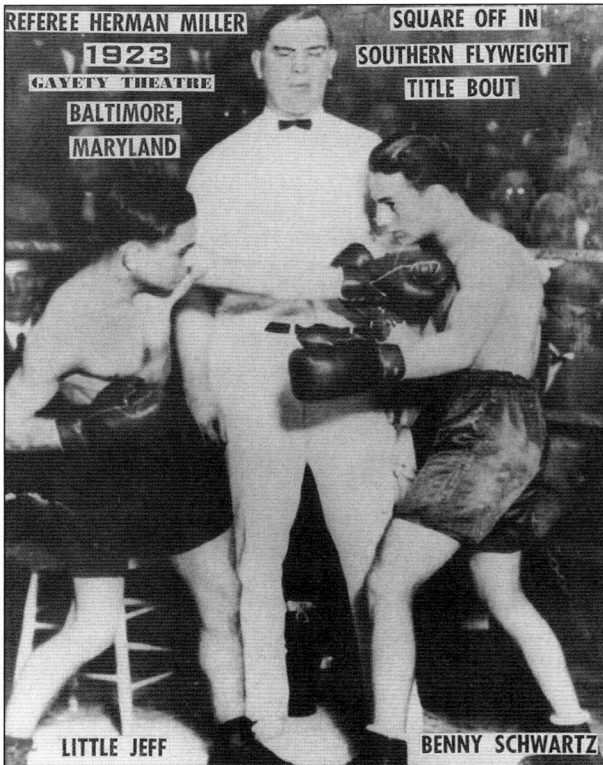

REFEREE HERMAN MILLER
1923
GAYETY THEATRE
BALTIMORE, MARYLAND

SQUARE OFF IN
SOUTHERN FLYWEIGHT
TITLE BOUT

LITTLE JEFF

BENNY SCHWARTZ

TWO BALTIMORE LEGENDS OF THE ROARING 1920S. Little Jeff and Benny Schwartz fought each other three times from 1922 to 1924. Jeff took only one of the decisions. Herman Miller, a popular referee during the 1920s, was an excellent boxer in his own right at the turn of the century. He met such good men as Jack Blackburn and Tim Kearns.

SPIKE WEBB. Christened Hamilton Murrel Webb, a native of Baltimore, Spike fought as a featherweight. His legacy is better known as a trainer of fighters. He enlisted in the Army in World War I and became boxing instructor of the 29th Division at Anniston, Alabama. Returning home in 1919, he was appointed boxing instructor at the U.S. Naval Academy in Annapolis, Maryland. He remained there for 35 years until his retirement in 1954. Webb served as an American Olympic boxing coach in 1920, 1924, 1928, and 1932. He trained future world champions Frankie Genaro, Jackie Fields, and Fidel LaBarba. He also trained world champions Paul Berlanbach, Gene Tunney, and Baltimorean Kid Williams.

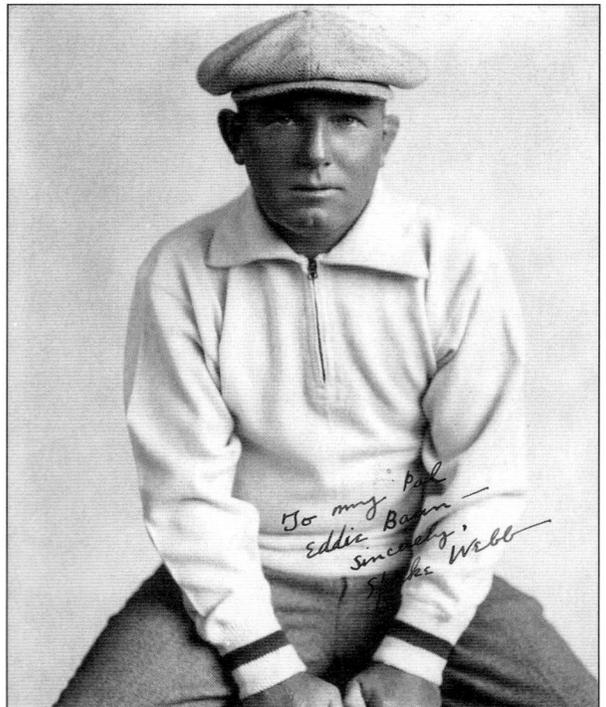

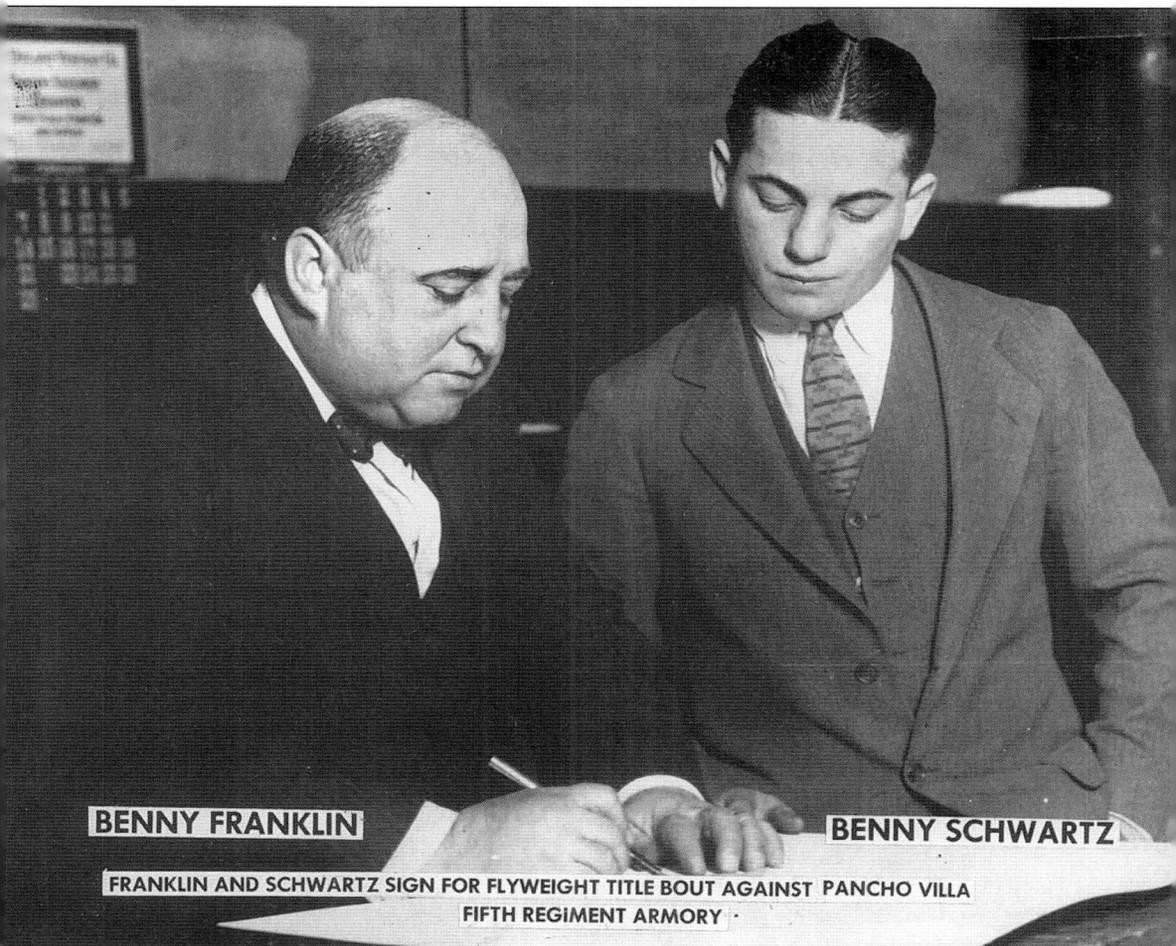

BENNY FRANKLIN

BENNY SCHWARTZ

FRANKLIN AND SCHWARTZ SIGN FOR FLYWEIGHT TITLE BOUT AGAINST PANCHO VILLA
FIFTH REGIMENT ARMORY

WORLD FLYWEIGHT TITLE AT STAKE. Champion Pancho Villa came to Baltimore and successfully defended his crown on October 13, 1923. He won a 15-round decision over Benny Schwartz at the Fifth Regiment Armory on North Howard Street. At the time, Benny Franklin was managing Schwartz, working in his corner, and promoting the fight. Schwartz had a long career as a flyweight and bantamweight from 1920 to 1933. He met champions Joe Lynch, Johnny Buff, Charley Phil Rosenberg, Panama Al Brown, and Petey Sarron.

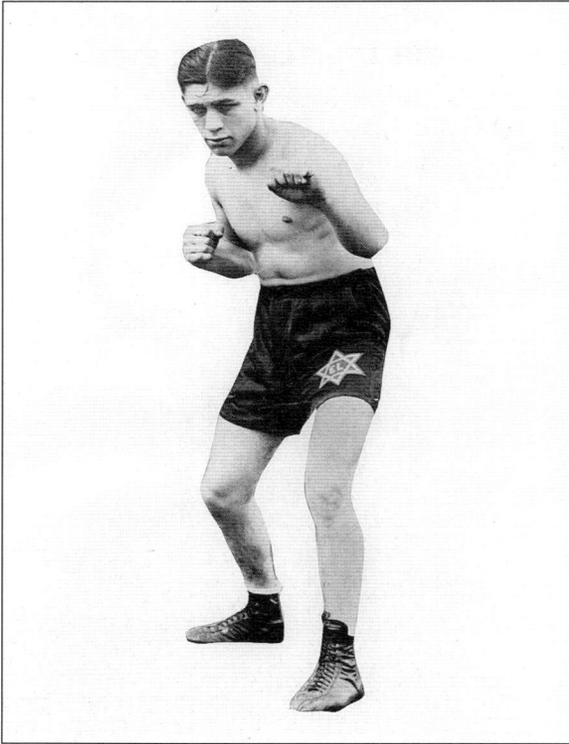

A GREAT FLYWEIGHT AND REFEREE.
Managed by Max Waxman and trained by Heine Blaustein, Jewish Eddie Leonard fought around 50 battles during his first two years after turning professional in 1923. Before retiring, Eddie engaged in some 105 battles, losing only to Battling Frye twice, Ernie Jarvis, and Tony Ross. His last fight, a defeat to Tony Ross, was held at Carlin's Park on September 20, 1928. He also met flyweights Marty Gold, Jackie Feldman, Pinkey White, and Clovis Kid Durant. After retiring, Eddie became a famous referee in Maryland until 1969, giving out instructions to Joe Louis, Archie Moore, Willie Pep, and Harry Jeffra.

A FLYWEIGHT SENSATION. Little Jeff, born Joseph James Cossentino, like many Italian stars grew up in the Little Italy section of town. Turning professional at the tender age of 14 in 1916 he had a meteoric career that lasted until 1931. Frankie Rice, another local scrapper, got him started in fisticuffs. Both fighters were under the guidance of Sammy Harris. Jeff fought his first dozen fights under the non de plume, Joe Burman. After that, he renamed himself after the famous cartoonist Bud Fisher's character, "Little Jeff." He met the more experienced flyweight title claimant Frankie Mason at the Fifth Regiment Armory on June 9, 1921. Here he suffered a 12-round loss. Other tough contenders he met included Kid Fredericks, Jockey Joe Dillon, Nate Carp, and world flyweight champions Corporal Izzy Schwartz and Frankie Genaro.

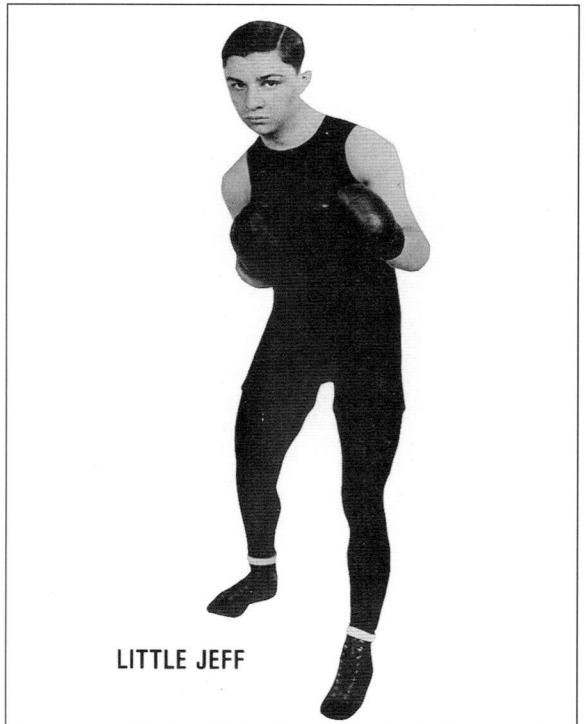

LITTLE JEFF

MEXICAN BOBCAT. Bobby Garcia fought 142 bouts from 1920 to 1930. He met four world champions including Kid Williams (three times), Louis Kid Kaplan (four times), Benny Bass, and Tony Canzoneri. He defeated such stars as Joe Glick, Babe Herman, Danny Kramer, Frankie Rice, and Dick Honeyboy Finnegan. He was a miniature Jack Dempsey with a bobbing, weaving style and a strong kick in either fist. Whenever his name graced a fight card, the promoters were assured a sellout. (Photograph courtesy of Robert Carson.)

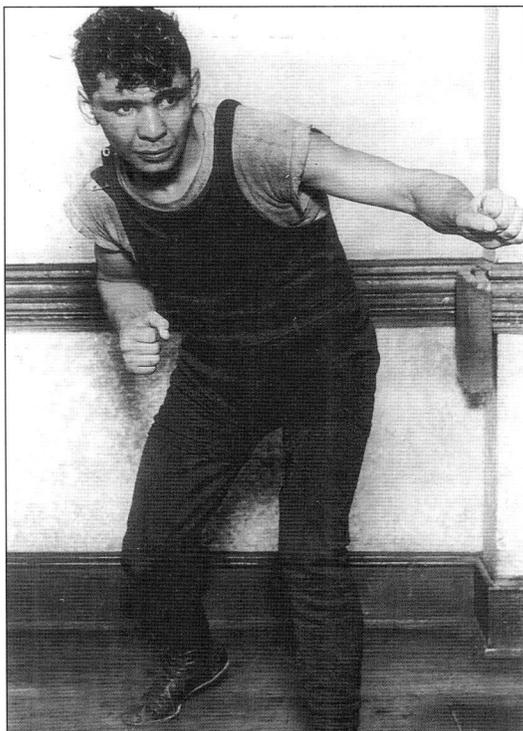

A HARD-HITTING MIDDLEWEIGHT. Over a career from 1923 to 1930, Nick Bass (Basciano) engaged in 40 bouts. He won 35 of them. Len Mahoney, Joe Smallwood, Harry Kid Groves, Willie Greb, Sergeant Sammy Baker, and future middleweight champion Vince Dundee were some his stiff competitors. His last bout in 1930 was perhaps his best effort, a hard-earned, 10-round decision over previously undefeated Gene Buffalo at the Cambria Athletic Club in Philadelphia, Pennsylvania.

FIRST BALTIMORE DEATH IN A RING. Tragedy struck on September 4, 1924, when Lew Mayrs learned that the game of boxing has two faces. He set to fight Charlie Holman, shown here, for the Southern Featherweight Championship at Folly Theatre. Lew and Charlie were pals. They trained in the same gym and both shared dreams of one day winning a championship. The favored and more experienced Holman won the first 7 rounds, but in the 8th, Mayrs exploded a stick of dynamite in Holman's face that drew blood. From that moment on, the tide turned. In the 12th and last round, Holman was knocked down, got up, and crumpled to the ground never to regain consciousness. His wife, who was at ringside, had thrown in the towel. Her efforts were in vain. (Photograph courtesy of Robert Carson.)

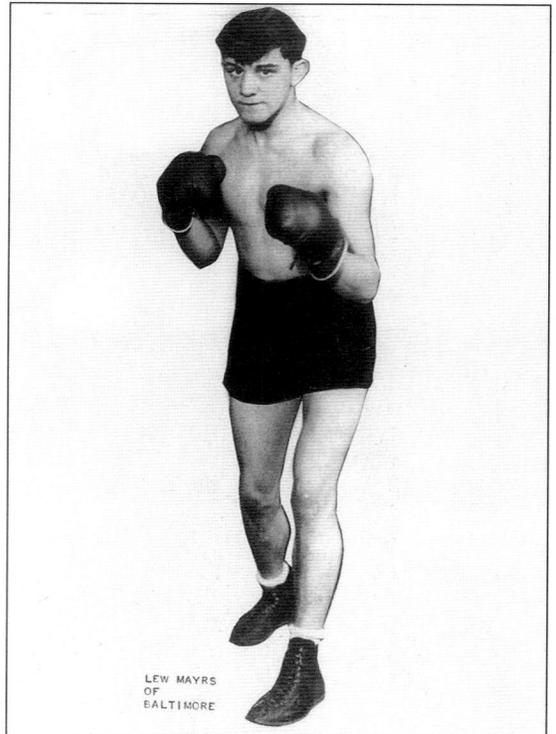

LEW MAYRS. Mayrs was a top featherweight who laced them up between 1922 to 1929. His greatest victory was over featherweight claimant champion Dick Honeyboy Finnegan in 1925. In addition, he also met world champions Kid Williams and Benny Bass, and top contenders Bobby Garcia, Danny Kramer, Tommy Herman, Buster Brown, and Charlie Holman. (Photograph courtesy of Robert Carson.)

HYMAN (GENE) GOREN.
Gene was a tough-as-nails,
133-pound contender who
got started professionally in
1924. He took the name
Gene to honor heavyweight
champion Gene Tunney. In
the ring, he met Sammy
Glass, Angelo Meola, Mike
Wing, and Mickey White.
Upon retiring in 1930, he
trained local stars Johnny
Schuss, Charley Gomer, Izzy
Caplan, Bucky Taylor, and
Jimmey Read.

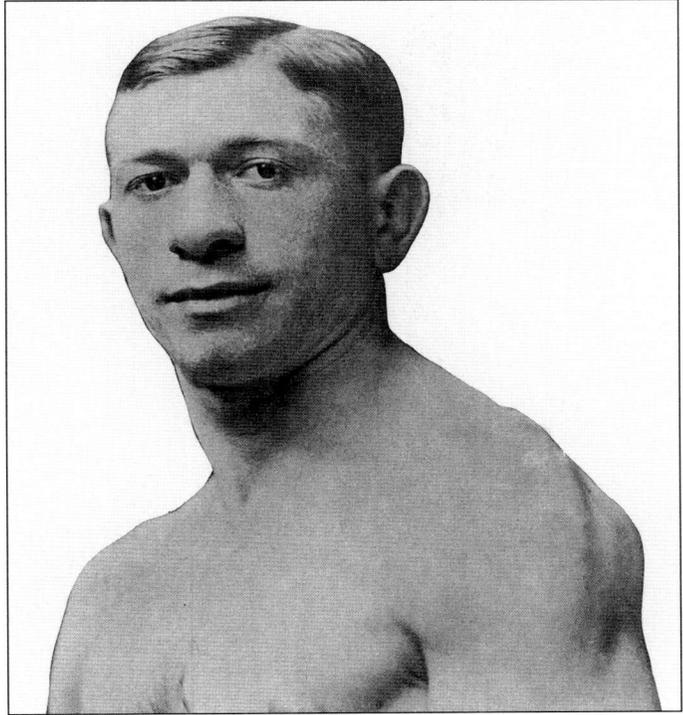

**TRAINED BY YOUNG BRITT AND
GENE GOREN.** Johnny Schuss learned
his trade at the local YMCA under
tutelage of numerous ring savvy
veterans. He had an outstanding
amateur career from 1923 to 1925,
but achieved more notoriety as a
trainer/coach of Baltimore fighters.
These included Joe "Reds"
Transparenti, Johnny Fortuna, Earl
Clemons, and Don Braun.

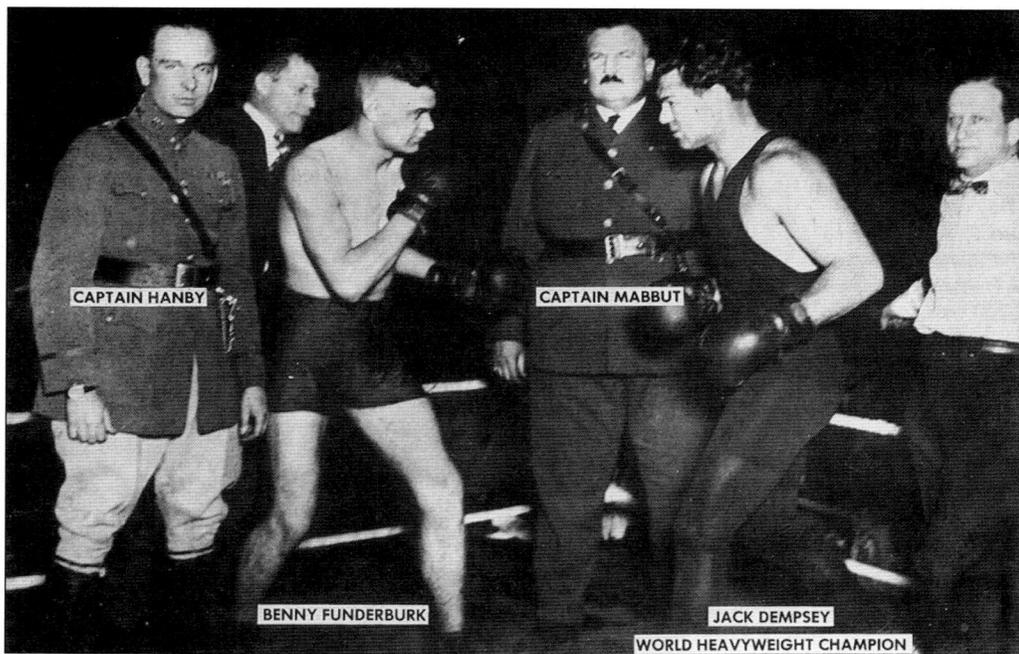

CAPTAIN HANBY

CAPTAIN MABBUT

BENNY FUNDERBURK

JACK DEMPSEY
WORLD HEAVYWEIGHT CHAMPION

THE MANASSA MAULER. On March 3, 1926, a legend by the name of Jack Dempsey, reigning world heavyweight champion, rolled into Baltimore. Captain Mabbutt organized a boxing show between members of all the armed forces at the Fifth Regiment Armory. Dempsey boxed 10 servicemen one two-minute round each. Benny Funderburk was one of those men. Gen. Douglas McArthur was in the audience that night.

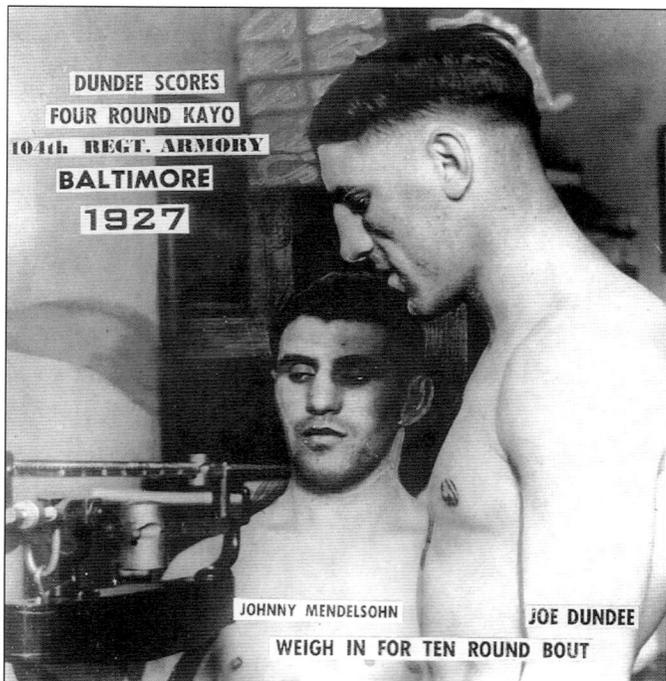

DUNDEE SCORES
FOUR ROUND KAYO
104th REGT. ARMORY
BALTIMORE
1927

JOHNNY MENDELSOHN JOE DUNDEE
WEIGH IN FOR TEN ROUND BOUT

TUNE UP FOR THE WORLD CHAMPIONSHIP FIGHT. Joe Dundee was knocked by out Johnny Mendelsohn on May 2, 1927, just one month prior to winning the welterweight title from Pete Latzo. Joe fought world champions Ben Jeby, Young Jack Thompson, Pinky Mitchell, Tommy Freeman, Kid Williams, Mickey Walker, Pete Latzo, and Jackie Fields from 1919 to 1931. Mendelsohn was no slouch; he met champions Benny Leonard, Rocky Kansas, and Pinkey Mitchell.

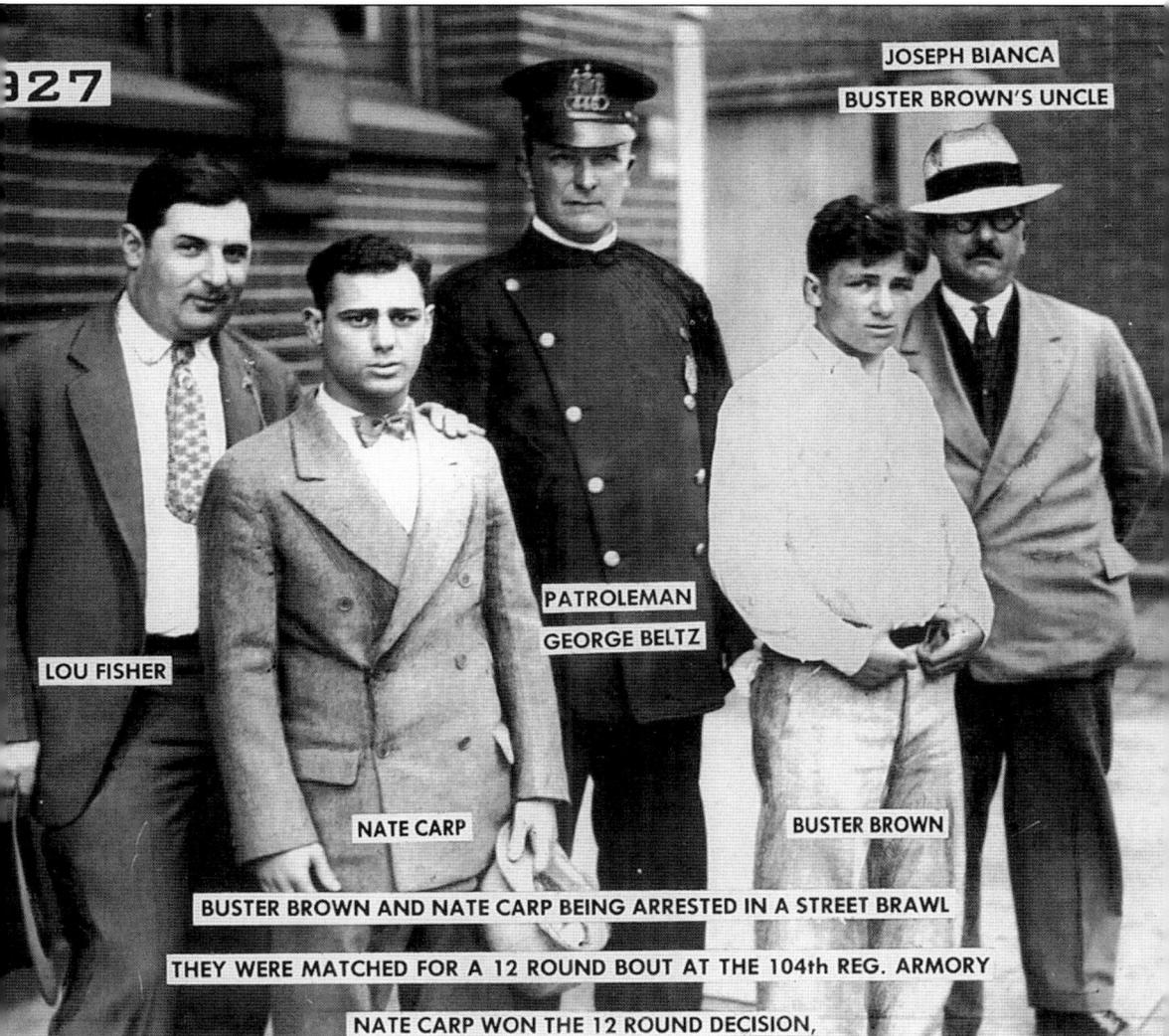

927

JOSEPH BIANCA
BUSTER BROWN'S UNCLE

PATROLEMAN
GEORGE BELTZ

LOU FISHER

NATE CARP

BUSTER BROWN

BUSTER BROWN AND NATE CARP BEING ARRESTED IN A STREET BRAWL

THEY WERE MATCHED FOR A 12 ROUND BOUT AT THE 104th REG. ARMORY

NATE CARP WON THE 12 ROUND DECISION,

BOYS WILL BE BOYS. Baltimoreans Nate Carp and Buster Brown could not wait to get into the ring. The two men decided to take out their frustrations on each other in the streets of downtown Baltimore. In the ring that year, they split a pair of decisions on April 25 and October 17. Carp's career lasted during most of the 1920s with almost all fights in Baltimore. His contenders included Benny Schwartz, Eddie O'Dowd, and former champion Kid Williams.

DREW WITH KID WILLIAMS. Tony Ross was a local bantamweight and featherweight contender whose career was active from 1924 to 1932. He laced it up with Buster Brown, Benny Schwartz, Lenny Mahoney, Sid Lampey, and Jimmy Tramberia.

BOBBY GARCIA AND AL MARTIN. Garcia (left) was a very popular featherweight contender in the 1920s, and Martin (right) was a local bantamweight club fighter during the late 1920s and early 1930s. Al met such men as Tony Ross, Harry Groves, Benny Goldstein, Jimmy Tramberia, Joe Bruno, and Frank McKenna. (Photograph courtesy of Robert Carson.)

BUSTER BROWN. Just four years into his professional career, Brown (Sebastian Catanzaro) fought Frenchman Andre Routis (left) for the world's featherweight championship. On May 27, 1929, this fight would be Buster's seventh loss by way of a three-round knockout at Carlin's Park. Nearly two years later, Brown got a shot at Jackie Kid Berg's junior welterweight title. He lost the decision that the fans thought he surely won. Brown fought 108 bouts and aside from the two title fights, he took on five more world champions—Benny Leonard twice, Lou Ambers, Kid Chocolate, Louis Kid Kaplan, and Benny Bass. (Photograph courtesy of Robert Carson.)

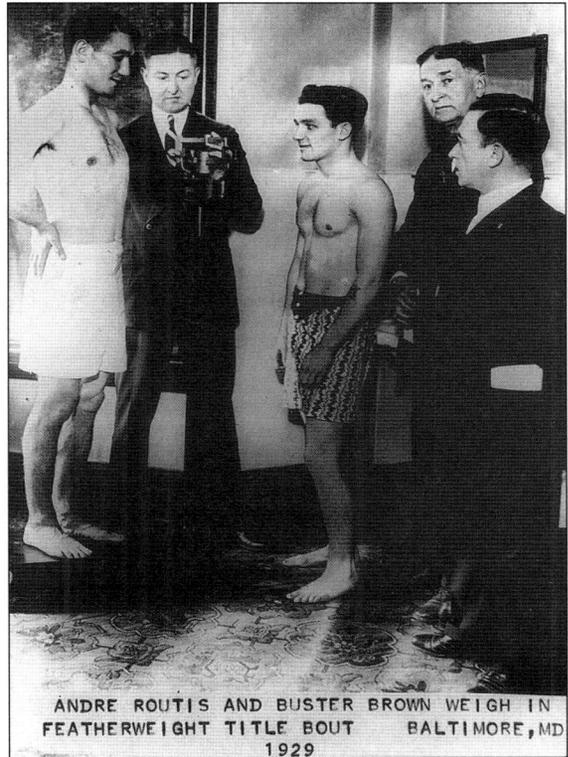

ANDRE ROUTIS AND BUSTER BROWN WEIGH IN FEATHERWEIGHT TITLE BOUT BALTIMORE, MD 1929

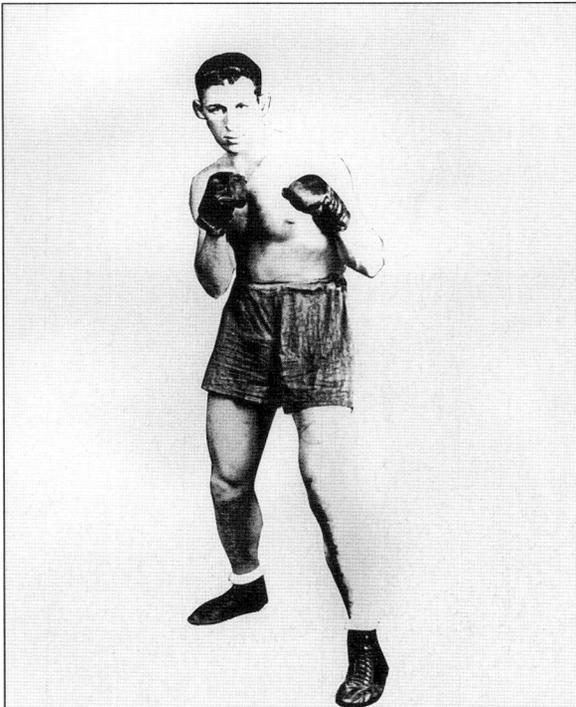

HE KNOCKED OUT BATTLING LEVINSKY. Hyman (Herman) Weiner was a 195-pound fighter with an explosive punch. As former light heavyweight champion, Battling Levinsky was knocked out by him in the first round on January 15, 1929. Two years later on January 19, 1931, thousands of fans jammed the 104th Regiment Armory to see Herman fight the world middleweight champion, Mickey Walker, in a non-title bout. Weiner aggressively rushed in and paid the price. He was caught with a knockout blow in the first round. Herman had better luck against former light heavyweight champion Paul Berlenbach on July 22, 1931, whom he knocked clean off his feet in the first round. He also met Will Matthews, Australian Tommy Freeman, and Sam Weiss.

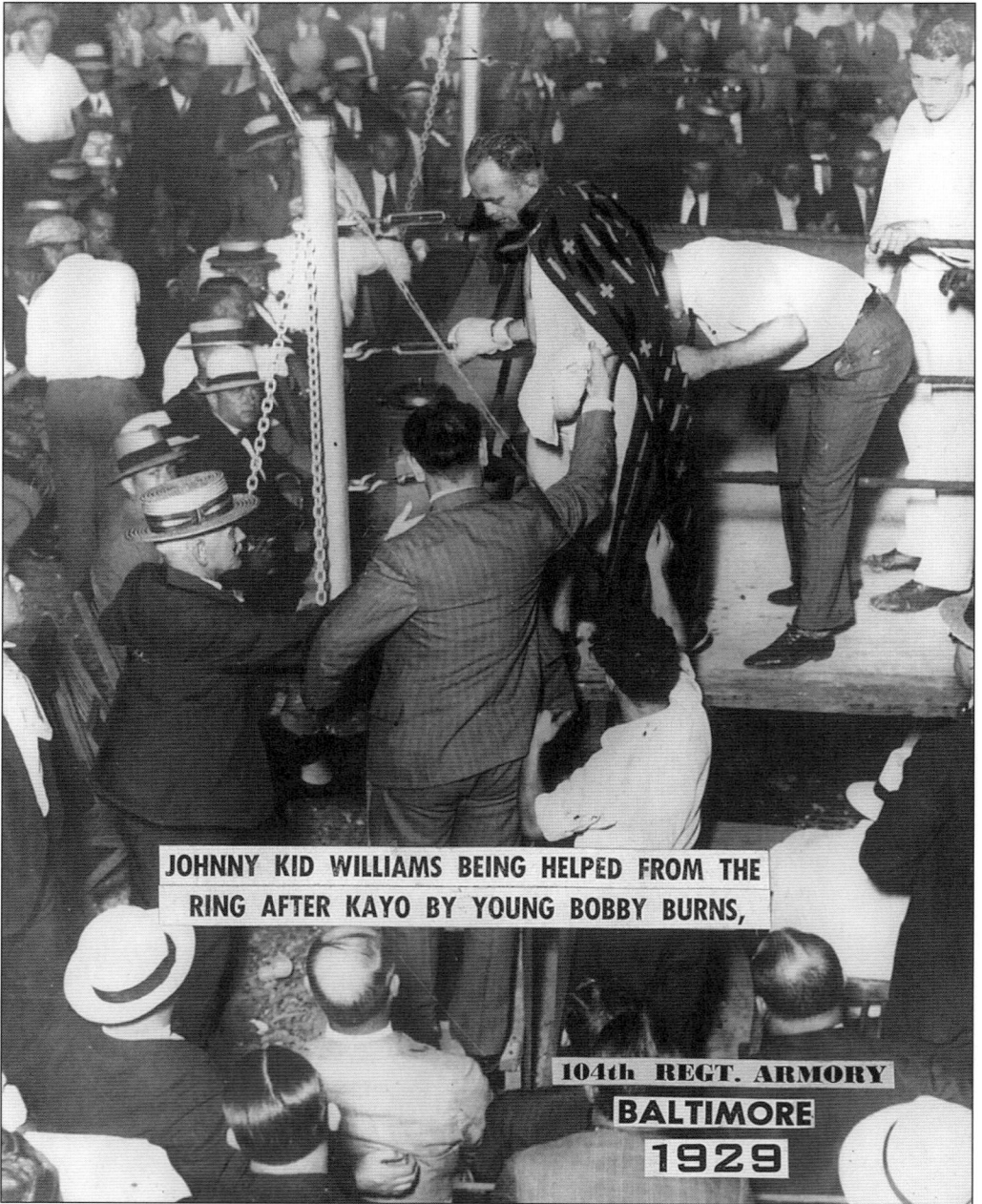

JOHNNY KID WILLIAMS BEING HELPED FROM THE
RING AFTER KAYO BY YOUNG BOBBY BURNS,

104th REGT. ARMORY
BALTIMORE
1929

SWAN SONG. Kid Williams's last professional fight, on September 3, 1929, ended in a second-round knockout by the hands of young Bobby Burns. The fight was held at the popular 104th Medical Regiment Armory on Fayette and Paca Street.

PETE DeAngelis. Active during the later 1920s and early 1930s, Pete tipped the scales at 140 pounds. He met many of Baltimore's highly rated stars of the day such as Lew Raymond, Buster Brown, Herman Gunn, Charlie Gomer, Vince DeSantis, and Bobby Burns.

209 BOUTS IN FIVE YEARS OF FIGHTING. Izzy Caplan (Leon Louis Luckman) learned to box at the Americus Club on Gay and Colvin Streets in 1928. He took his ring name in honor of fellow Jewish fighters of the time Corporal Izzy Schwartz and Louis Kid Kaplan, both world champions. From 1929 to 1933, he was very successful as an amateur flyweight and bantamweight. He beat future world champ Harry Jeffra and barely lost to future champ Joey Archibald in 1931. Upon turning pro in 1933, he won his first 10 bouts. He decided to quit after 24 pro bouts.

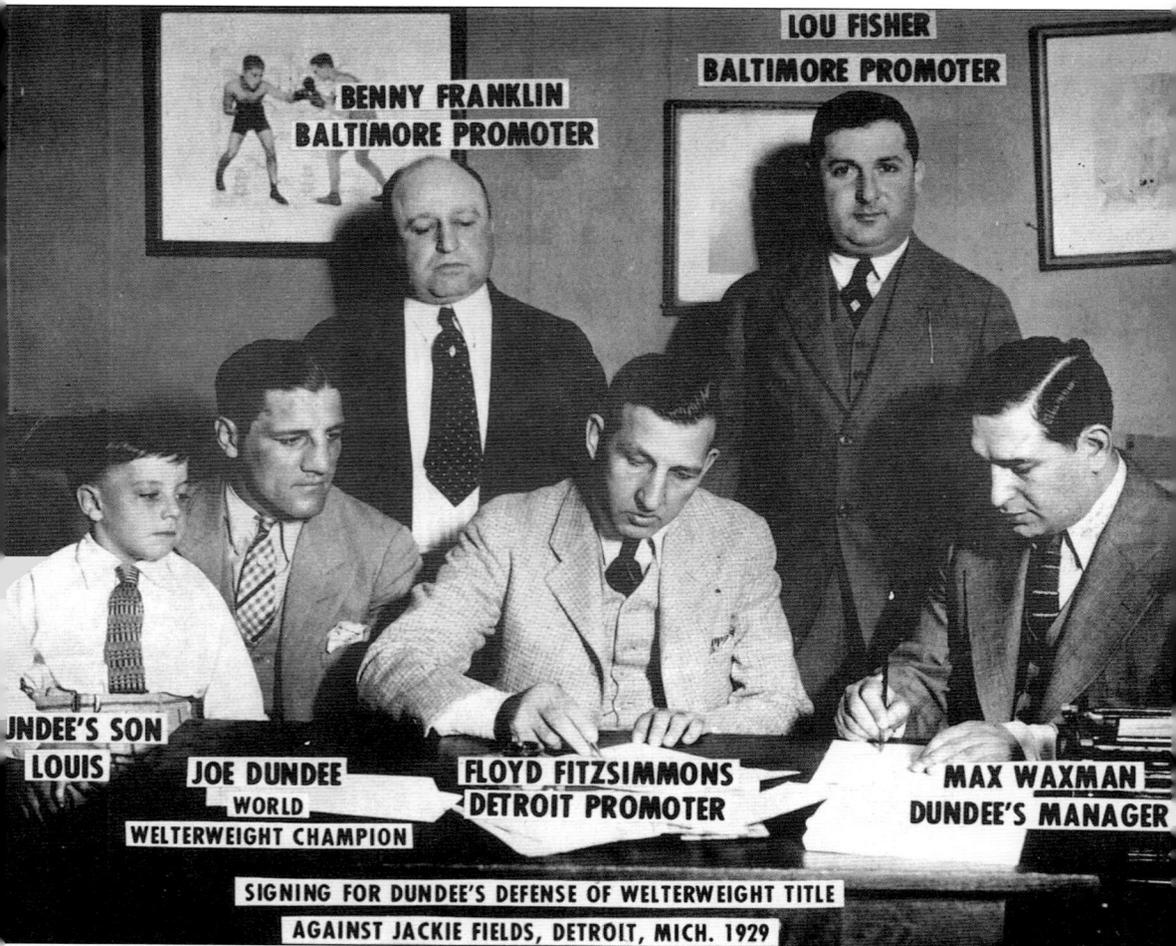

BENNY FRANKLIN
BALTIMORE PROMOTER

LOU FISHER
BALTIMORE PROMOTER

DUNDEE'S SON
LOUIS

JOE DUNDEE
WORLD
WELTERWEIGHT CHAMPION

FLOYD FITZSIMMONS
DETROIT PROMOTER

MAX WAXMAN
DUNDEE'S MANAGER

SIGNING FOR DUNDEE'S DEFENSE OF WELTERWEIGHT TITLE
AGAINST JACKIE FIELDS, DETROIT, MICH. 1929

LOSING THE WORLD WELTERWEIGHT TITLE. Here is the signing for Joe Dundee's July 25 fight against Jackie Fields, in which Dundee would lose his world title on a foul in the second round. Max Waxman managed Dundee and fellow Baltimorean world champions Vince Dundee (brother of Joe) and Harry Jeffra. With an incredible managerial span from 1910 to 1951, he also looked after the interests of Little Jeff; Buster Brown; Phil, Joey, and Lew Raymond; Red Burman; and Laurent Dauthuille. Waxman, Franklin, Fisher, and George Goldberg worked together in building Baltimore into one of the leading fight towns in the nation.

LEARNING FROM THE BEST.
Upon retiring from a very
impressive professional career,
Andy (Young) Chaney stayed
in the game serving as a
handler of local boxers. Here
he is in 1930 with
featherweight charge Sid
Lampe. Sid met some
outstanding talent including
world champions Kid Williams
and Philadelphia's Benny Bass.
Buster Brown, Bobby Garcia,
Allentown Johnny Leonard,
Eddie Cool, Tony Ross, and
Johnny Sheppard were some
other top men he tangled with
during a career that lasted from
1926 to 1933.

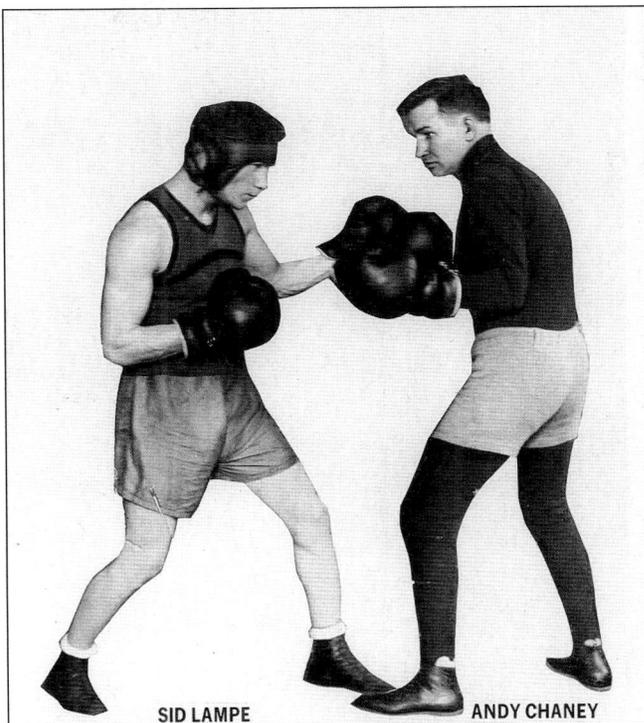

SID LAMPE ANDY CHANEY

A SLICK LIGHTWEIGHT STAR.
Vincent Leo DeSantis started
boxing under the tutelage of
Bobby Garcia at the downtown
YMCA. Upon turning professional
in 1929, he started fighting with
some tough local competition.
Tony Ross, Lew Raymond, Angelo
Meola, Pete DeAngelis, and
Bobby Burns were among these
competitors. In the Burns fight on
May 2, 1931 at the Gayety
Theatre, he broke his left hand in
the sixth round. This would turn
out to be his last fight.

51

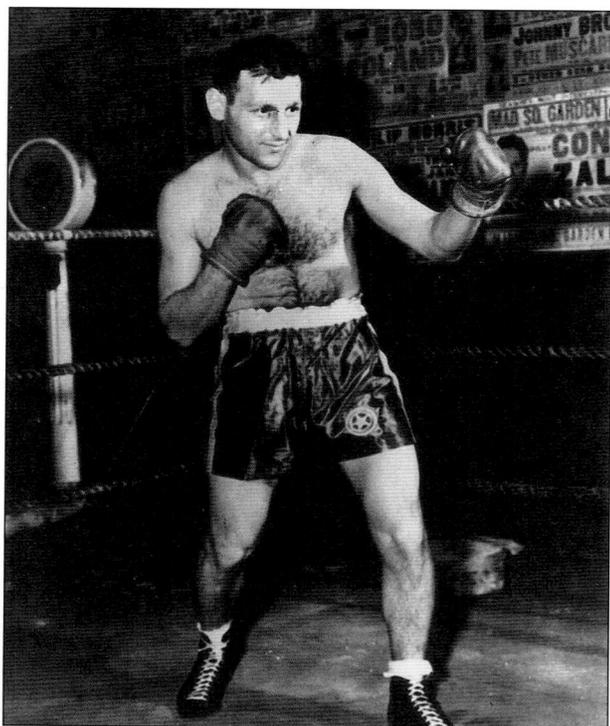

BOXED LIKE TONY CANZONERI. It was quite a compliment given to Frankie Cicero, since Canzoneri was a world champion and an idol of many Italian pugilists. Frank was a hard-hitting and clever lightweight fighter during the late 1920s and early 1930s. He met Jimmy Tramberia, Jimmy Reed, Johnny Borozzi, Angelo Meola, and Charley Breitenbach.

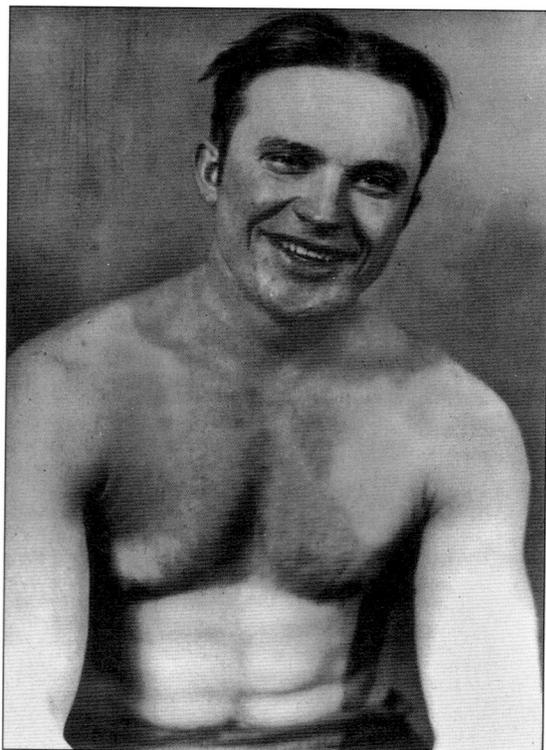

JOHNNY ADAMS. Adams was a club fighter who fought from 1930 to 1932. Some of the middleweights he fought were Dutch Miller, Dutch Adams, and Joe Glazer. (Photograph courtesy of Robert Carson.)

THE BOBCAT AND THE TIGER. Kid Williams, The Baltimore Tiger, tried his hand at managing Bobby Garcia just two years after Williams had ended his career. They met three times in Baltimore rings during the 1920s. On April 4, 1923, Garcia won a 9th-round foul and on April 25, 1923, Garcia won on a 12-round decision. The Kid enacted revenge on January 14, 1929, by winning in a 10-round decision.

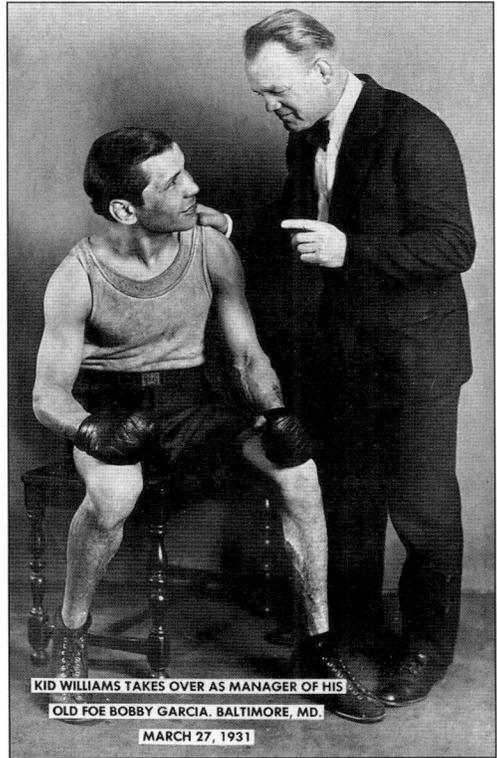

KID WILLIAMS TAKES OVER AS MANAGER OF HIS OLD FOE BOBBY GARCIA. BALTIMORE, MD. MARCH 27, 1931

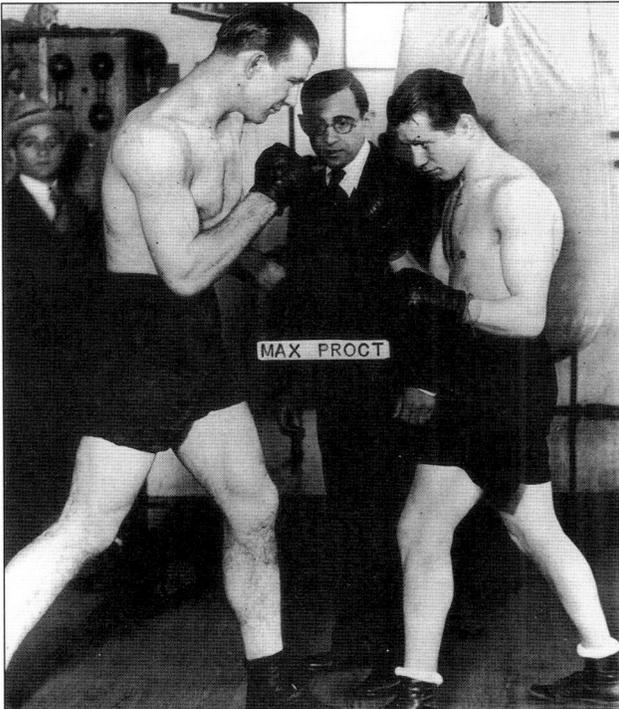

MAX PROCT

MAX PROCK'S STABLE. Prock was a popular manager in the 1920s and 1930s. Here are two of his charges at his gym on Gough and Broadway. Wild Bill Matthews (1928–1934), a heavyweight who fought Steve Dudas and Tony Two Ton Galento, and Willie Parrish (1925–1928), a featherweight who fought Kid Williams, Sid Lampe and Buster Brown, were both his fighters. Prock also managed Lawrence Gunn and Nick Bass. (Photograph courtesy of Robert Carson.)

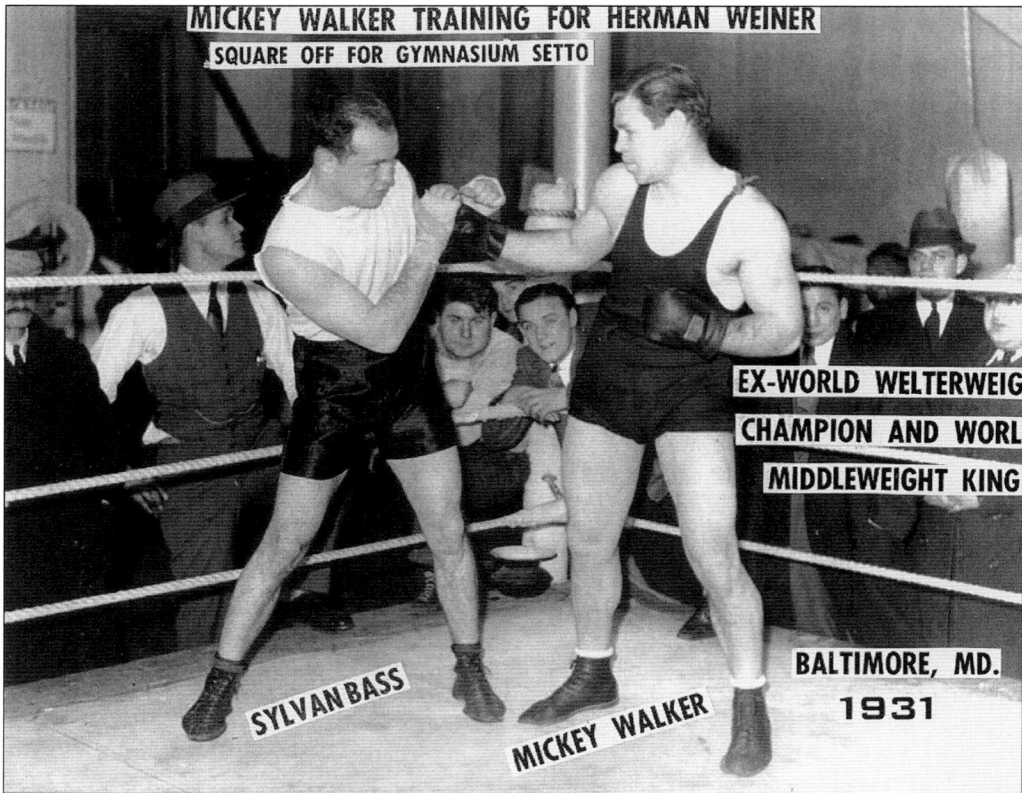

MICKEY WALKER TRAINING FOR HERMAN WEINER
SQUARE OFF FOR GYMNASIUM SETTO

EX-WORLD WELTERWEIG
CHAMPION AND WORL
MIDDLEWEIGHT KING

SYLVAN BASS

MICKEY WALKER

BALTIMORE, MD.
1931

THE TOY BULLDOG IN BALTIMORE. Mickey Walker, reigning world middleweight champion, knocked out Herman Weiner in one round on January 19. Baltimorean Sylvan Bass served as his sparring partner.

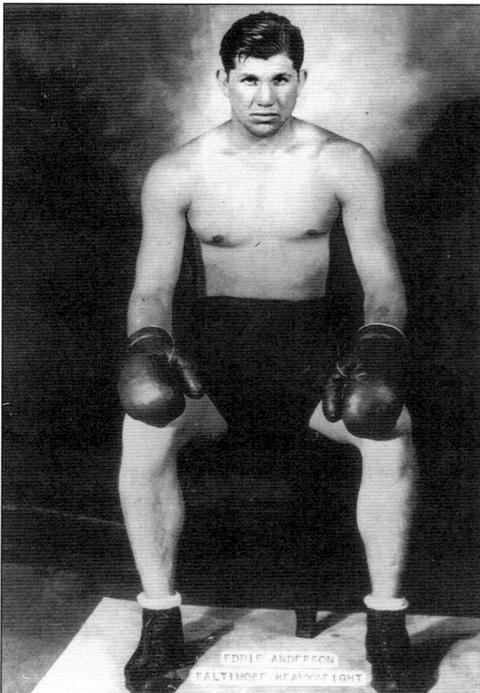

EDDIE ANDERSON
BALTIMORE HEAVYWEIGHT

A RUGGED HEAVYWEIGHT. Eddie Anderson had a lengthy career from 1926 to 1935. Most of his early fights occurred in Baltimore. He headed out to the Midwest later in his career. Buddy Baer, Duane Duncan, Harry Nelson, Herman Weiner, and Ken Houser were some of his opponents.

LOOKS LIKE A MOVIE STAR AND BUILT LIKE A WEIGHTLIFTER. Ely Taylor, a.k.a. Bucky Taylor, had a long (from 1930 to 1945) and impressive career with some 150 fights on record. Some of his opponents included Irish Eddie Dunne, Lew Feldman, Harry Kid Groves, Charley Gomer, Jack Sharkey Jr., Charley Gilley, Cowboy Howard Scott, Carmine Fatta, and Morris Reif. His looks and build would often draw comparison to heavyweight champion of the time, Max Baer.

TRAINER OF THE AMERICUS CLUB. Herman Gunn was the head trainer at the famous club, which flourished from 1929 to 1932 and was named after the early 20th century Baltimore wrestler. In that time, Gunn looked after amateurs Izzy Caplan, Angelo Meola, Jake Hudson, and Benny Funderburk. Simultaneously, he boxed on the professional circuit, meeting the likes of Bobby Burns, Joey Goodman, Tony Ross, Lew Raymond, and Lee Halfpenny. His brother, Lawrence Gunn, boxed as a featherweight in Baltimore from 1928 to 1940.

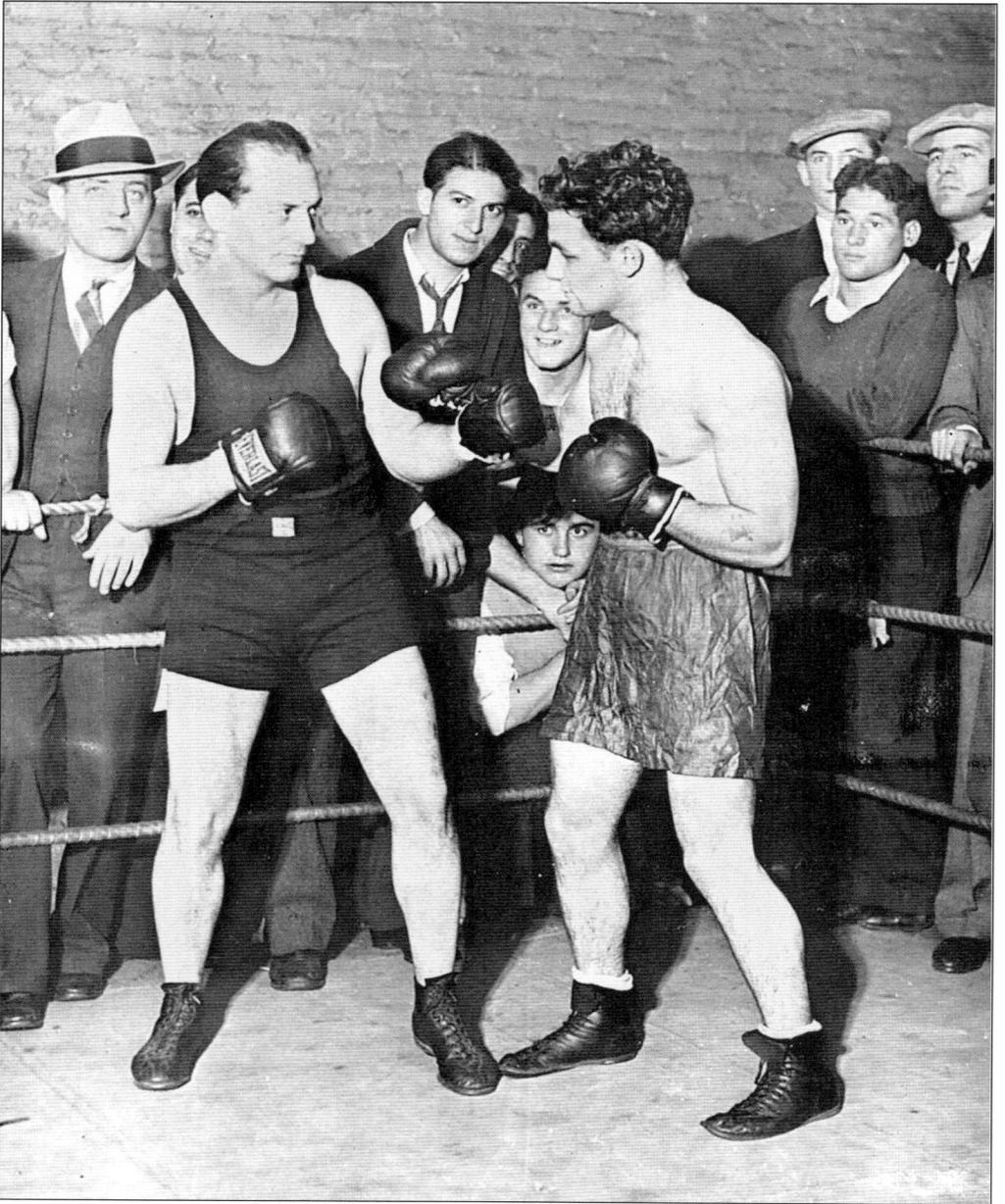

THE IMMORTAL BENNY LEONARD. Former world lightweight champion Leonard (left) squares off with Baltimore's Buster Brown in a 10-round bout at Carlin's Park Arena on November 23, 1931. Benny won this 10-round decision. He also won another decision on April 11, 1932, in New York City, his last year of boxing, which was an amazing feat considering he started boxing in 1911. Old-timers consider Baltimore's Joe Gans and Leonard as the two best lightweights of all time.

Five
1933–1942

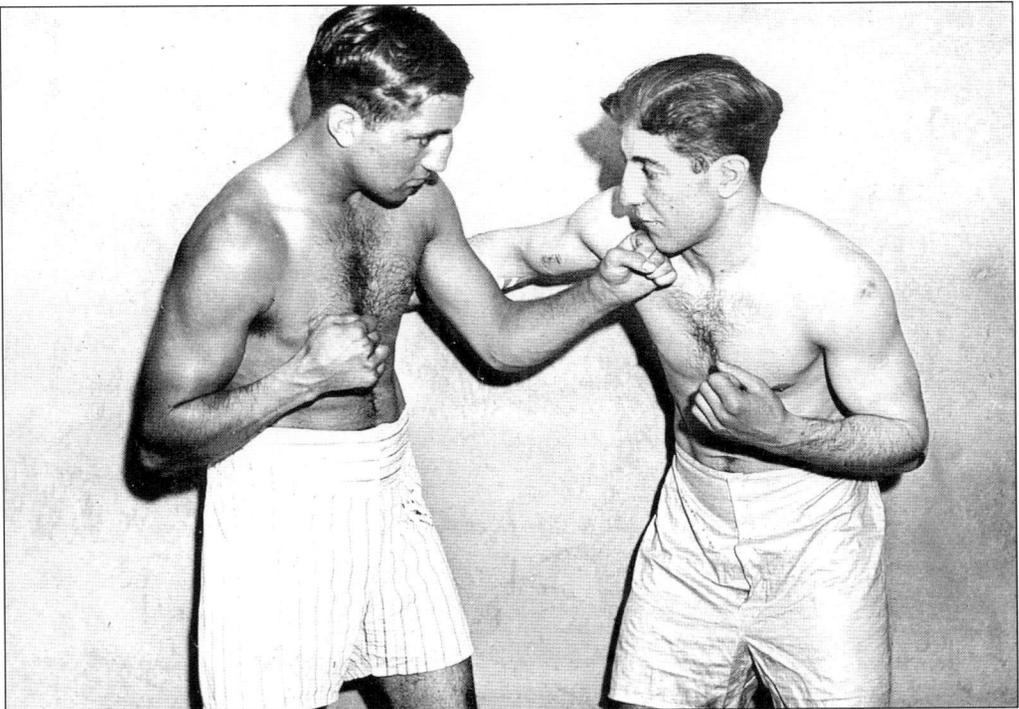

BALTIMORE'S FOURTH WORLD CHAMP. Vince Dundee (left), christened Vincenzo Lazzara, squares off against world middleweight champion Ben Jeby (right) of New York City. They met at Madison Square Garden March 17, 1933, with Jeby retaining his crown by way of a 15-round draw. On October 30, 1933, Dundee annexed the crown by whipping Lou Brouillard in Boston, Massachusetts, by a 15-round decision. Dundee had an outstanding career from 1923 to 1937 fighting anyone, anywhere, anytime.

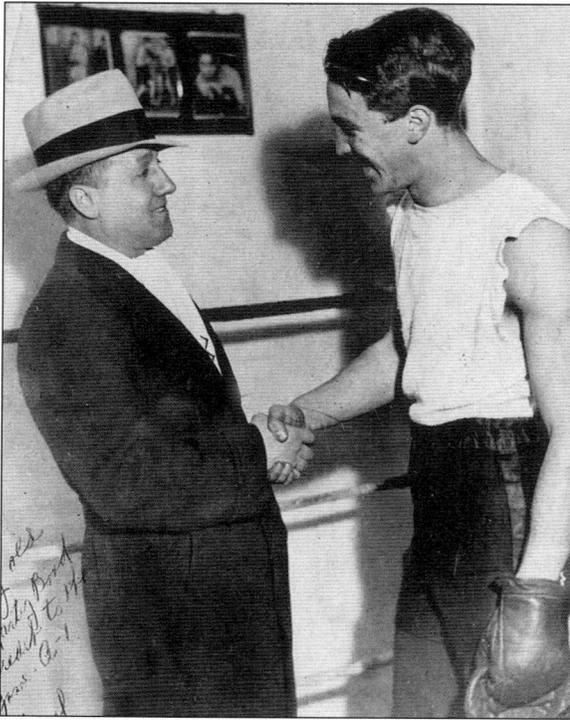

MANAGED 31 PROFESSIONALS. Bill Bandy, left, of the Arena Athletic Club on 419 E. Baltimore Street from the 1920s to 1940s, produced a long list of highly rated local talent. One of his fighters, shown here in 1933, was Marty Bond. Other top men he mentored were Benny Trotta, Harry Groves, Nick Bass, Jimmy Tramberia, Joe and Sam Finazzo, Jake Hudson, and Benny Kessler.

BOXER AND TRAINER. After boxing as an amateur while a member of the Maryland National Guard, Salvadore David Selina laced up the gloves for his first professional fight against a very young Clarence Red Burman in 1933. He followed this bout by challenging another excellent contender, Charley Gomer. He received more notoriety for training Harry Jeffra (early on in his career), Jack Portney, Jimmy Jones, Vic Finazzo, Jimmy McAllister, Elmer Barksdale, and Carl Coates. His third floor gym was located on Baltimore and Pearl Streets.

A DURABLE BALTIMORE LIGHTWEIGHT. Leroy Zinkham had a long career from 1932 to 1938 as a local fighter. Sailor Leonard, Charley Gomer, Lew Raymond, Jimmy Reed, Bobby Burns, and Bucky Taylor were some of the men he fought in Baltimore. These fights were mostly held at Carlin's Park. (Photograph courtesy of Robert Carson.)

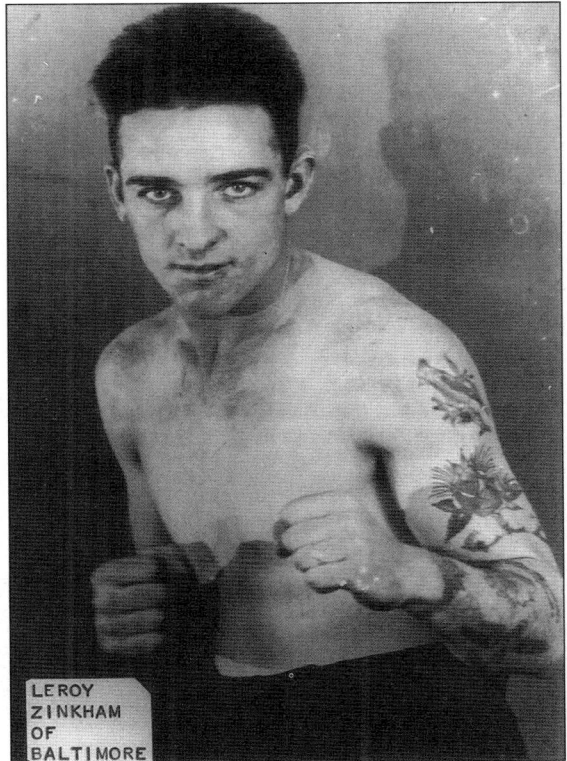

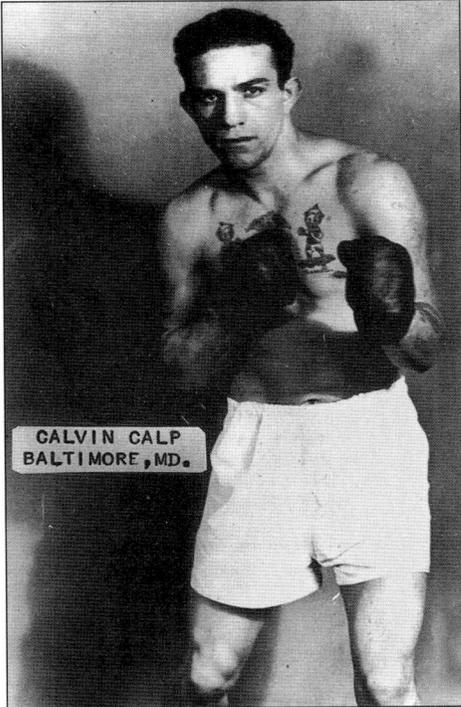

POPULAR CLUB FIGHTER OF THE 1930S. Calvin Calp's lightweight career spanned from 1931 to 1940. In that time, he met Joey Silva, Young Raspi, Izzy Rainess, Joey Schwartz, Pete Galiano, Jimmy Tramberia, and Jimmy Letto. (Photograph courtesy of Rober Carson.)

59

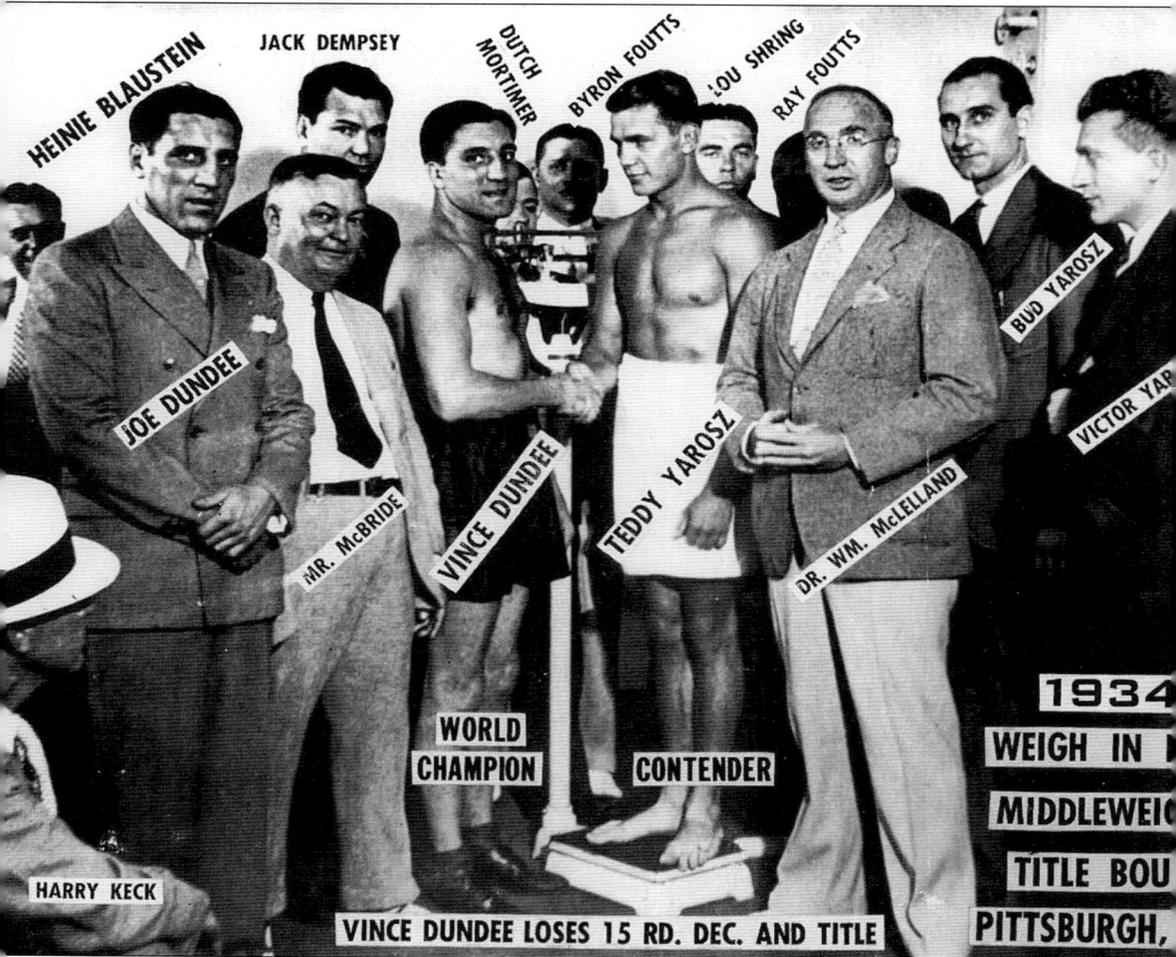

HEINIE BLAUSTEIN
JACK DEMPSEY
DUTCH MORTIMER
BYRON FOUTTS
LOU SHRING
RAY FOUTTS

JOE DUNDEE
MR. McBRIDE
VINCE DUNDEE
TEDDY YAROSZ
DR. WM. McLELLAND
BUD YAROSZ
VICTOR YAR

HARRY KECK

WORLD CHAMPION
CONTENDER

VINCE DUNDEE LOSES 15 RD. DEC. AND TITLE

1934
WEIGH IN
MIDDLEWEI
TITLE BOU
PITTSBURGH,

ON THE SCALE. Pictured above is Vince Dundee at the weigh-in for his September 11, 1934 fight with Teddy Yarosz. In this fight, Dundee lost his title via a 15-round split decision. Also pictured are his trainer Heine Blaustein, partial manager and former heavyweight champion Jack Dempsey, and his brother, former world champion Joe. Joe and Vince became the first universally recognized brother world champions.

A POPULAR UNDERCARD FIGHTER. Joe Raspi had a long career in Baltimore rings from 1930 to 1940. Joe Bruno, Joe Burns, Harry Kid Groves, Joey Schwartz, and Calvin Calp were some of the men he tangled with during the decade.

FRANK KAISER. A hard-hitting lightweight of the 1930s, Frank met such local talent as Woody Pestridge, Mike O'Leary, Jimmy Pearre, Benny Kessler, and Jimmy Letto.

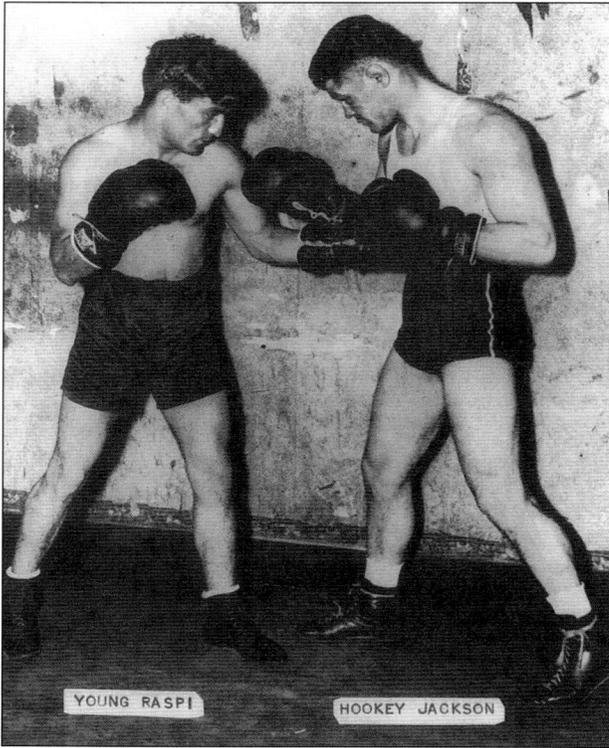

SPARRING SESSION. Young Raspi was a popular lightweight throughout the 1930s. He met Bucky Taylor, Buster Brown, Pete Galiano, Frankie Litt, and Vic Finazzo, and he was knocked out in six rounds by world lightweight champion-to-be Bob Montgomery in 1939. Hookey Jackson, a middleweight, fought in Baltimore from 1934 to 1938 meeting such good men as Sam Finazzo, Bob Turner, and Sylvan Bass. (Photograph courtesy of Robert Carson.)

YOUNG RASPI HOOKEY JACKSON

A PRODUCT OF LITTLE ITALY. Johnny Borozzi was a tough lightweight active from 1928 to 1938. After a stellar amateur career, he turned pro in 1934 weighing in at 130 pounds. Fighting all over Maryland he faced contenders Frankie Cicero, Frank Kaiser, Sailor McKenna, and Frank Hoza.

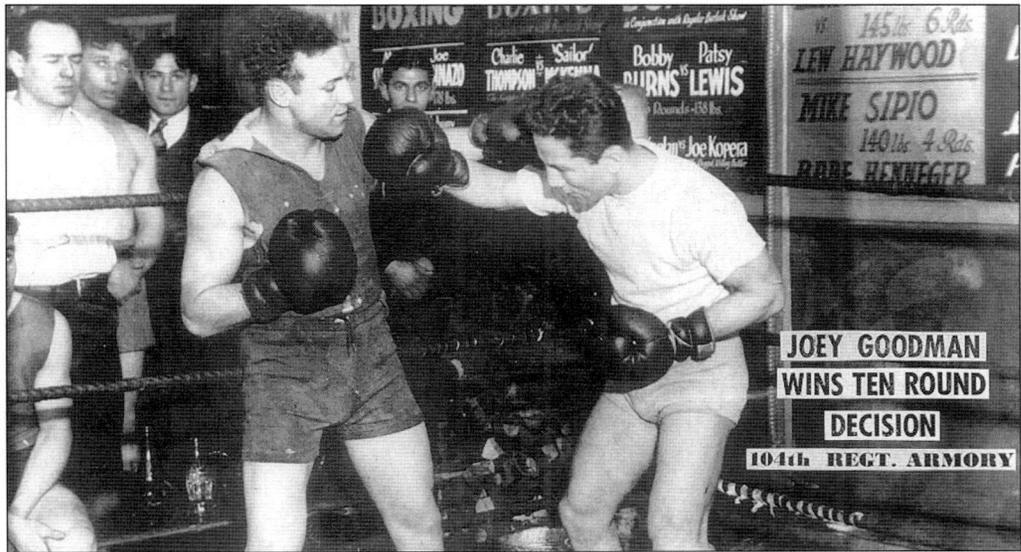

ONE OF THE RAYMOND BOYS. Lew Raimondi and his cousins Phil and Joey were all boxers with Sicilian blood. Lew (left) turned pro in 1927 and was managed by Max Waxman. Fighting as a lightweight and welterweight, he met Pedro Montanez, Jack Portney, Lee Halfpenny, Charley Gomer, and Joey Goodman. He is pictured here before his 10-round loss to Joey Goodman (right) on February 22, 1933. Lew's career lasted until 1940. Goodman was a top contender meeting champions Sammy Mandell and Ceferino Garcia.

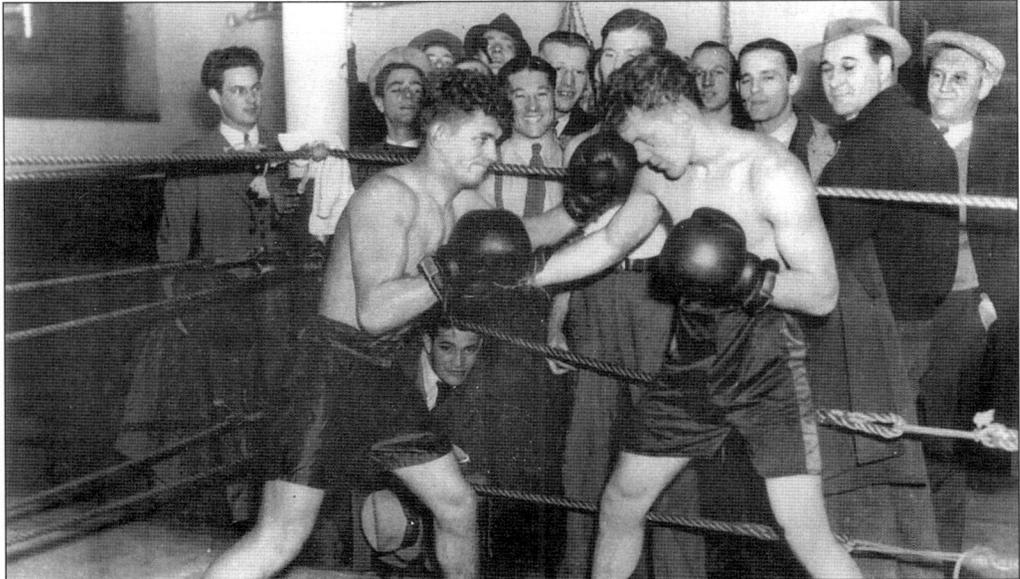

A FRIENDLY SCRAP. Jimmy Jones (left) spars at a local gym with Jake Hudson in 1935. Jones began boxing in 1933 as a welterweight and winded up his career in 1941 as a middleweight. His biggest match was against the coming middleweight champion Ken Overlin at Oriole Park on June 17, 1936. He also fought Buster Brown, Jack Portney, and Georgie Abrams. Hudson fought such good men as Frankie Martin, Walter Kirkwood, Sam Finazzo, and Joe Finazzo. (Photograph courtesy of Robert Carson.)

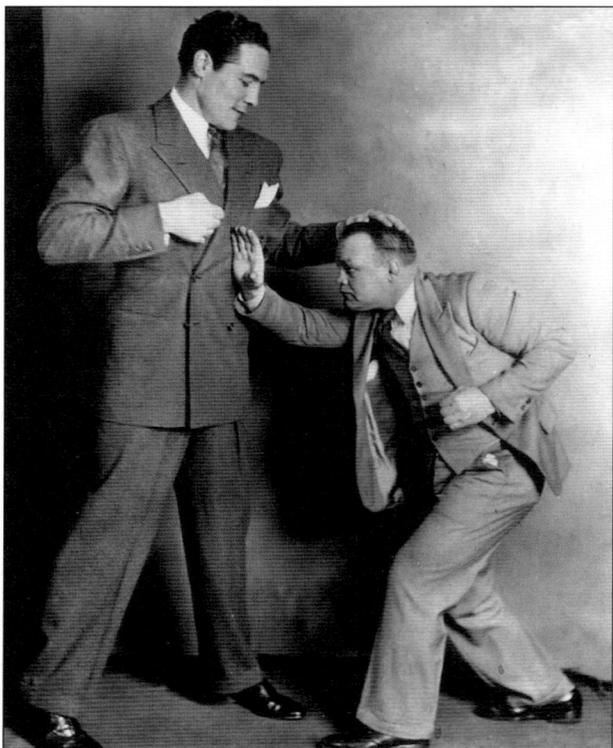

TWO WORLD CHAMPS. Heavyweight champ Max Baer clowns around with former Bantam king Kid Williams in 1935. Williams, 44, would attempt an unsuccessful comeback at this time, since the Maryland State Athletic Commission refused to issue him a license. Sadly, his later years were spent in poverty until he died on October 18, 1963, at the age of 72.

FRANKIE LITT. Frank Anthony Littriello started his career in New Jersey in 1932. He moved to Baltimore in 1935 and stayed there for the remainder of his lightweight career. Marty Bond, Pete Galiano, Cowboy Howard Scott, and Dominic Barrone were some of the tough contenders he met in Baltimore rings.

BALTIMORE'S BEST SOUTHPAW.
Jack started out as a featherweight in 1926 and ended his career as a welterweight in 1938, accumulating 150 wins out of 165 bouts. Jack never lost a bout to a fellow Baltimorean in his entire career. Although he never got a shot at a world title, he licked four world champions— Louis Kid Kaplan, Johnny Jadick, Tod Morgan, and Benny Bass, shown here weighing in for their November 11 fight.

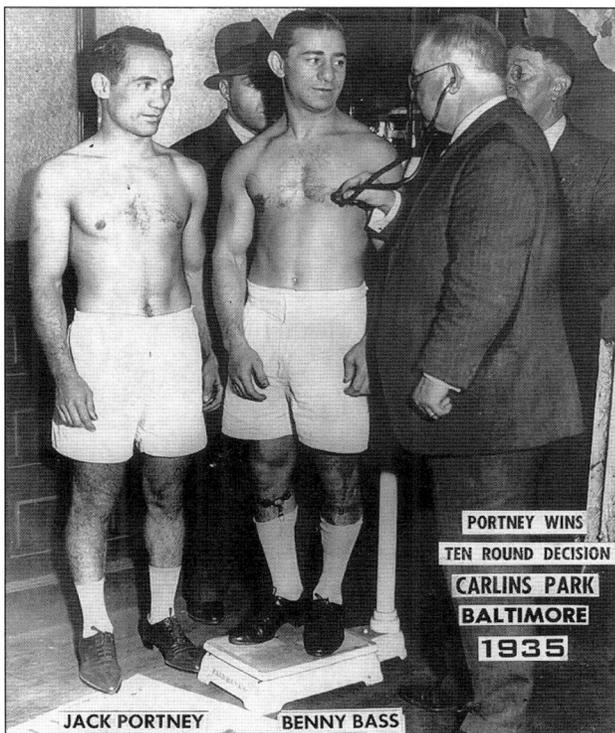

PORTNEY WINS
TEN ROUND DECISION
CARLINS PARK
BALTIMORE
1935

JACK PORTNEY BENNY BASS

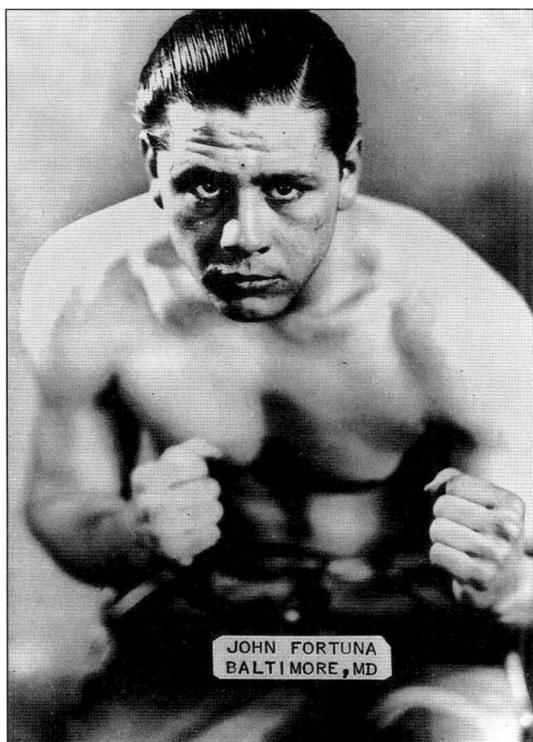

JOHN FORTUNA
BALTIMORE, MD

LIGHT HEAVYWEIGHT CLUB FIGHTER.
John Fortuna fought from 1935 to 1938. He met most of his adversaries, including Jack Stanley, Al Lowman, and Jim Schwemmer, at Carlin's Park. (Photograph courtesy of Robert Carson.)

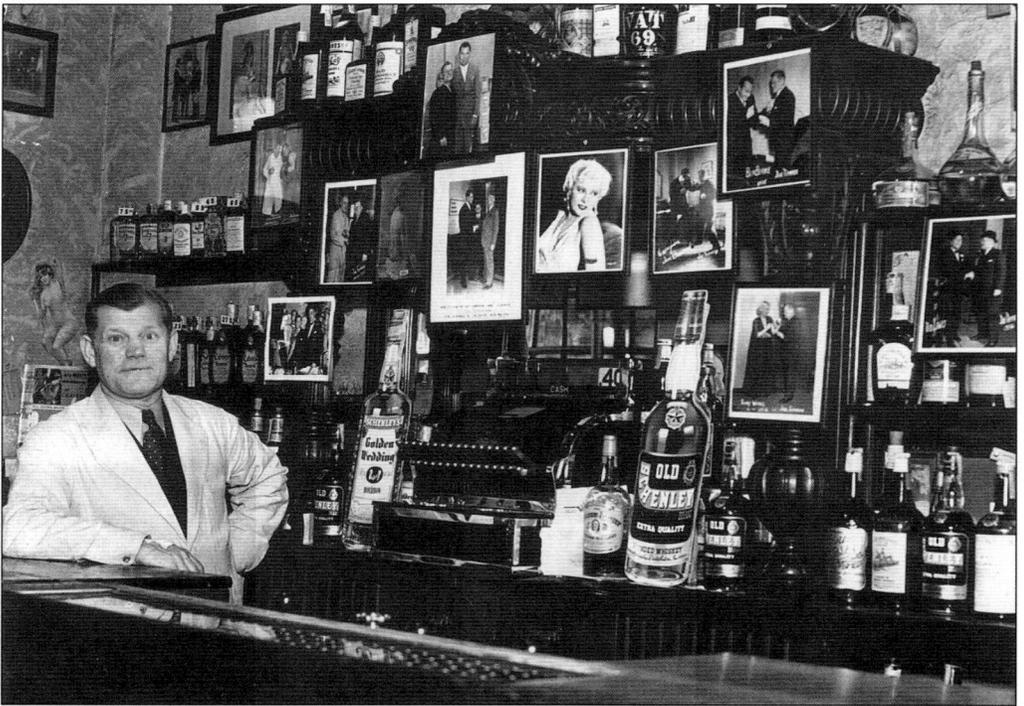

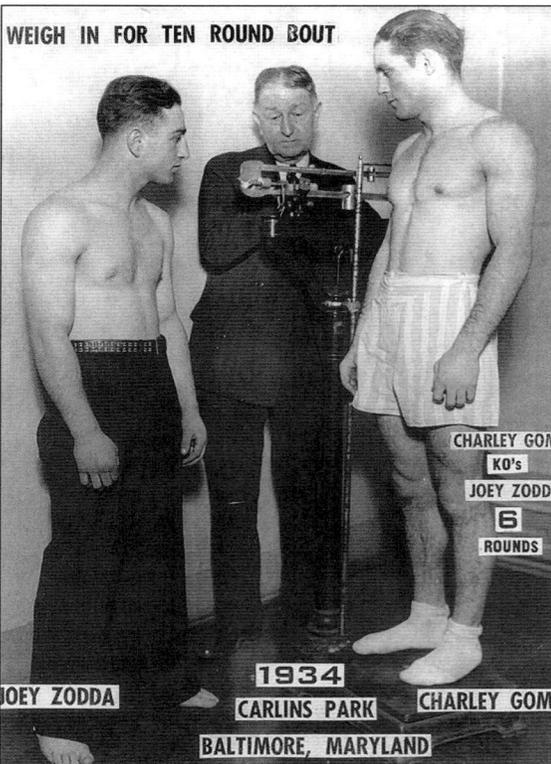

WEIGH IN FOR TEN ROUND BOUT

CHARLEY GOM
KO's
JOEY ZODD/
6
ROUNDS

JOEY ZODDA 1934 CHARLEY GOM
CARLINS PARK
BALTIMORE, MARYLAND

WHAT'S YOUR FIX. Joe Tipman's Tavern, located at 113 W. Fayette Street, was a place where "Who's Who" of the stage, screen, and sports world were seen in picture and often in person. Tipman was made famous for flooring champion Terrible Terry McGovern in two rounds at the Holliday Street Theater in 1901 in an exhibition match. He also met champions George Dixon, Joe Gans, Battling Nelson, and Young Corbett II.

LIGHTWEIGHT SHOWDOWN AT CARLIN'S PARK. Charley Gomer (right) knocked out Joey Zodda (left) twice in less than two months in 1934 doing the trick in fifth and sixth rounds at Carlin's Park. Gomer's career lasted from 1930 to 1941 during which time he met world champions Freddie Red Cochrane, Chalky Wright, Mike Belloise, and Kid Chocolate. Zodda, a New York native, was also a top contender meeting world champions Tony Canzoneri, Ike Williams, Lew Jenkins, Benny Bass, and Bushy Graham from 1932 to 1941.

WEIGH IN. Jimmy Jones beat Lew Raymond by an eight-round decision on March 4. Trained by the legendary Heinie Blaustein, Lew's biggest match was against Johnny Jadick two weeks after he won the Jr. Welterweight championship from Tony Canzoneri. The fight was held in Reading, Pennsylvania, on October 4, 1932, with Jadick barely taking the eight-round decision.

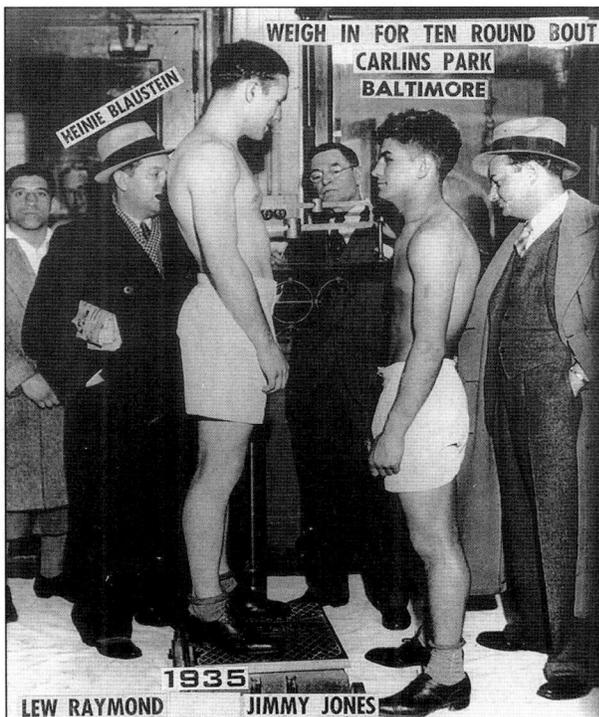

AUGIE KROLL. A bantam and featherweight contender from 1934 to 1940, Augie Kroll mixed it up with Lou and Joe "Reds" Transparenti, Al Mancini, Joey Green, and Sammy Seamon.

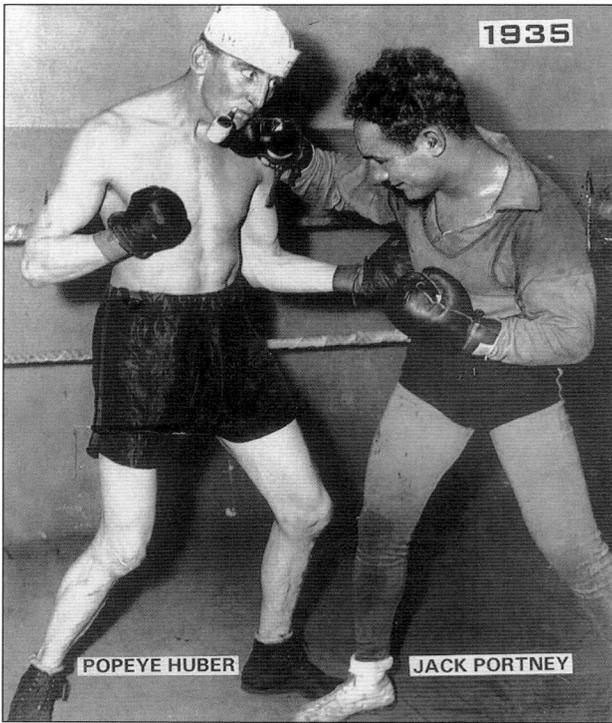

1935

POPEYE HUBER JACK PORTNEY

POPEYE THE SAILOR MAN.
Popeye Huber was all business when in the ring or so one would believe. Lawrence Gunn, Benny Kessler, and Scotty Smith both whipped him in 1935. That year was a big one for Jack Portney as he beat former champions Benny Bass and Johnny Jadick at Carlin's Park.

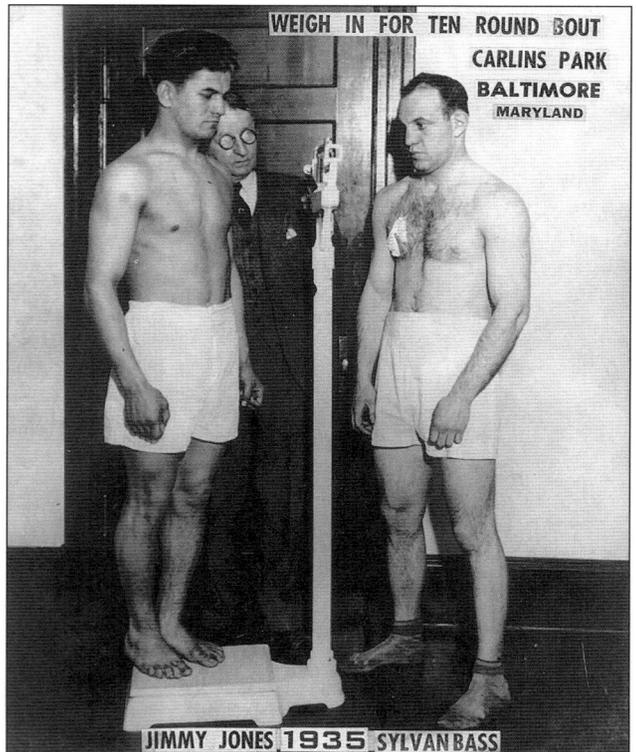

WEIGH IN FOR TEN ROUND BOUT
CARLINS PARK
BALTIMORE
MARYLAND

JIMMY JONES 1935 SYLVAN BASS

STILL GOING STRONG AFTER 12 YEARS IN THE RING.
Sylvan's career started in 1923 under the direction of Heine Blaustein and ended strong in 1936. He won a 10-round decision over a younger Jimmy Jones on March 25. His lengthy career included battles with Young Ketchell, Sergeant Sammy Baker, Cuddy DeMarco, Andy DiVodi, Jack Portney, and Young Terry. One of his biggest victories was overcoming world middleweight champion Ken Overlin on June 6, 1932.

PRE-FIGHT SQUARE OFF.
Cowboy Howard Scott and
California Joe Rivers met each
other two times in 1936 with
Scott winning both decisions in
10 rounds on January 13 and
December 7. They often boxed
on the local drawing cards in the
late 1930s. Scott also met Bucky
Taylor, Pete Galiano, and Eddie
Zivic. Rivers tangled with Joe
Foglietta, Jimmy Tramberia, and
Young Raspi. (Photograph
courtesy of Robert Carson.)

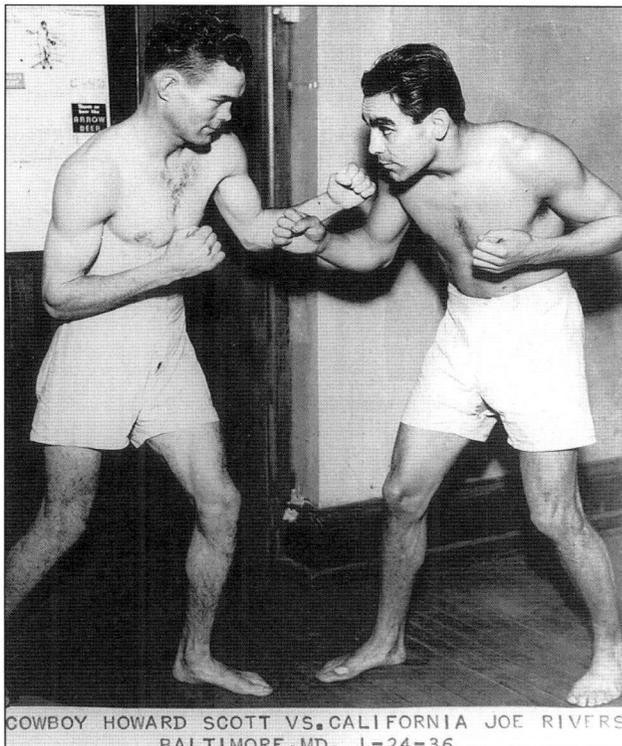

COWBOY HOWARD SCOTT VS. CALIFORNIA JOE RIVERS
BALTIMORE, MD. 1-24-36

BENNY KESSLER. At 120 pounds,
Kessler began boxing professionally
in 1928 and was a regular performer
in local rings until 1942. He faced
fellow Baltimoreans Young Raspi,
Harry Groves, Calvin Calp, Jimmy
Letto, and Stumpy Jacobs.

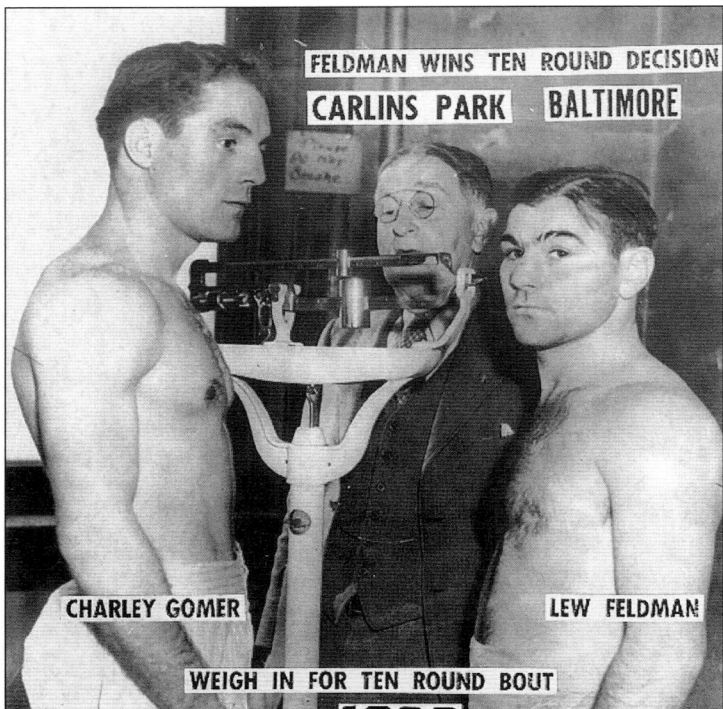

FELDMAN WINS TEN ROUND DECISION
CARLINS PARK BALTIMORE
CHARLEY GOMER
LEW FELDMAN
WEIGH IN FOR TEN ROUND BOUT

LEW FELDMAN AND CHARLEY GOMER. Feldman, a New York City product, boxed numerous times in Baltimore, including fights with champions Chalky Wright and Mike Belloise. On February 10, 1936, he beat local boy Gomer by a close 10-round decision. Feldman also met world champions Richie Lemos, Henry Armstrong, Lew Jenkins, Midget Wolgast, Freddie Miller, Battling Battalino, Petey Sarron, Tommy Paul, and Kid Chocolate.

ONE OF THE TRANSPARENTI BOYS. Joe "Reds" acquired his nickname from his ruby colored locks. Boxing like his other three brothers was in his blood. He turned professional in 1934 and retired in 1939. In that time, he engaged in contests with Lawrence Gunn, champion Harry Jeffra, Spud Murphy, and Chester Ruby, whom he defeated for the Maryland State Bantamweight title.

70

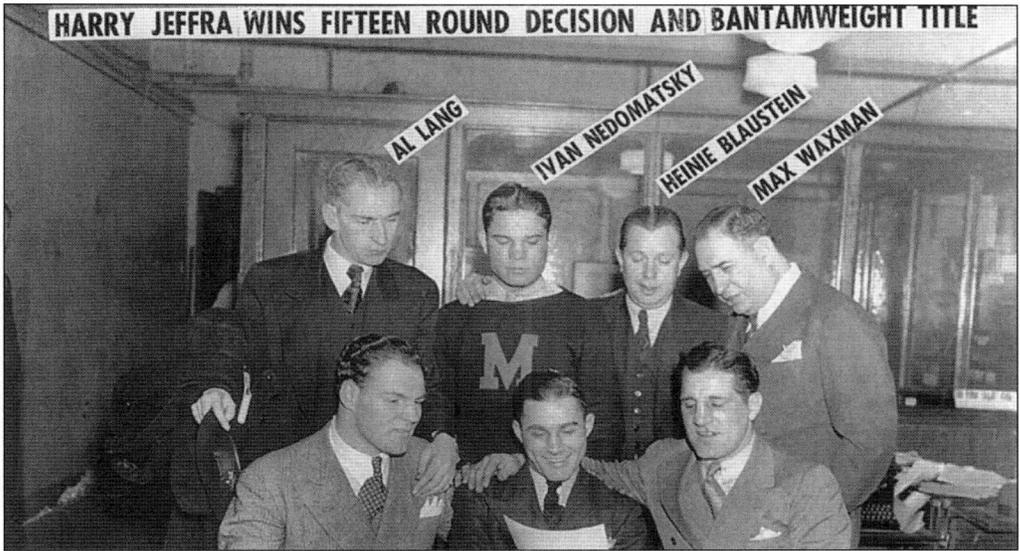

HARRY JEFFRA WINS FIFTEEN ROUND DECISION AND BANTAMWEIGHT TITLE

AL LANG IVAN NEDOMATSKY HEINIE BLAUSTEIN MAX WAXMAN

BALTIMORE'S FIFTH WORLD CHAMPION. Ignacius Pasquali Guiffi, better known as Harry Jeffra (center), reviews the contract for his fight with Sixto Escobar on September 23, 1937. Former welterweight champion Joe Dundee (right) and top heavyweight contender Red Burman (left) surround him. Ivan Nedamatsky, another local product, fought welterweights Hunter Crostic, Eddie Guerra, and Steve Mamakos. Blaustein, Baltimore's most famous trainer and cornerman of all time, guided Jeffra, Joe Dundee, and Vince Dundee to world titles.

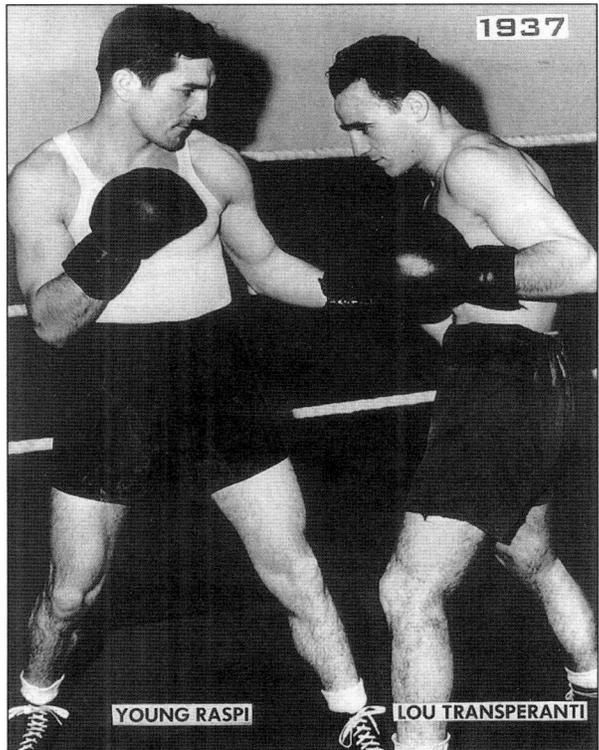

1937

YOUNG RASPI LOU TRANSPERANTI

ROOKIE YEAR. Italian-American Lou Transparenti followed in his brothers' (Joe "Reds" and Nick) footsteps when turning professional in 1937. He gave out as much as he took in from nine world champions—Willie Pep, Chalky Wright, Harry Jeffra, Joey Archibald, Manuel Ortiz, Petey Scalzo, Small Montana, Lou Salica, and Sixto Escobar. Although he never won a world title for the Monumental City, he came close against contenders Joey Archibald and Lou Salica.

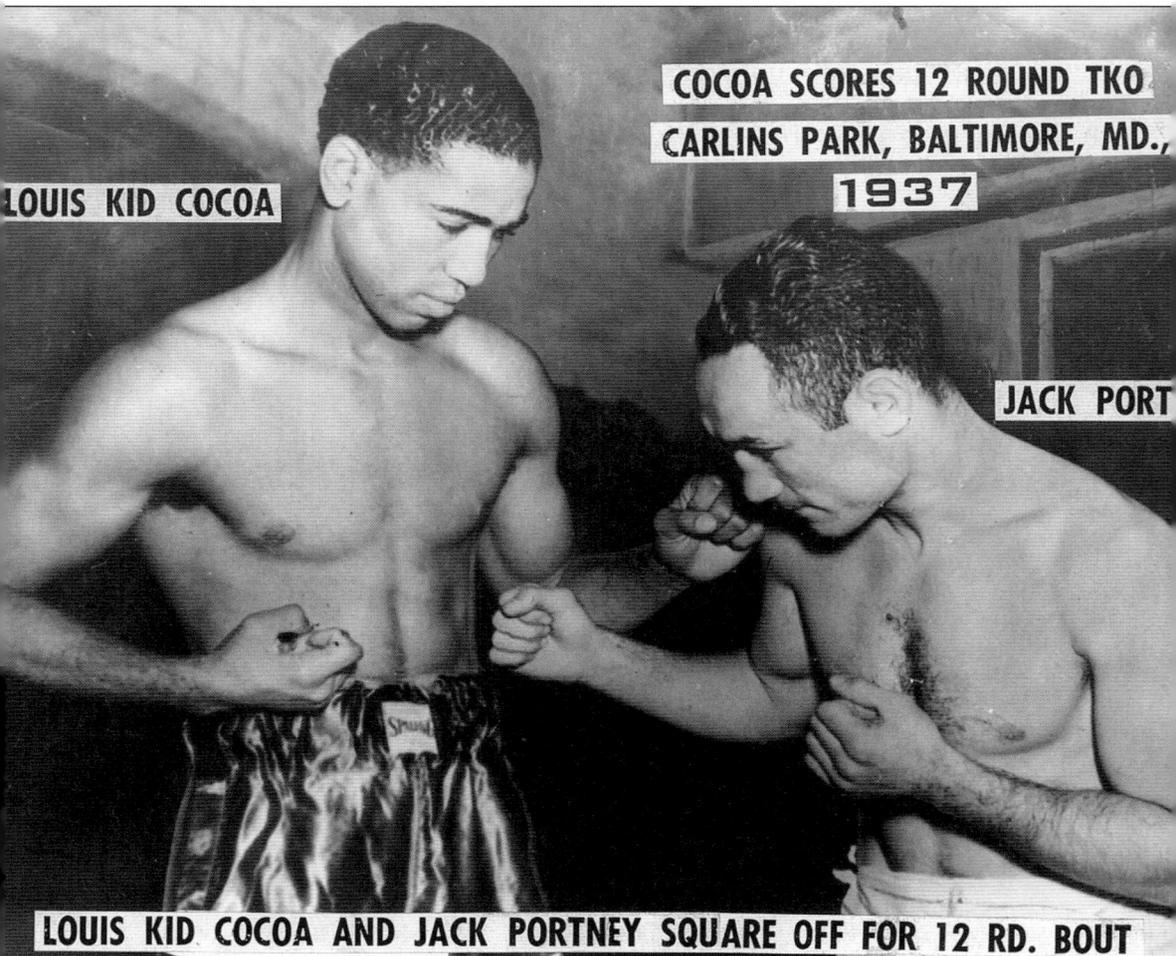

LOUIS KID COCOA

COCOA SCORES 12 ROUND TKO
CARLINS PARK, BALTIMORE, MD.,
1937

JACK PORT

LOUIS KID COCOA AND JACK PORTNEY SQUARE OFF FOR 12 RD. BOUT

TWO WARRIORS. Louis (Kid Cocoa) Hardwick was a Puerto Rican welterweight from New Haven, Connecticut. Many of his fights occurred in Baltimore, including his fight with Baltimorean Jack Portney on March 1, 1937. Carlin's Park, located on Park Circle and Reisterstown Road, was a big boxing venue of the 1930s. Portney would later become the promoter of the Baltimore Garden Athletic Club during the 1940s.

Two Top Featherweight Contenders. Sammy Laporte and Lawrence Gunn fought each other four times in Baltimore with Gunn winning in three of them between 1937 and 1940. Gunn boxed fellow Baltimorean Harry Jeffra (lost in 10 rounds) and other world champions Joey Archibald (lost by a knockout in the sixth), and Georgie Pace (lost by a knockout in the first). Laporte fought world champion Manuel Ortiz (lost by a knockout in seventh). Gunn believed Laporte was the hardest puncher he ever met. (Photograph courtesy of Robert Carson.)

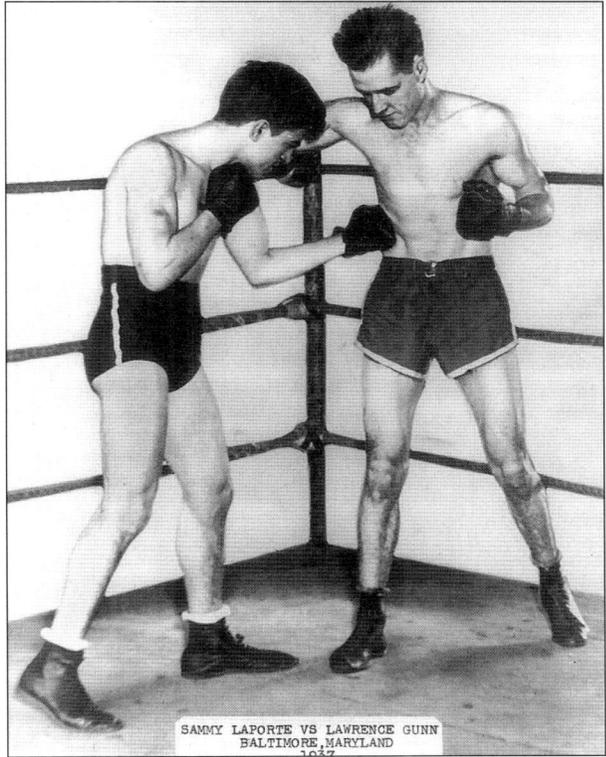

SAMMY LAPORTE VS LAWRENCE GUNN
BALTIMORE, MARYLAND

Otts Baker. Baltimore's hard-fighting middleweight of the 1930s met some tough competition in Vic Finazzo, Bobby Chavez, Leroy Zinkham, and Vince DePaula.

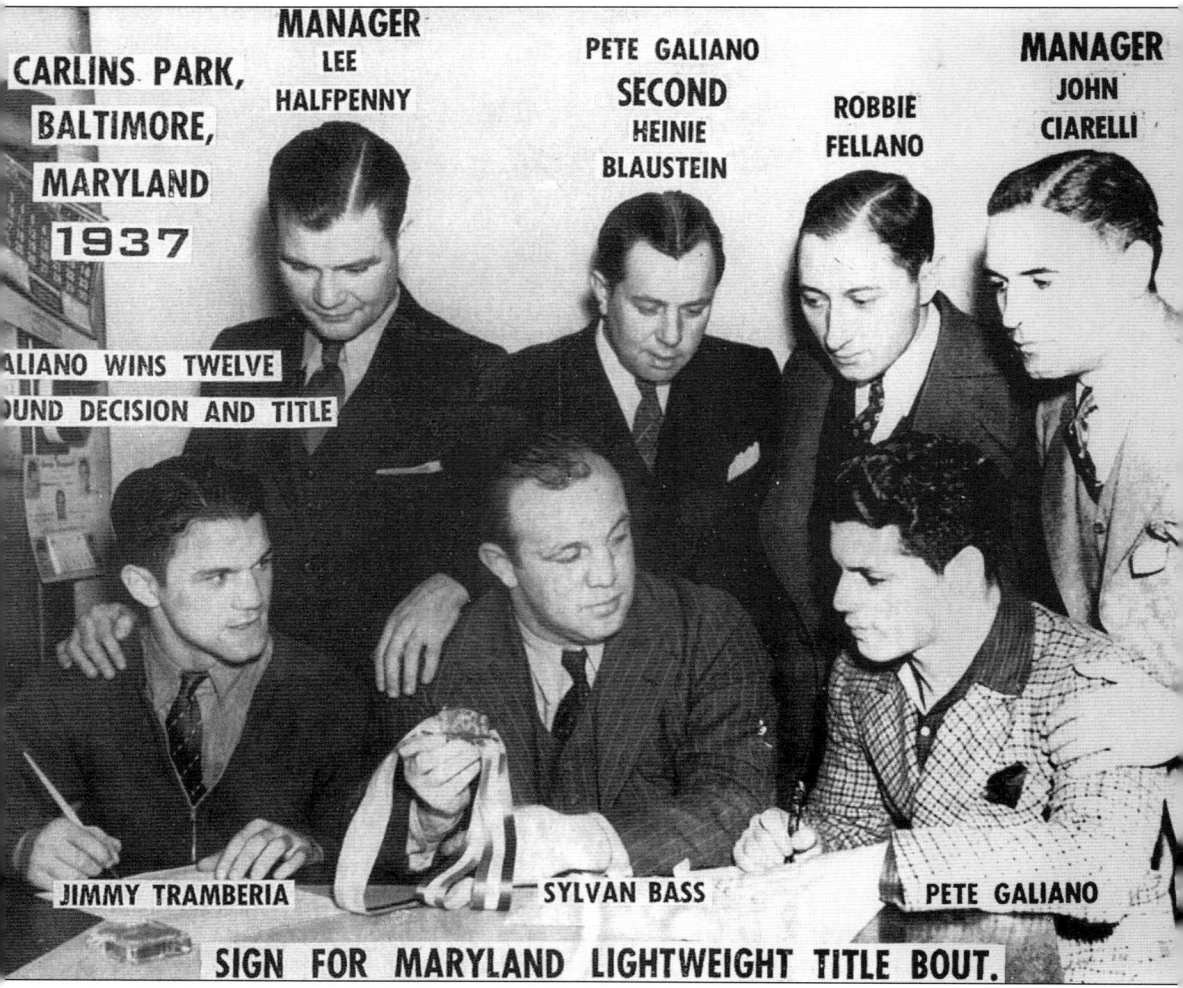

CARLINS PARK, BALTIMORE, MARYLAND 1937

MANAGER
LEE HALFPENNY

PETE GALIANO
SECOND
HEINIE BLAUSTEIN

ROBBIE FELLANO

MANAGER
JOHN CIARELLI

...ALIANO WINS TWELVE ...UND DECISION AND TITLE

JIMMY TRAMBERIA — SYLVAN BASS — PETE GALIANO

SIGN FOR MARYLAND LIGHTWEIGHT TITLE BOUT.

THE BEAU BRUMMEL OF BOXING. Peter Charles Galiano hailed from the Little Italy section of Baltimore. In 1933, he had his first professional bout at the age of 16 against Lou Votta at the Gayety Theatre. Before his career ended in 1949, he engaged in 152 bouts with some of the toughest fighters in the world. Pete met world champions Sammy Angott, Harry Jeffra, Jackie Kid Berg, and Henry Armstrong. The Armstrong bout was a four-round exhibition that turned out to be a bitter battle. He also met Cowboy Howard Scott, Lew Feldman, Jimmy McAllister, Jack Portney, Al Bummy Davis, Bobby Ruffin and Allie Stolz. Pictured here is the signing for the Maryland Lightweight Title bout against Jimmy Tramberia (whom he met seven times). On February 1, 1937, Pete won the title in a 12-round decision. Tramberia, a good and busy Baltimore fighter himself, contended with champion Kid Chocolate, Angelo Meola (Ace Dundee), Bucky Taylor, Marty Bond, Charlie Gomer, California Joe Rivers, Dominic Barone, and Frankie Litt.

74

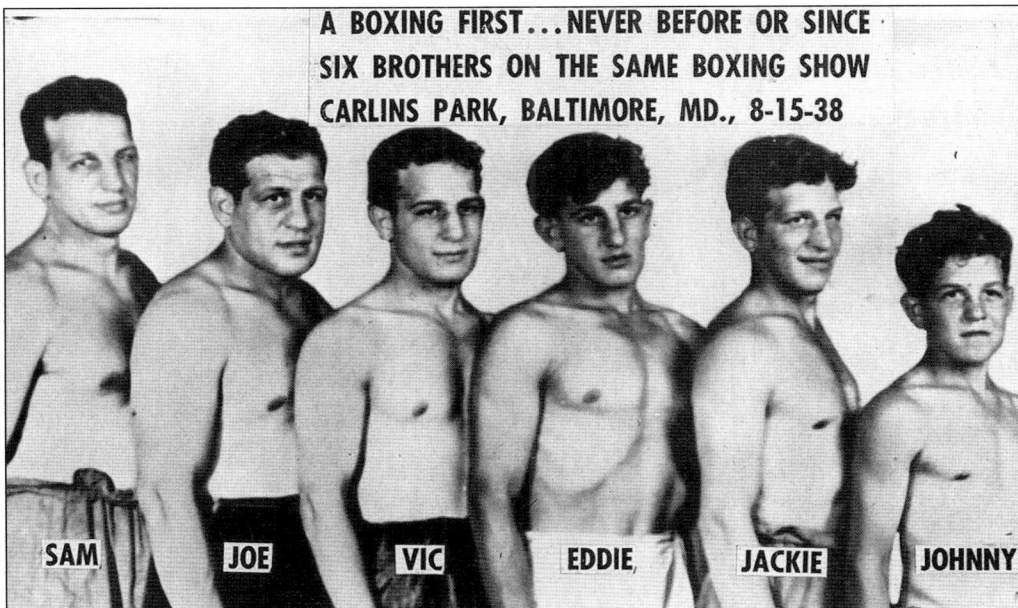

A BOXING FIRST...NEVER BEFORE OR SINCE SIX BROTHERS ON THE SAME BOXING SHOW CARLINS PARK, BALTIMORE, MD., 8-15-38

SAM JOE VIC EDDIE JACKIE JOHNNY

SIX BROTHERS ON THE SAME CARD. The Finazzo brothers were all native Baltimoreans whose careers were active from the 1920s to the 1940s. Joe, the first to box professionally in 1927, fought contenders Ken Overlin, Sylvan Bass, and Jimmy Jones. Sam laced up the gloves soon after, fighting such stars as Red Burman and Hookey Jackson. Jackie was a lightweight whose career started in 1937 but was cut short due to the war. Vic also had a short career but was very active in his five years. His bouts include Pete Galiano, Young Raspi, Lew Raymond, Cowboy Scott, and Jose Basora. Eddie's career spanned from 1938 to 1947 and was best known for his matchup against middleweight legends Sugar Ray Robinson and Rocky Graziano. Johnny, the youngest brother, campaigned professionally from 1941 until 1947 with his biggest match against top contender Bert Lytell.

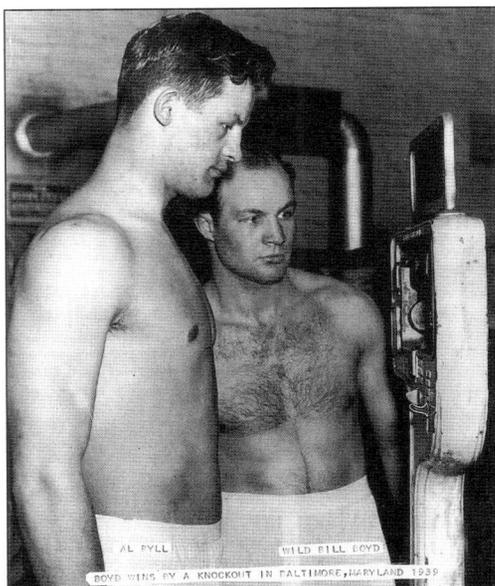

WEIGH-IN AT CARLIN'S PARK. Prior to their February 27, 1939 heavyweight fight, Al Ryll, 182 pounds, and Baltimorean Wild Bill Boyd, 184 pounds, hit the scales. Boyd would win by a fourth-round knockout. Boyd was a headliner during the 1930s in Baltimore, fighting such men as Joe Wagner, Jim Robinson, and Mario Liani. (Photograph courtesy of Robert Carson.)

COLISEUM
BENEFIT BOXING SHOW

DOWNTOWN LIONS CLUB
and NATIONAL A. C., Inc.

THURSDAY, JULY 20, 1939

PROGRAM

4 Rounds
WALLY BOOKER, Baltimore vs. KEN LOUDEN, Baltimore

6 Rounds
BRUCE ALEXANDER. Baltimore vs. EDDIE DREHER, Baltimore

6 Rounds
PETE TARPLEY, Wilkesbarre, Pa. vs. RUSSELL TUCKER, Mobile, Ala.

6 Rounds
TOOTS BASHARA, Norfolk, Va. vs. ALI BEN HASSAN, Baltimore

10 Rounds
LOUIS KID COCOA vs. STEVE MAMAKOS
New Haven. Conn. Washington, D. C.

NEXT WEEK --- THURSDAY, JULY 27th
3000 SEATS AT 40c

THE COLISEUM. Most of all Baltimore's big fights in the late 1930s to 1960s were held at the Coliseum on 2201 North Monroe Street. This handbill features a main event bout where welterweight Louis Kid Cocoa won by decision over Steve Mamkos in 10 rounds.

BALTIMORE'S FIRST TWO DIVISION CHAMPION. Harry Jeffra made history when he won a 15-round decision over world featherweight champion Joey Archibald at the Baltimore Coliseum on May 20, 1940. Max Waxman, with the able assistance of Jack Dempsey, guided Jeffra to two world titles, the bantamweight and featherweight diadems.

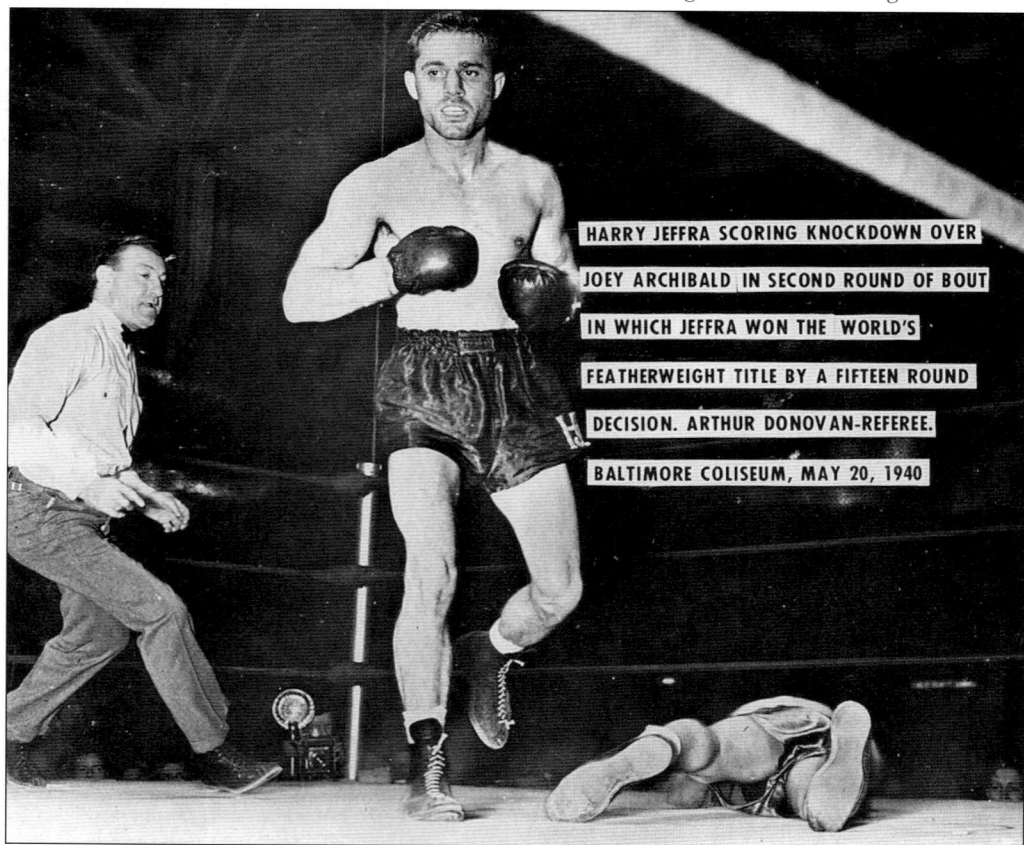

HARRY JEFFRA SCORING KNOCKDOWN OVER JOEY ARCHIBALD IN SECOND ROUND OF BOUT IN WHICH JEFFRA WON THE WORLD'S FEATHERWEIGHT TITLE BY A FIFTEEN ROUND DECISION. ARTHUR DONOVAN-REFEREE. BALTIMORE COLISEUM, MAY 20, 1940

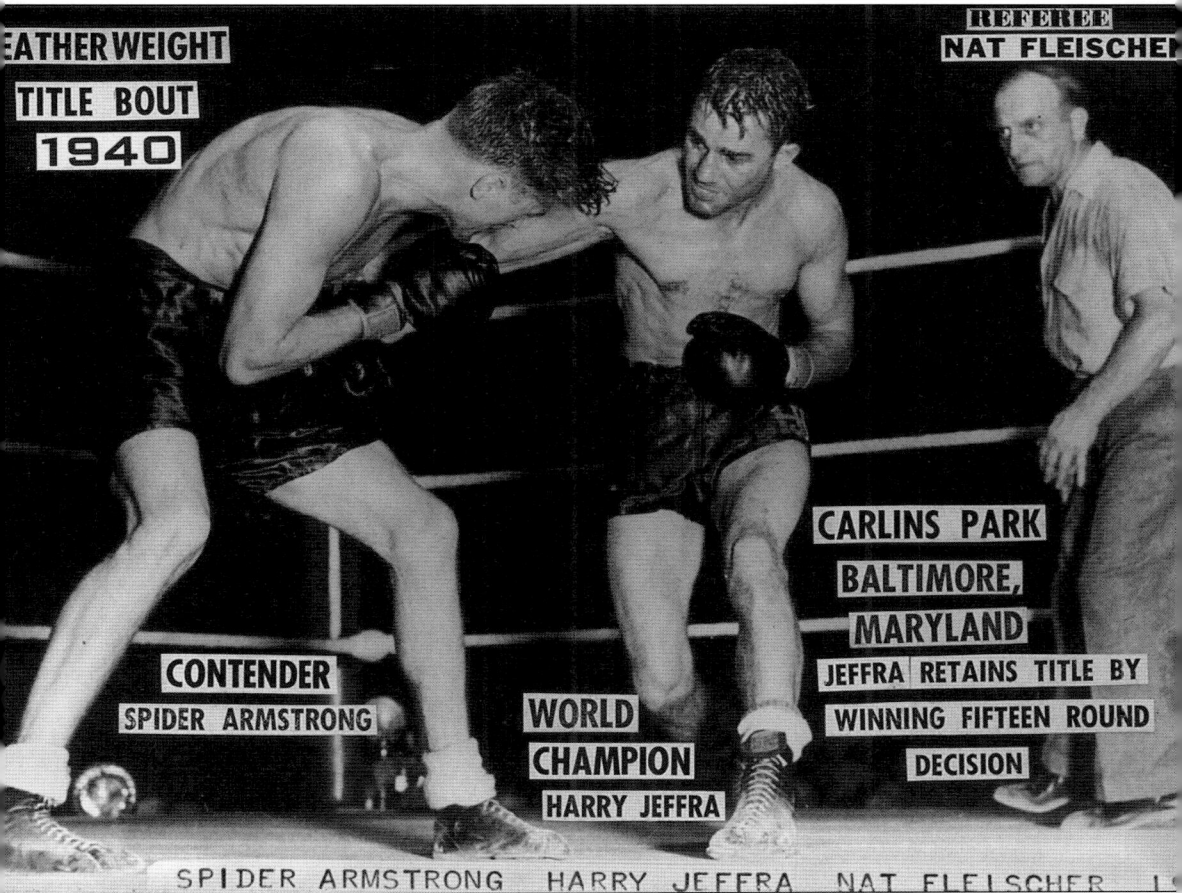

FEATHERWEIGHT TITLE BOUT 1940

REFEREE NAT FLEISCHER

CONTENDER
SPIDER ARMSTRONG

WORLD
CHAMPION
HARRY JEFFRA

CARLINS PARK BALTIMORE, MARYLAND
JEFFRA RETAINS TITLE BY WINNING FIFTEEN ROUND DECISION

SPIDER ARMSTRONG HARRY JEFFRA NAT FLEISCHER

AND STILL THE WORLD'S CHAMPION. On July 29, 1940, hometown hero Harry Jeffra decisioned Johnny "Spider" Armstrong in 15 rounds. Armstrong had better luck against fellow Baltimorean Lou Transparenti the previous year, knocking him out in one round. Famous historian and publisher of the Ring magazine, Nat Fleischer, refereed the bout. (Photograph courtesy of John Gore.)

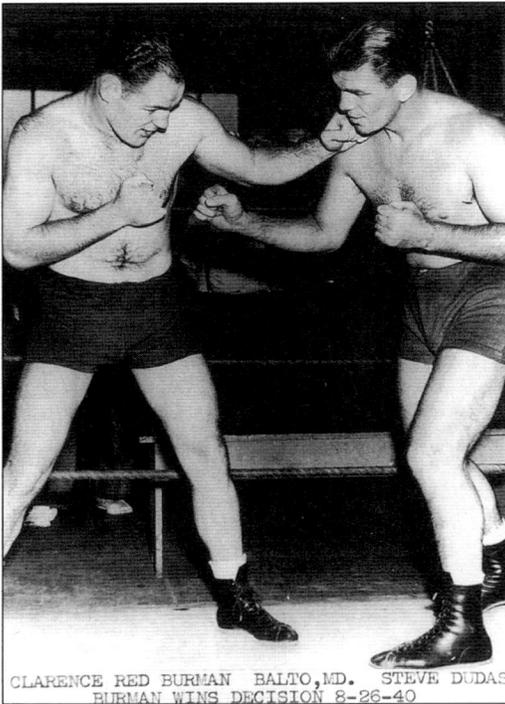

CLARENCE RED BURMAN BALTO,MD. STEVE DUDAS
BURMAN WINS DECISION 8-26-40

FIRST BALTIMOREAN TO FIGHT FOR THE HEAVYWEIGHT CHAMPIONSHIP. Clarence Red Burman fought all the way from flyweight to heavyweight during the 1930s and 1940s. He was best known for his five-round knockout loss to Joe Louis. Wins over Johnny Risko, Tommy Farr, Steve Dudas, and Tony Musto culminated in the title bout with Louis on January 31, 1941. Red also fought four additional world champions—Joey Maxim, Melio Bettina, John Henry Lewis, and Ken Overlin. Max Waxman managed and Jack Dempsey consulted later on in Red's career.

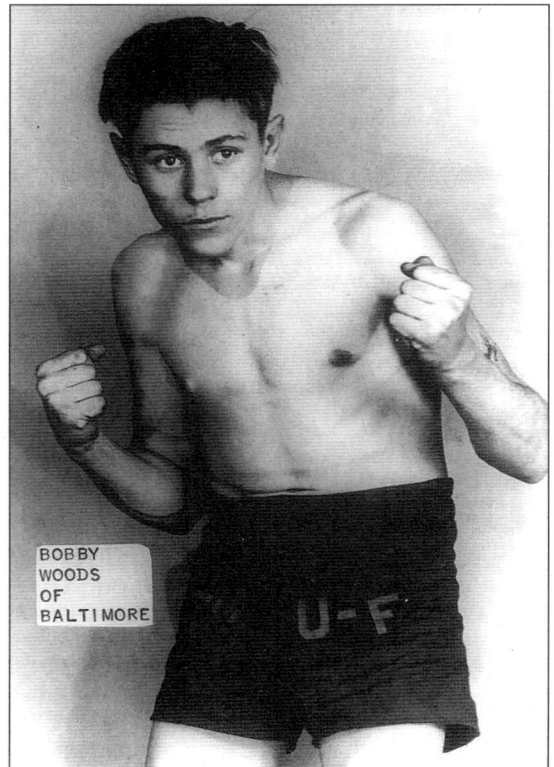

BOBBY WOODS OF BALTIMORE

SUGAR RAY ROBINSON'S FOURTH OPPONENT. Bobby Woods fought during the late 1930s and early 1940s. He met such men as Manuel Rosa, Jimmy Collins, Frank Possidente, and Nick Londos in Baltimore rings. He had the distinction of being Sugar Ray Robinson's fourth professional opponent; Ray knocked him out in one round on November 11, 1940, in Philadelphia, Pennsylvania. (Photograph courtesy of Robert Carson.)

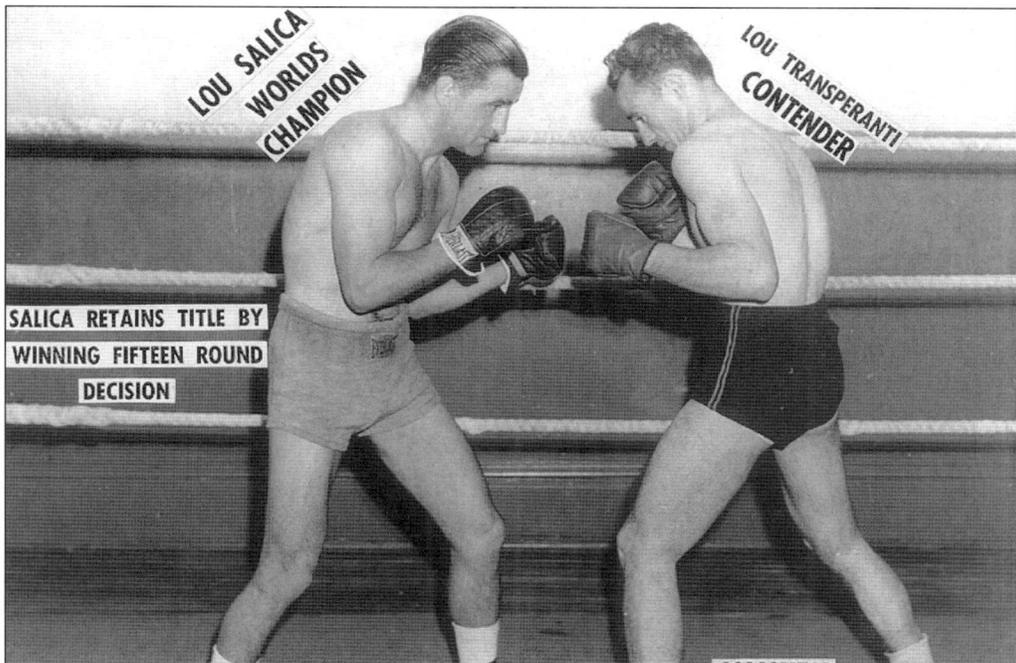

LOU SALICA WORLDS CHAMPION

LOU TRANSPARENTI CONTENDER

SALICA RETAINS TITLE BY WINNING FIFTEEN ROUND DECISION

SO CLOSE. Lou Transparenti came close to becoming Baltimore's sixth world champion when he lost a 15-round decision to bantamweight champion Lou Salica at the Baltimore Coliseum on April 25, 1941. Just one month earlier Transparenti had beaten Salica in a non-title bout.

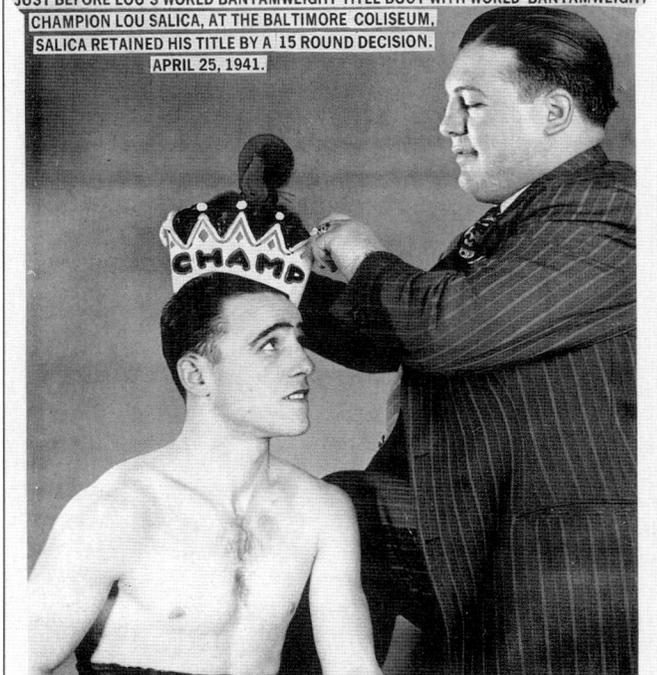

MANAGER BENNY TROTTA TRYING THE CROWN ON LOU TRANSPARENTI'S HEAD FOR SIZE. JUST BEFORE LOU'S WORLD BANTAMWEIGHT TITLE BOUT WITH WORLD BANTAMWEIGHT CHAMPION LOU SALICA, AT THE BALTIMORE COLISEUM, SALICA RETAINED HIS TITLE BY A 15 ROUND DECISION. APRIL 25, 1941.

CHAMP

A FICTITIOUS CROWN. Manager Benny Trotta Magliano was very active with Baltimore fighters from the 1930s through the 1950s. Besides Lou Transparenti, he piloted the careers of Pete Galiano, Young Raspi, Holly Mims, and Jimmy McAllister. He also had great success as a promoter. On August 15, 1951, he pulled off the biggest fight ever held in Baltimore. A record breaking crowd of 18,215 fans watched Joe Louis defeat Jimmy Bivins in 10 rounds at the old Memorial Stadium.

79

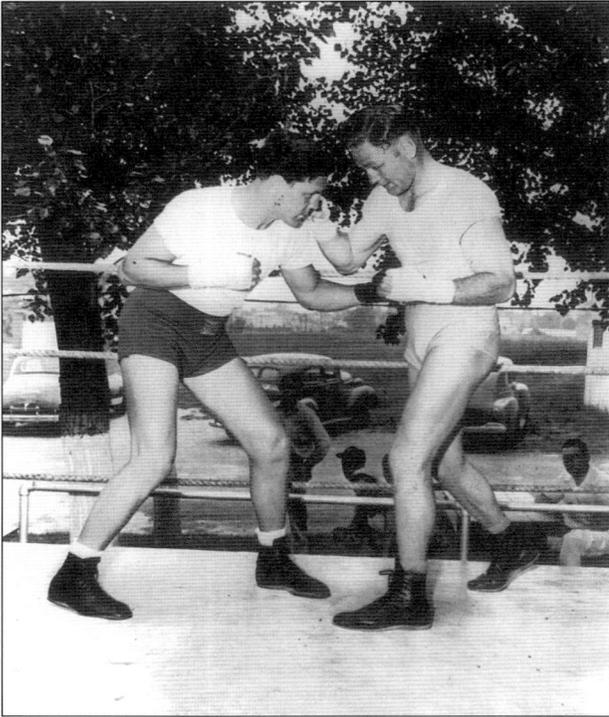

FIRST BOXING PROGRAM AT BALTIMORE STADIUM. Heavyweights Bill Poland (left) and Lee Savold (right) square off in training for their June 26, 1941 heavyweight bouts at Baltimore Stadium, the first program ever staged in the big bowl. Poland from New York knocked out Harry Bobo in eight rounds, and Savold from Des Moines, Iowa, knocked out King Kong in six rounds. (Photograph courtesy of Robert Carson.)

HEY BUB! World champion Wilson grimaces at Baltimore lightweight Gilley. Although they never met, Wilson had several bouts in Baltimore including Leo Rodak in 1938, Chalky Wright in 1941, and Harry Jeffra in 1945. Gilley debuted in 1936 and fought several local boys including Young Raspi, Bucky Taylor, Tommy Brown, Frankie Litt, and Joey Greb. His biggest match was against future lightweight champion Bob Montgomery in 1939, who stopped him in six rounds.

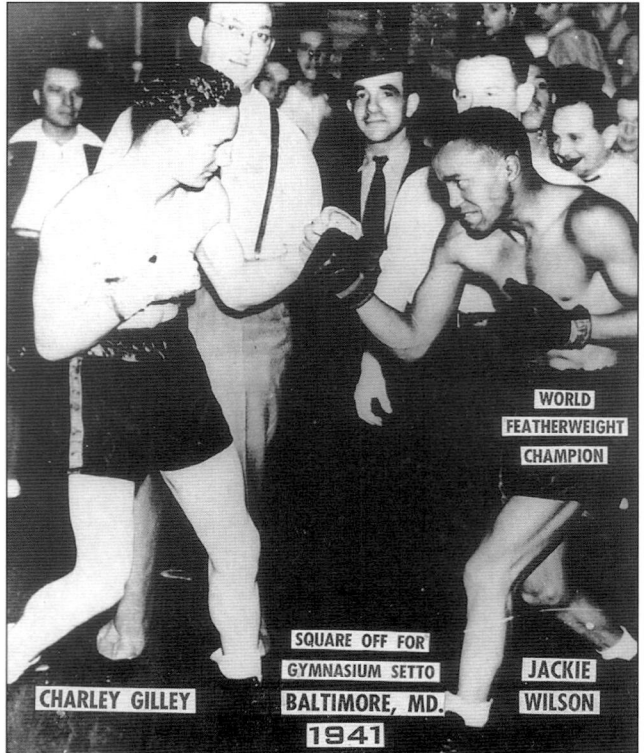

WORLD FEATHERWEIGHT CHAMPION

SQUARE OFF FOR GYMNASIUM SETTO BALTIMORE, MD. 1941

CHARLEY GILLEY

JACKIE WILSON

SLUGGER. Luther White, born in Athens, Georgia, was a top notch lightweight from 1937 to 1944. Almost all of his 1941 and 1942 bouts were held in Baltimore, where he fought Leo Rodak, Bob Montgomery, Mike Evans, Jimmy Leto, Louis Kid Cocoa, and Willie Joyce. He is best remembered for fighting world champions Sammy Angott, Ike Williams, and Henry Armstrong.

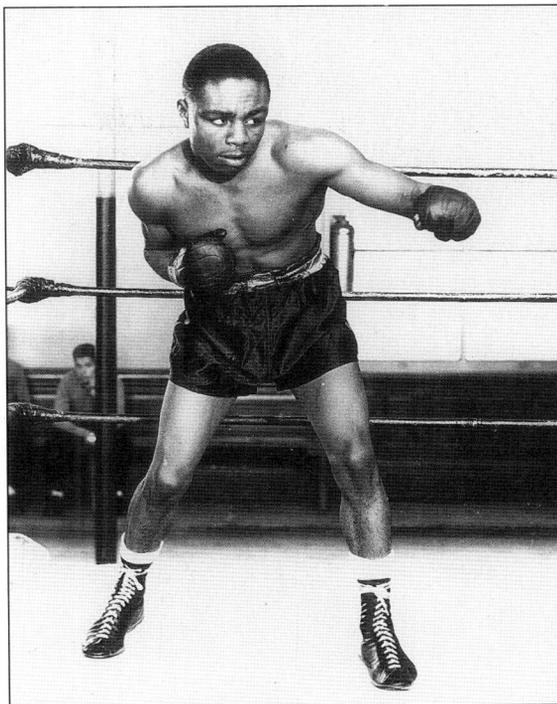

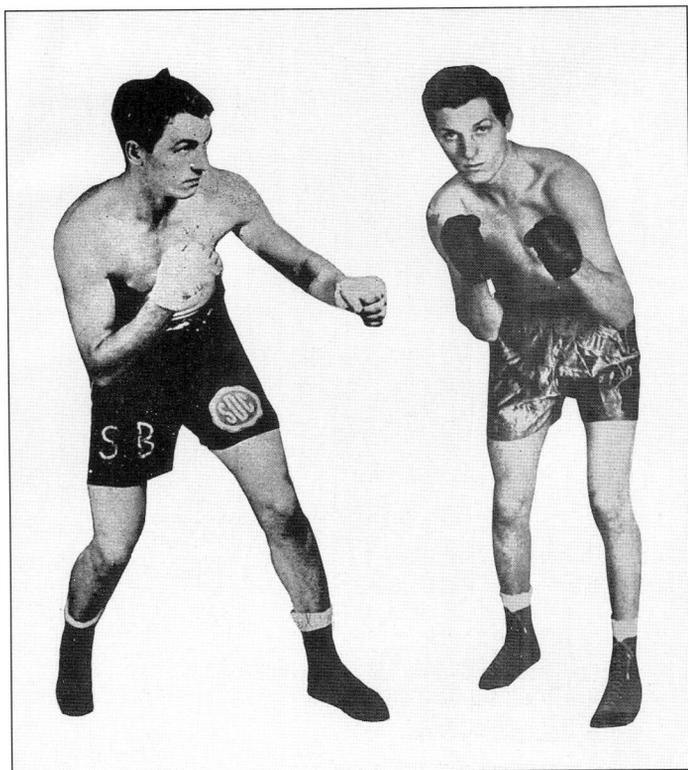

THE BACCALA BOYS. Sam (left) and Dominic (right) fought professionally in the 1930s and 1940s, mostly at local clubs. Sam, a welterweight, laced them up with Georgie Abrams, Vic Finazzo, Ivan Nedamatsky, and Bee Bee Wright. The lighter Dom started professionally a little later in 1941. He tangled with Terry Moore, Leslie Harris, Kid Lewis, and Buddy Garcia.

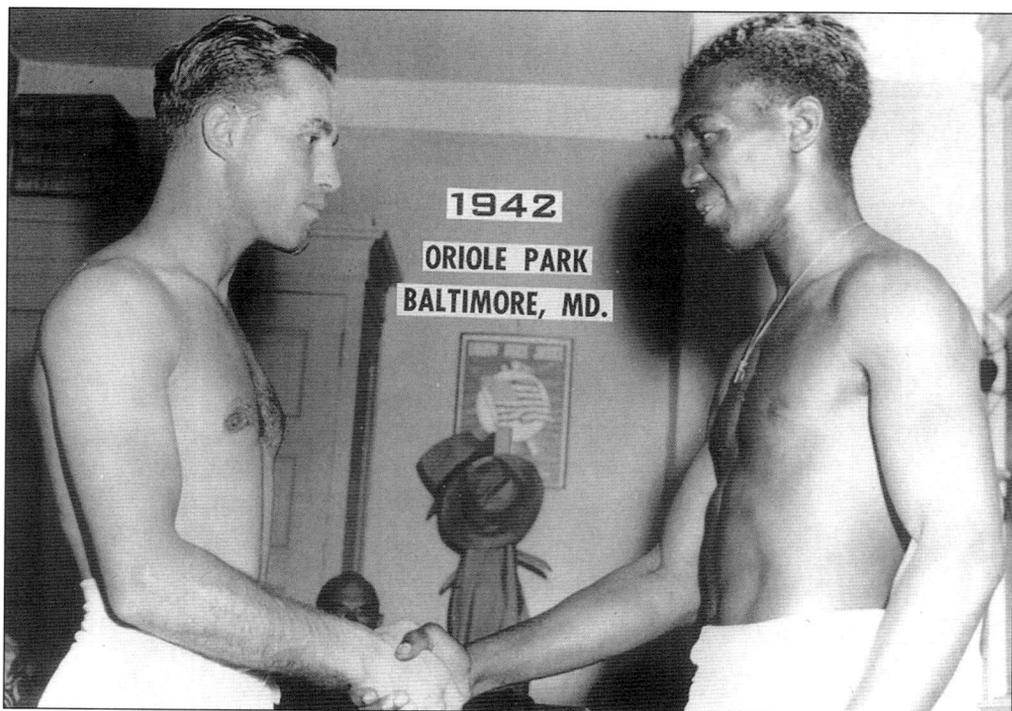

TRYING TO WIN BACK HIS CROWN. Harry Jeffra (left) lost his world featherweight title the year before to Joey Archibald, who, in turn, lost to Albert Chalky Wright, right. The two met on June 19 with Wright knocking out Jeffra in 10 rounds.

A GREAT AMATEUR AND PROFESSIONAL. Charles Manuel Wible had a outstanding career as a lightweight from 1934 to 1939. Mannie fought professionals Calvin Calp, Angelo Mecla, Bucky Taylor, LeRoy Zinkham, Sam Baccala, Vic Finazzo, and Eddie Guerra—his last fight.

Six
1943–1972

TOP RATED FEATHERWEIGHT. Jimmy McAllister began boxing professionally in 1941 under the direction of Nate Klein, and later under Benny Trotta and Sam Lampe. He traded blows with Pete Galiano, Charley Riley, Red Top Davis, and featherweight champions Phil Terranova and Willie Pep. Jimmy had well over 100 fights during his splendid career which lasted through 1951. (Photograph courtesy of Robert Carson.)

TAUGHT JOE LOUIS A TRICK OR TWO. Holman Williams, a tough Detroit middleweight fighter, gave Joe Louis some pointers when the Brown Bomber emerged from the amateur ranks in the early 1930s. Williams had several key bouts in Baltimore during two decades. In the 1930s, he met Jack Portney and Louis Kid Cocoa. In the 1940s, he fought Steve Mamakos, Izzy Jannazzo, Kid Tunero, and twice future light heavyweight champion Archie Moore. (Photograph courtesy of Robert Carson.)

EARL BAYNE. He had a stellar amateur career in the late 1930s and early 1940s as a featherweight. He met some tough local competition such as Phil Transparenti, Eli Hanover, Nick Longo, Bucky Jeffra, Johnny Finazzo, and Dom Baccala.

THE HATCHETMAN. Managed at one time by Max Waxman, Curtis Sheppard was a heavyweight whose career spanned from 1938 to 1949. He fought Archie Moore, Lee Q. Murray, Al Hart, Jimmy Bivins, Johnny Shkor, and Jersey Joe Walcott—all in Baltimore. (Photograph courtesy of J.J. Johnston.)

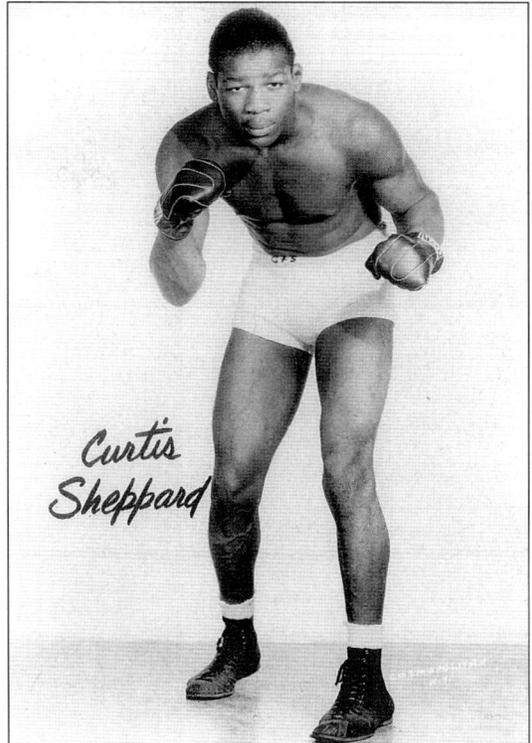

Curtis Sheppard

A GLOBETROTTING ITALIAN HEAVYWEIGHT. Managed first by Freddy Barth and later by Max Waxman, Leo Mattricciani had a stellar career from 1942 to 1948. He had a stint in the Air Force during World War II, also during these years. He was selected as the first white serviceman to box an exhibition with world heavyweight champion Joe Louis. The fight was refereed by former world light heavyweight champion Billy Conn. Conn was so impressed with Leo's ability that he signed him up as his sparring partner. Upon returning to the States, he met Vern Mitchell, Johnny Shkor, and Cleo Everett.

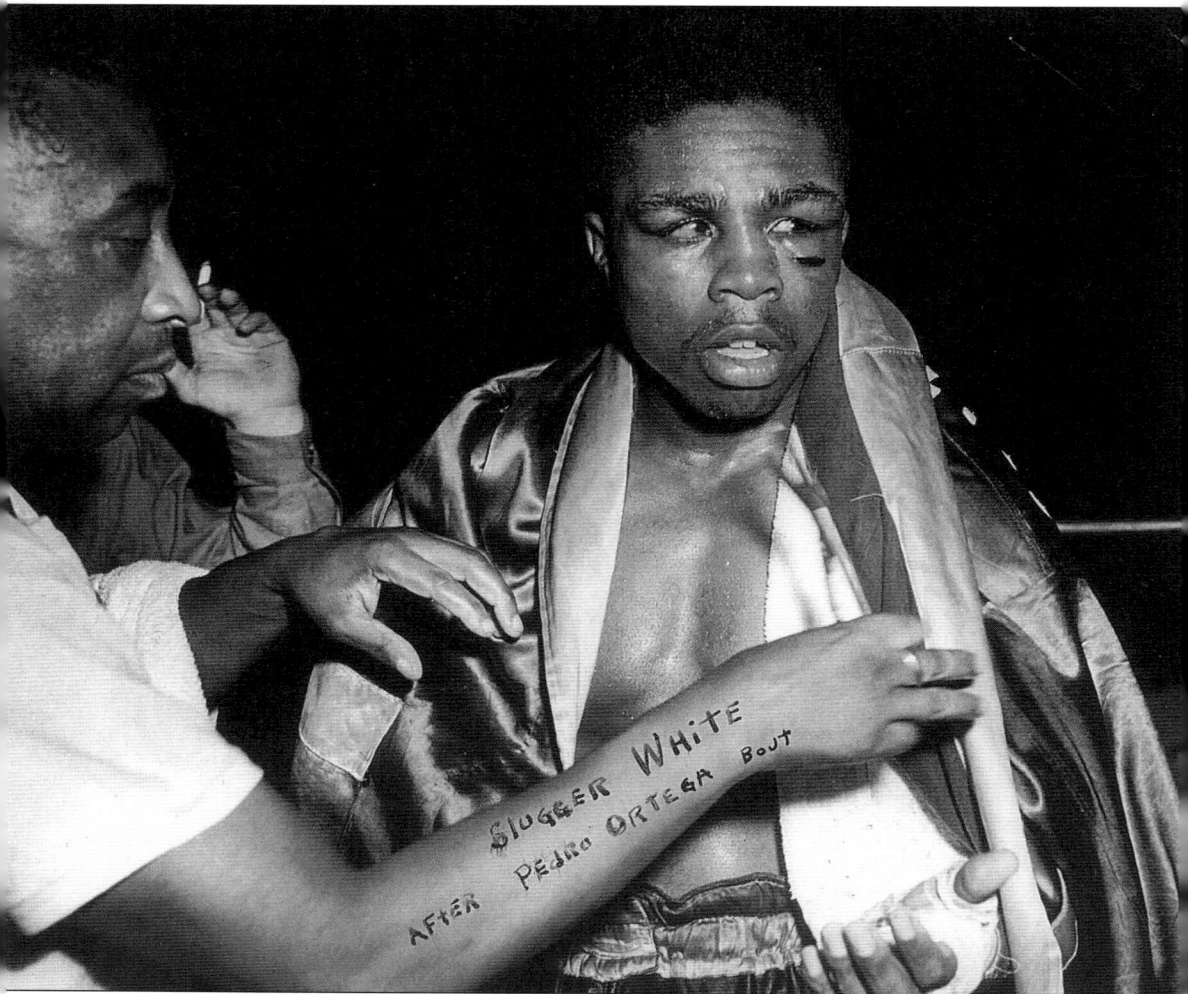

SO MUCH FOR AN EASY TUNE UP FIGHT. Luther Slugger White, a fixture in Baltimore rings during the 1940s, bares a nice shiner after his 10-round win over Pedro Ortega in Oakland, California, on September 15, 1943. This fight was supposed to be a tune up for his lightweight championship fight against Sammy Angott, which he wound up losing in 15 rounds. Shortly after this bout, his eye "popped out" during a sparring session, which ended his career. On the left is Seattle Kid, his trainer. (Photograph courtesy of Robert Carson.)

AL BLAKE. A big, stocky heavyweight born and raised in Baltimore. His professional career spanned from 1936 to 1946. He started as a middleweight in the 1930s as Bruce Alexander. He did cross gloves with Jersey Joe Walcott, Tony Shucco, Lee Oma, Young Kid Norfolk, and Tony Musto, among others. (Photograph courtesy of Robert Carson.)

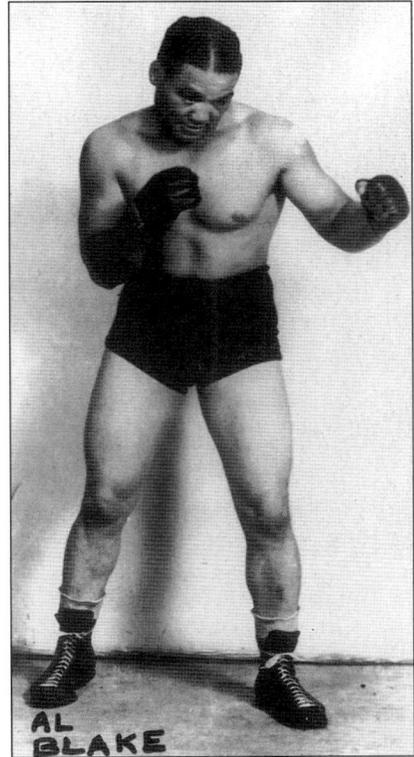

AN ALL-AROUND TALENT. Herbert Petro Bass, better known in fistic circles as Pete Bass, was a boxer, manager, and trainer. During his 1940s career he tangled with Jimmy Mack, Johnny DeMaio, and Emitt Harris. He developed Rudy Watkins, Norman Carrolland, and numerous others. When Johnny Cunningham upset lightweight champion Jimmy Carter in a non-title fight, Pete was responsible for his training. Warnell Boom Lester also benefited from Pete's guidance when he beat Bert Whitehurst for the Maryland State Heavyweight Championship.

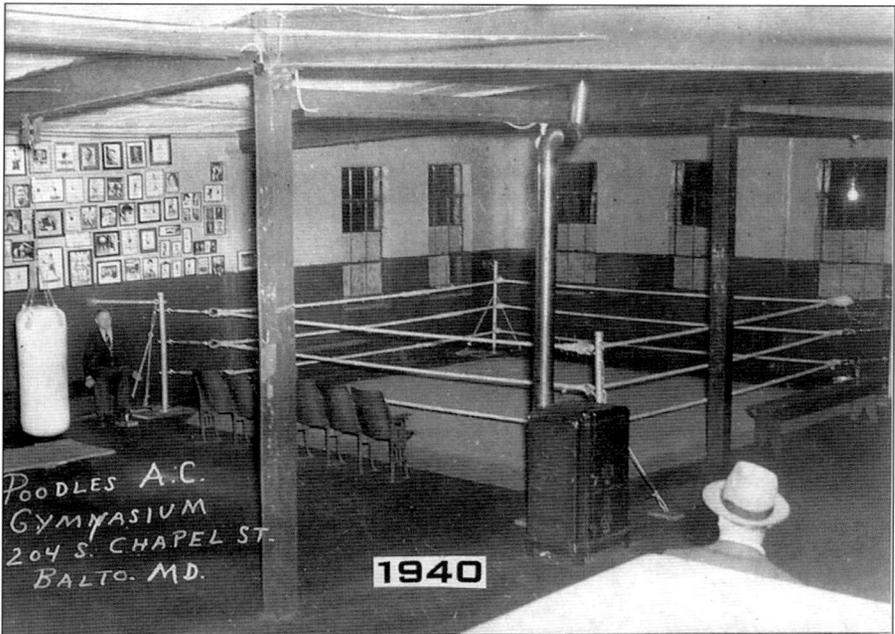

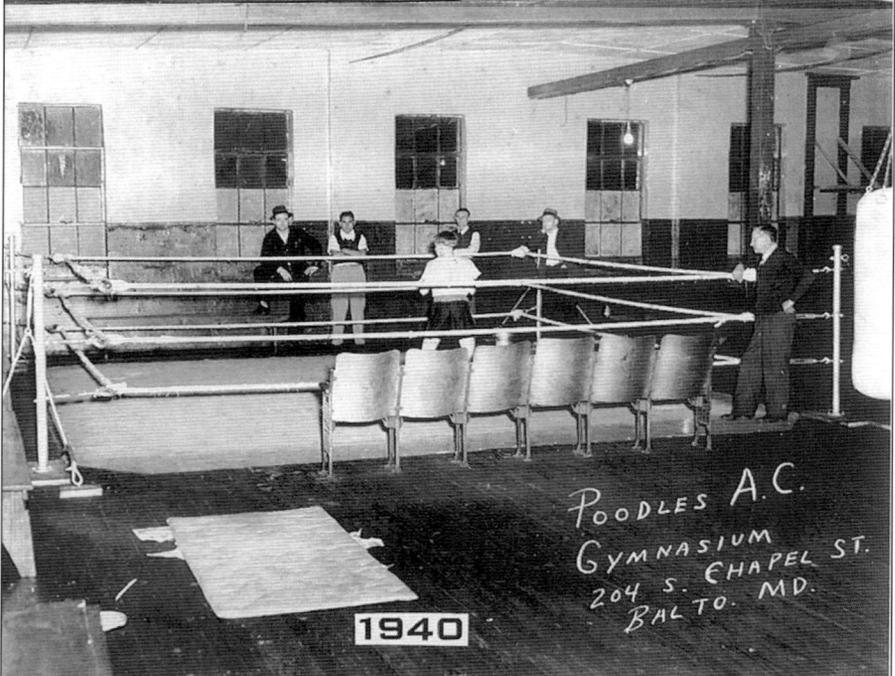

JOE POODLES GYMNASIUM. Joe opened his gym in 1939 on the second floor of 204 S. Chapel Street. From that point on, he served in every conceivable way to influence Baltimore boxing. He served as manager, trainer, cornerman, promoter, publicist, timekeeper, judge, referee, matchmaker, historian, and correspondent for *The Ring* magazine in Maryland 25 years. His gym was open for more than 20 years before he moved it to 831 S. Milton Avenue. (Photograph courtesy of John Gore.)

FOUGHT BEAU JACK. Maxie Starr was a local welterweight contender during the 1940s. His most famous bout was against Beau Jack, who knocked him out in six rounds on June 21, 1943, in Washington, D.C. Starr also boxed Billy Graham, Pete Galiano, Willie Joyce, and Morris Reif.

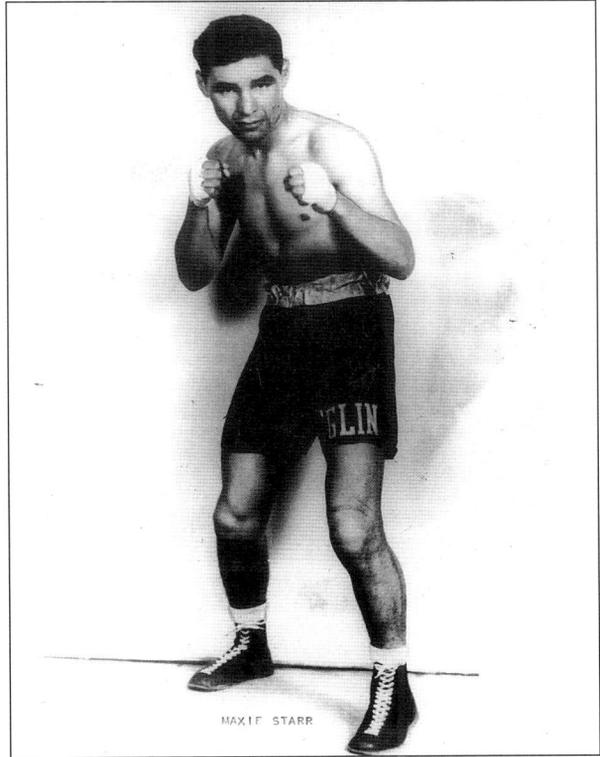

MAXIE STARR

HOWARD BENNETT. Howard was a good middle and light heavyweight during the 1940s. On August 30, 1943, he fought the number one rated middleweight contender Steve Belloise in Baltimore. An upset was almost made when Howard landed a left hook that opened a gash over Steve's eye in the fourth round, but Steve came out fast in the fifth and stopped him. Howard also met Johnny Finazzo, George Kochan, and Joe Carter in Baltimore.

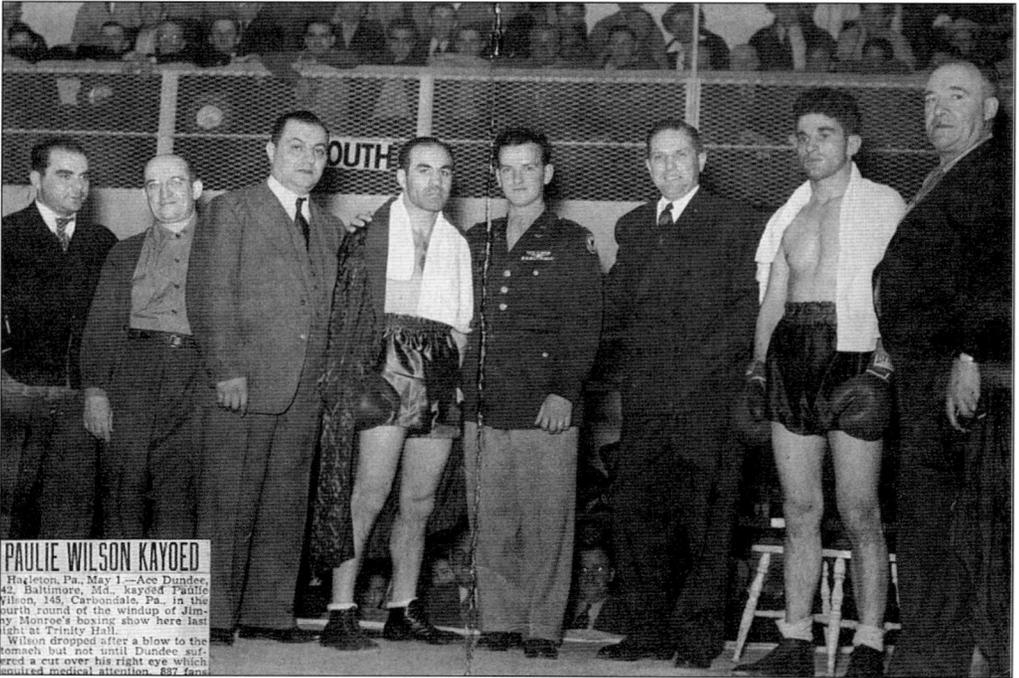

PAULIE WILSON KAYOED
Hazleton, Pa., May 1—Ace Dundee, 42, Baltimore, Md., kayoed Paulie Wilson, 145, Carbondale, Pa., in the fourth round of the windup of Jimmy Monroe's boxing show here last night at Trinity Hall.
Wilson dropped after a blow to the stomach but not until Dundee suffered a cut over his right eye which required medical attention. 837 fans

ACE DUNDEE. Angelo Peter Meola—active from 1929 to 1945—took the ring name Ace Dundee for his out-of-town fights. The name was chosen in respect for his three uncles—world champions Joe and Vince Dundee (Lazzara), and Baltimore Dundee (Samuel Ranzino). This picture, taken at Hazleton, Pennsylvania, on April 30, 1945, shows Meola (fourth from the left) before his fourth-round knockout over Paulie Wilson (second from the right). Meola also met Charley Gomer, Bobby Burns, Young Raspi, Bucky Taylor, Pete DeAngelis, Vince DeSantis, and world champion Frankie Klick.

VINCE TUMINELLO. After an illustrious amateur career under the direction of Dave Selina, Vince turned professional in 1940, weighing 126 pounds. Over the next six years, he met some great fighters including Jimmy McAllister, Jimmy Collins, Paul Shinn, Young Beau Jack, and Young Lee Q. Murray—his last fight in 1945.

KING KONG. Local heavyweight King Kong, whose real name was Robert Lockett, fought with some stiff pugs including Ed Bearcat Wright, Lee Q. Murray, Lee Savold, Al Blake, Arthur Johnson, and Natie Brown during a career that lasted from 1936 to 1947.

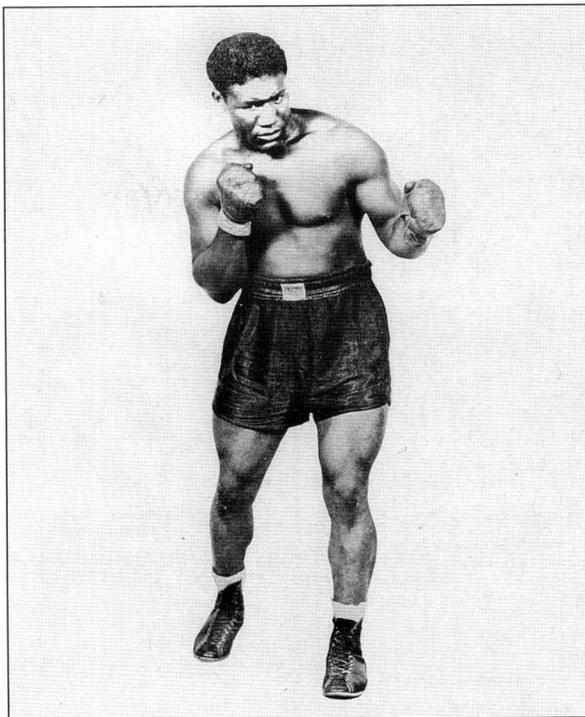

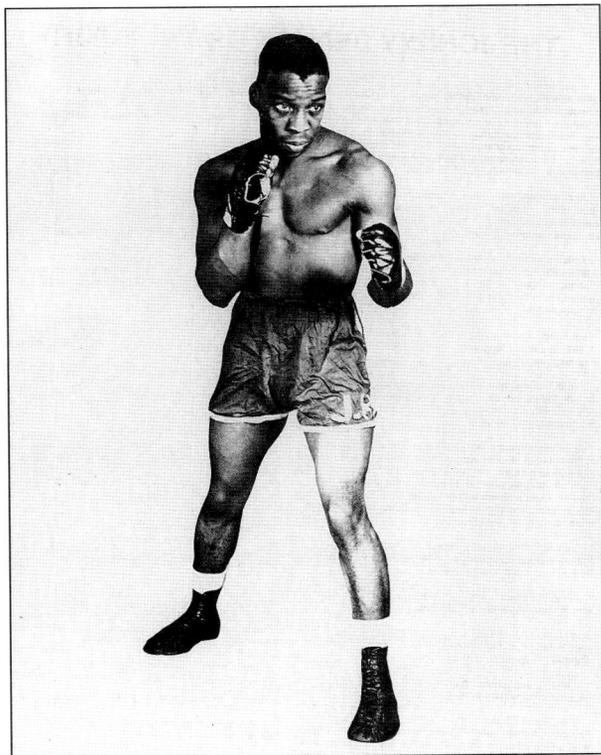

THE DEACON. Johnny Brown's nickname was in honor of 1920s middleweight champion Tiger Flowers. He was predominantly active during the 1940s, meeting Bert Lytell, Phil Furr, Holman Williams, Steve Belloise, Tiger Ted Lowry, and Louis Kid Cocoa. The Deacon satisfied a long time desire to become the first black fight promoter in Baltimore in 1976 when he promoted the Alvin Anderson Mike Baker bout.

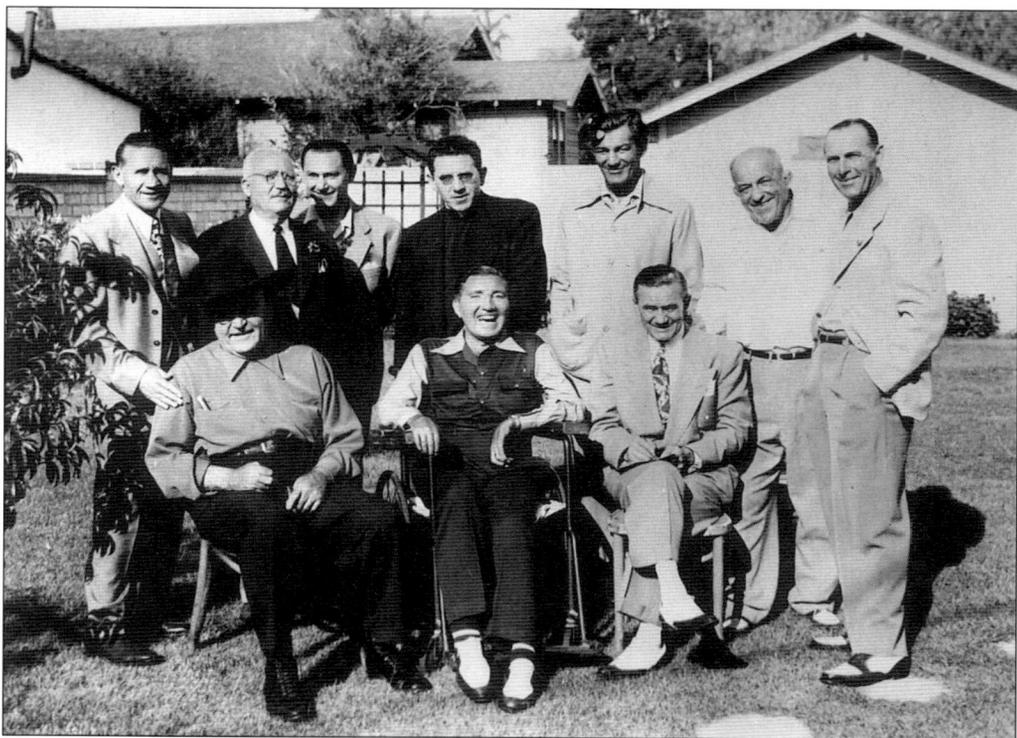

FAREWELL VINCE. Suffering from advanced Lou Gehrig's Disease, Vince Dundee celebrated his 39th birthday in 1947 at Glendale, California. Those in attendance, from left to right, included the following: (front row) Jim Jeffries, ex-heavyweight champion; Vince Dundee; and Willie Ritchie, ex-lightweight champion; (back row) Mushy Callahan, ex-welterweight champion; Victor Rossi; Georgie Levine; Father McHale; Abie Bain; Bull Montana; and Bull Atom. Dundee would die at Laurel Sanitarium two years later. He was only 41 years old.

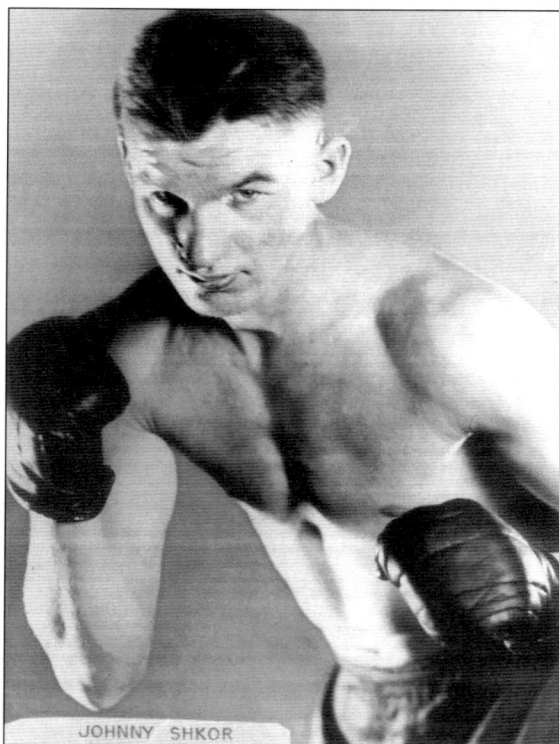

JOHNNY SHKOR

THE FIGHTING SAILOR. Johnny Shkor was a capable ring technician with a lengthy career from 1940 to 1954. Born in Baltimore, he fought as a heavyweight. Opponents included Wild Bill Boyd, Red Burman, Joe Muscato, Tami Maruiello, Jimmy Bivins, and world champions Jersey Joe Walcott and Rock Marciano. (Photograph courtesy of Buddy Ey.)

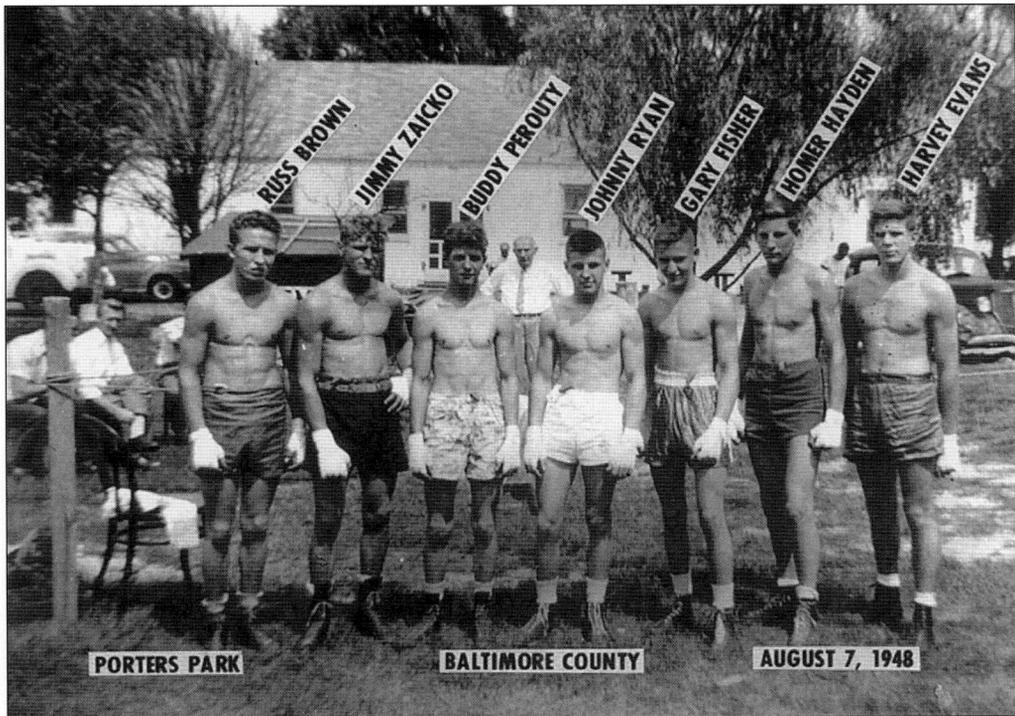

RUSS BROWN · JIMMY ZAICKO · BUDDY PEROUTY · JOHNNY RYAN · GARY FISHER · HOMER HAYDEN · HARVEY EVANS

PORTERS PARK BALTIMORE COUNTY AUGUST 7, 1948

A LOCAL HANGOUT. Porter's Park was a place where young talent would often congregate to train and box with the hopes of one day making it to the "big show." (Photograph courtesy of John Gore.)

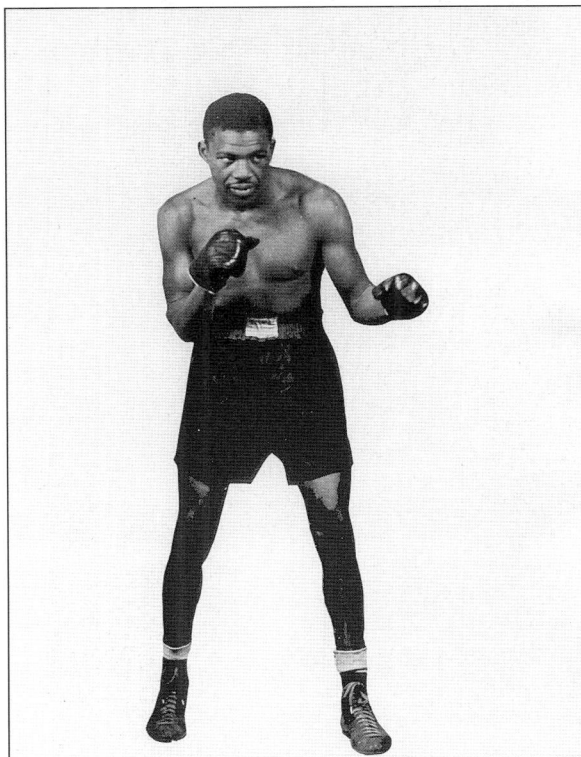

CHAPPIE. Charles Edward Manning, a middleweight, debuted at Griffith Stadium in Washington, D.C. in 1940. His career continued until 1948. Some of his opponents were Howard Bennett, Young Joe Poodles, Joey DeJohn, Jimmy Briscoe, and Oscar Wakefield. In 1947 he faced future light heavyweight champion Harold Johnson.

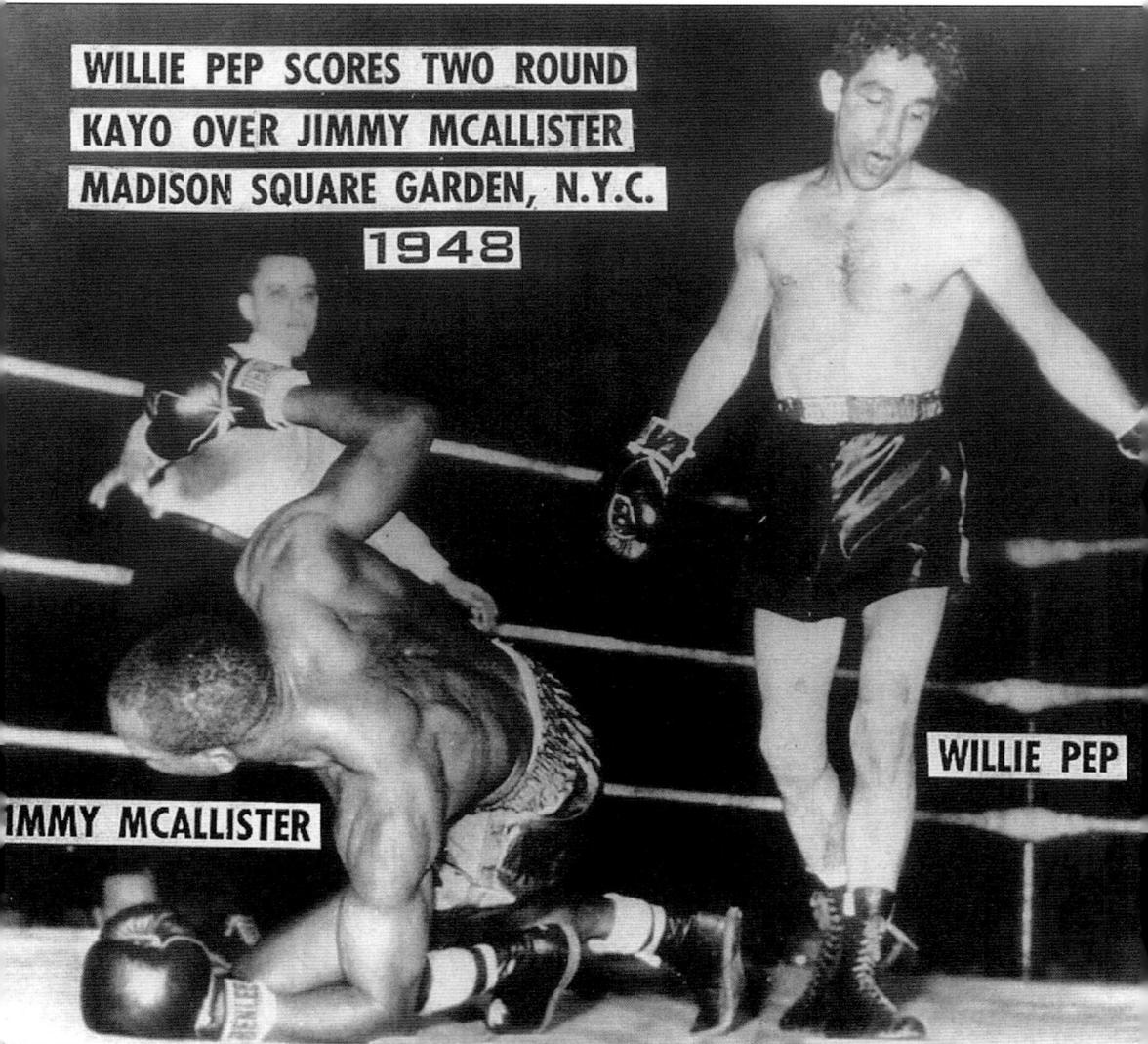

WILLIE PEP SCORES TWO ROUND KAYO OVER JIMMY MCALLISTER MADISON SQUARE GARDEN, N.Y.C. 1948

JIMMY MCALLISTER

WILLIE PEP

WORLD FEATHERWEIGHT CHAMPIONSHIP MATCHUP. Down goes Baltimore's Jimmy McAllister on March 1, 1946. This was a rematch of their Baltimore fight the year before, which ended in a 10-round draw with champ Pep taking a nine count. Pep fought him again two years later in 1948, taking the 10-round decision.

TUTORED BY JACK DEMPSEY. Carrying 163 pounds on a 6'3" frame when he debuted professionally in 1938, Johnny Kapovich soon blossomed into a 200 pound heavyweight when manager Max Waxman, his business partner Jack Dempsey, and trainer Heine Blaustein got their hands on him. His biggest thrill came at Madison Square Garden in 1941 when he boxed on the undercard of his stablemate Red Burman's fight with Joe Louis. He electrified the crowd by knocking out Jimmy Boyle in two rounds. Johnny Shkor, Al Blake, Lee Savold, Buddy Walker, and Gus Dorazio were some of the other top contenders he met in a career that lasted until 1949. Another career high for Johnny came in his last year of fighting when he served as Joe Louis' sparring partner for his fight with Johnny Shkor in Boston, a fight that never materialized.

JIMMY COLLINS. Irishman Collins turned professional in Baltimore in 1939 and ended his career in 1948. Along the way, he fought three former world champions—Harry Jeffra, Petey Scalzo, and Beau Jack. He also met numerous top contenders of the day including Lou Transparenti, Sammy LaPorte, Al Brown, Pete Galiano, Dorsey Lay, Bobby Woods, and Vince Tuminello.

95

A Baltimore Legend. Mack Benjamin Lewis, better known as Mister Mack, started boxing in the U.S. Army in 1940 and was later discharged in 1943. He returned to Baltimore, where he became the first black fighter to join Mickey O'Donnell's Baltimore Athletic Association Gym on Broadway and Eager Streets. O'Donnell relinquished the club to Mr. Mack in 1957. He has been there ever since, as a manager and trainer.

Baltimore's Boxing Human Encyclopedia. Herbert William Ey Jr., better known as Buddy, acted as Veteran Boxers Association Ring 101 historian during the 1970s and early 1980s. In doing so, he has chronicled the history of the fight game in Baltimore and published a record book on every professional boxing match held in Maryland from 1930 to 1940. He helped former bantamweight champion Kid Williams sign autographs in the 1950s and still has an umbrella with a gold plated handle that was given to him by the Kid, who carried it during his career. Buddy did box on the amateur level during 1947 and 1948. He later decided to join the Police Force and was a boxing instructor at the Police Academy.

ONE TOUGH MIDDLEWEIGHT. Holly Mims from Washington, D.C. had a remarkable career spanning from 1948 to 1967. In that time, he fought Terry Moore in Baltimore, Johnny Bratton in Baltimore, Sugar Ray Robinson, Joey Giardello, Rubin Hurricane Carter, and Emile Griffith.

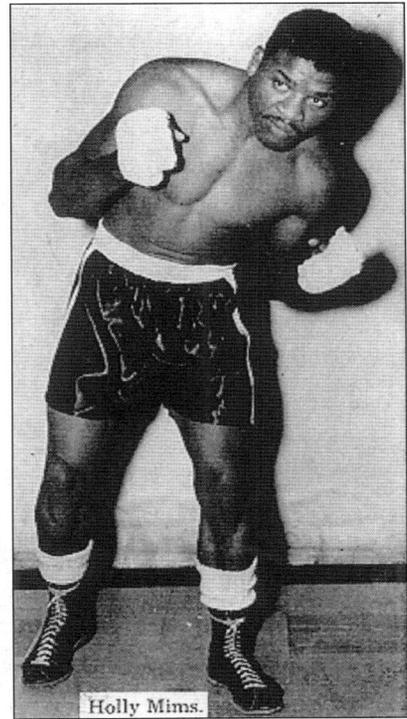

Holly Mims.

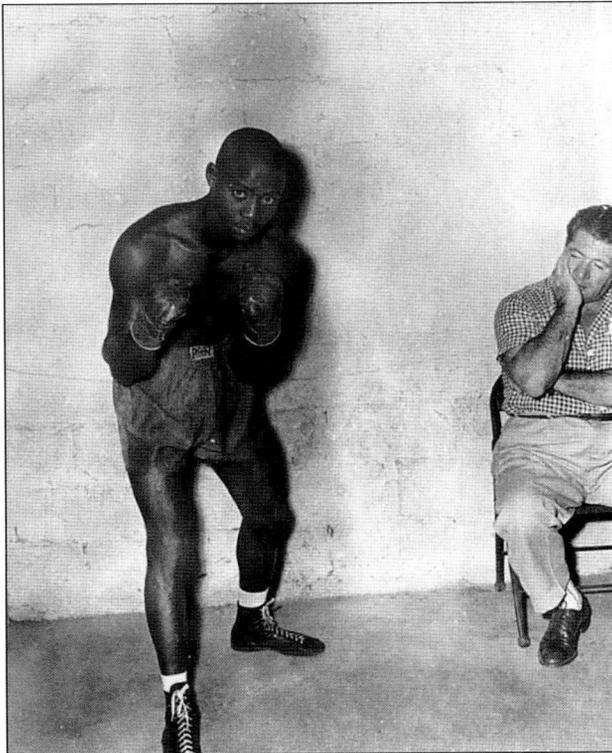

HE FOUGHT CARMEN BASILLIO, IKE WILLIAMS, JIMMY CARTER, AND KID GAVILAN. Welterweight Johnny Cunningham had a long career from 1947 to 1962 meeting several world champions. He met Basillio alone five times with four of those matches in 1949. The results on those meetings were one win, two losses, and one draw. His greatest victory was over champion Jimmy Carter in a non-title bout. He was a 100-to-1 underdog for this fight, held in Miami, Florida, on September 12, 1953. In addition to other champions like Williams and Gavilan, he laced them up in the ring with Gil Turner and Holly Mims. (Photograph courtesy of Robert Carson.)

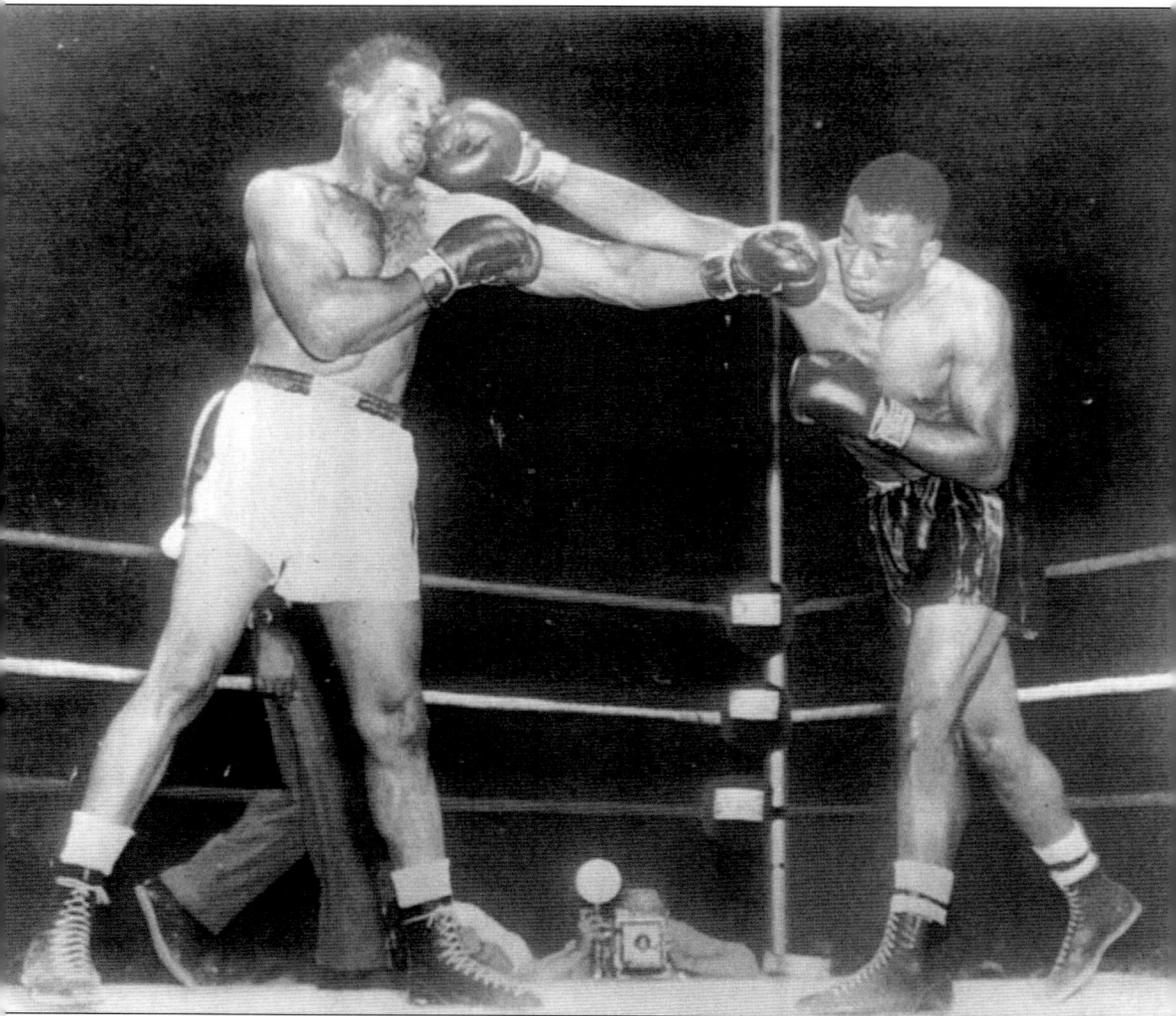

TRADING PUNCHES. On June 26, 1952, Archie Moore, a light heavyweight contender and later title winner, takes one on the nose from 24-year-old Clarence Henry in the second round. The fight, a ten rounder, went to Moore by unanimous decision. The bout took place in 91 degree heat in Memorial Stadium. Moore had many important fights in Baltimore including Lloyd Marshall, Cocoa Kid, Holman Williams, Jimmy Bivins, and Ted Lowry. (Photograph courtesy of J.J. Johnston.)

MET WILLIE PEP. On December 15, 1953, Baltimore's Tony Longo's dream came true. He fought his idol Willie Pep. Tony traveled 10 rounds with the all time great featherweight champion. Longo had a long distinguished career from 1945 to 1957 meeting the likes of European featherweight champion Ray Famechon, Jimmy Cooper, and Johnny Breeze. He was best known for his great left hook and steel chin, since he only was on the deck once in 61 bouts.

ANOTHER LONGO BOXING TALENT. Coming from a boxing family—with brothers Tony and Nick as local stars—it was inevitable that Joey Longo would box. Upon turning professional in 1942 at the tender age of 16, he went on a whirlwind tour of fighting some of the best in the business. Such names as Percy Bassett, Spider Armstrong, Richie Callura, Young Lee Q. Murray, and Timothy Buddy Hayes were some of the men he hooked up with in the ring.

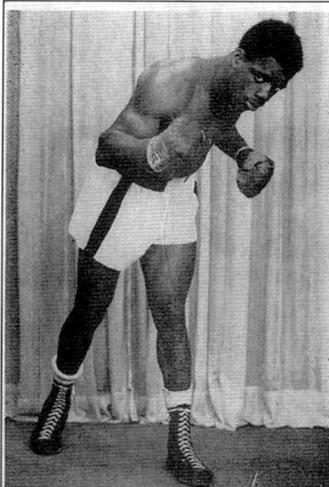

ORIOLE BOXING
CLUB of MARYLAND
PRESENTS:

Carl
COATES
WEST BALTIMORE

VS

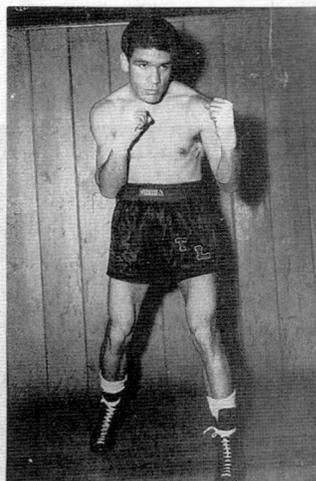

El
CONSCRIPTO
MEXICO CITY

10 ROUNDS

July 16, 1954

6 Rounds SEMI - WINDUP 6 Rounds
GENE GUNTER
DUNDALK

VS

JOE AURILLO
CHESTER, PA.

CARL COATES

EL CONSCRIPTO

6 Rounds SPECIAL BOUT 6 Rounds	THREE FOUR ROUNDERS			PROMOTER:
LOU BENSON EAST BALTIMORE	Johnny Ford W. Baltimore	vs	Al Battle N. Baltimore	**HARRY STRANG** * * * * *
VS	Rocky Dalton Philadelphia	vs	Don Mathews W. Baltimore	**MATCHMAKER:**
FRANKIE SMITH PHILADELPHIA	Paul Kostopolous College Park, Md.	vs	Archie Monroe W. Baltimore	**JOE POODLES, SR.**

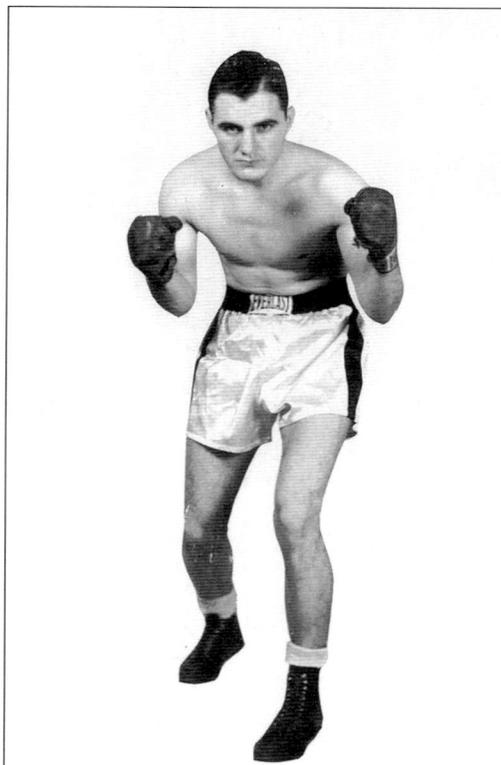

NEWLY FORMED ORIOLE BOXING CLUB.
Carl Coates broke in the Club with a close
10-round decision loss to El Conscripto. He
redeemed himself with his next fight against
champion-to-be Joe "Old Bones" Brown,
winning a 10-round decision. He also met
champion Wallace Bud Smith and
contenders Harold Jones and Don Braun
during his 1950-to-1955 career.

**WELTERWEIGHT CHAMPION OF
MARYLAND.** Don Braun defeated highly
rated Johnny Cunningham at the Baltimore
Coliseum on April 8, 1954, for the title in
what the local papers described as the best
bout held in Maryland in 20 years. In a
career that spanned from 1950 to 1959, Don
fought Jimmy Carter, Eddie Giosa, Charlie
Little, Carl Coates, and Larry Baker. Joe
Poodles Sr. served as his manager.

ORIOLE BOXING CLUB

OF MARYLAND

presents

ELMER BARKSDALE
WEST BALTIMORE

vs

EARL CLEMONS
WEST BALTIMORE

10 ROUNDS • AUGUST 19, 1954

Baltimore Coliseum

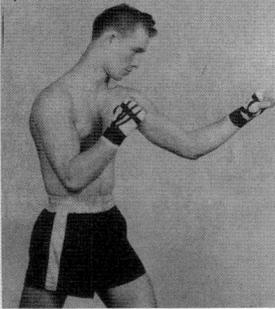

EARL CLEMONS

ELMER BARKSDALE

SEMI-WINDUP—6 ROUNDS	PRELIMINARY BOUTS—4 ROUNDS EACH		SPECIAL BOUT—6 ROUNDS
TEX NEWBY *East Baltimore*	**DON OLIVER** *Washington*	**HARRY HOUSTON** *Washington*	**GENE GUNTER** *Dundalk*
vs	**vs**	**vs**	**vs**
WILLIE TITUS *West Baltimore*	**JOHNNY FORD** *West Baltimore*	**BILLY FRANCIS** *Dundalk*	**RUDY WATKINS** *West Baltimore*

Watch newspapers for announcement of our next show	BE YOUR OWN JUDGE		WINNER	Promoter: Harry Strang Matchmaker: Joe Poodles, Sr.
	BARKSDALE			
	CLEMONS			

THE COLISEUM MAIN EVENT. Two pesky lightweights matched at the popular 1950s Coliseum fight venue. Elmer Barksdale won the 10-round decision. Earl Clemons boxed professionally from 1952 to 1957. In that time, he touched gloves with Jimmy Carter, Bernie Lynn, and Tommy Roberts. (Photograph courtesy of John Gore.)

SUGAR BOY. Rudy Watkins was also known as Sugar Boy. His nickname was coined by his manager Nick Bass, who had taken the young man under his wing. In 1949, Rudy turned professional by fighting the future star Holly Mims. More fights followed against tough opposition including Larry Barrett, Tony Baldoni, Ernie Knox, future light heavyweight champion Harold Johnson, and Wayne Bethea. A low point in his career was in Philadelphia in 1956. He delivered a freak punch to opponent Bob Perry, killing him. Sugar Boy was affected tremendously and truly never recovered from this event.

ORIOLE BOXING CLUB

OF MARYLAND

presents

TONY BALDONI
N. W. BALTIMORE

vs

JOE 'ROCKY' TOMASELLO
MATTAWAN, N. J.

10 ROUNDS • OCTOBER 25, 1954

Baltimore Coliseum

TONY BALDONI

JOE 'ROCKY' TOMASELLO

SEMI-WINDUP—6 ROUNDS	6 ROUNDS	6 ROUNDS	4 ROUNDS
EARL CLEMONS West Baltimore	**ARCHIE MONROE** West Baltimore	**DELMONT COLEMAN** West Baltimore	**BOOM LESTER** West Baltimore
vs	vs	vs	vs
NORMAN CAKE Chester, Pa.	**FRANKIE LENTINE** Cleveland, Ohio	**BUDDY RUSHINSKI** Wilkes-Barre, Pa.	**AL AMES** West Baltimore

Watch newspapers for announcement of our next show	BE YOUR OWN JUDGE		WINNER	Promoter: Harry Strang Matchmaker: Joe Poodles, Sr.
	BALDONI			
	TOMASELLO			

TONY BALDONI. Baldoni was only 14 when he turned pro in 1946. He flourished as a middleweight under the tutelage of Al Flora. In the above main event, he won the 10-round decision. He also battled contenders Harold Green, Ralph Tiger Jones, and champion-to-be Joey Giardello. Baldoni's biggest and regrettably his last important match was against the immortal Sugar Ray Robinson. Robinson knocked him out in first round at the Coliseum on April 2, 1960.

BOXER, MANAGER, AND PROMOTER. Al Flora turned professional in 1938, weighing in at 135 pounds. He participated in close to 35 fights until 1941 with some success. However, a broken jaw that never fully healed prevented him from returning to the ring. Artie Dorell, Billy Ferrone, and Pete Asero were some of his adversaries. In 1955, he was promoting shows at the Coliseum on a full time basis. The Sugar Ray Robinson versus Tony Baldoni fight in 1959 was one of the biggest match ups he promoted at the Coliseum. In addition to managing Baldoni, he looked after the interests of Carl Coates, Rocky Castellani, Frankie Abrams, and Dom Baccala.

LEE HALFPENNY AND JOE
SANCHEZ, TWO BALTIMORE
LEGENDS. Lee (left) had
moderate success as a lightweight
from 1928 to 1931 engaging in
47 fights and only losing 5. He
was plagued by bad hands, which
led to an early retirement. He
was more famous as a trainer of
many local pros from 1921 to
1972, mostly at the YMCA. Joe,
a natural heavyweight, turned
pro in 1952 after many years of
boxing on the amateur level.
During his career, he met the
likes of Lou Benson, John Hoye,
Tommy Haskins, and Gil
Newkirk, whom he battled on
the undercard of the Rocky
Marciano versus Roland La
Starza card.

LARRY BARRETT. A product of
Baltimore's Dunbar High School,
Larry was trained by Mack Lewis.
Before turning pro in 1955, he
defeated middleweight champion-to-
be Terry Downes in the Washington
D.C. Golden Gloves. He turned pro
on November 2, 1955 winning a four-
round decision over Rudy Watkins.
He also fought George Benton, Holly
Mims, Jesse Smith, and Dick
Young—his last fight in 1967.

103

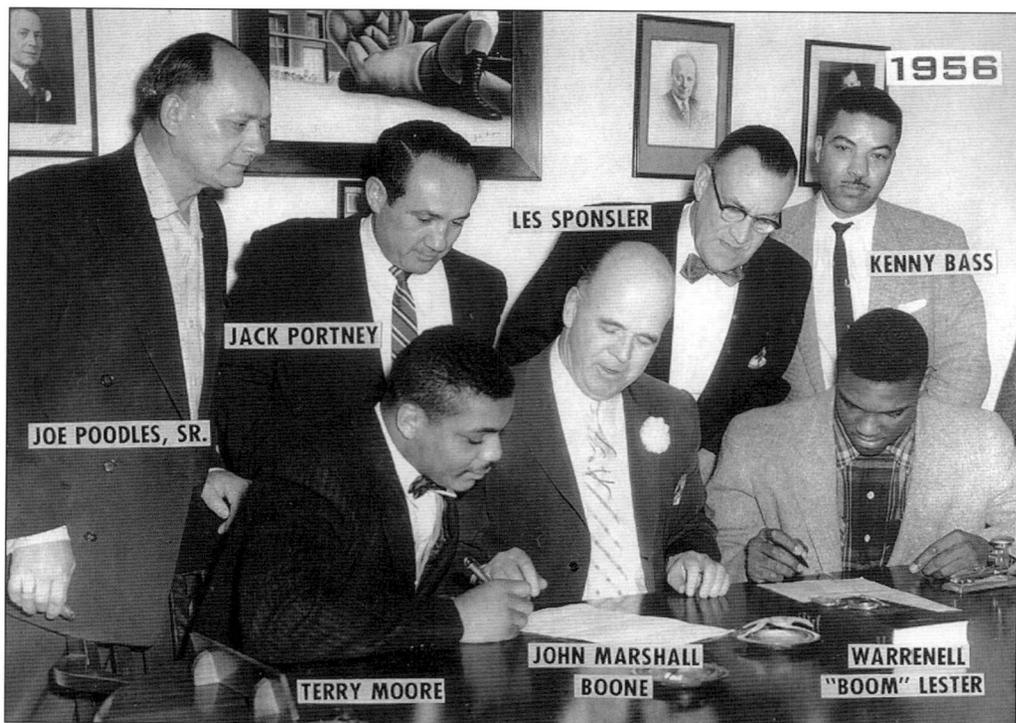

1956

JOE POODLES, SR.
JACK PORTNEY
LES SPONSLER
KENNY BASS
TERRY MOORE
JOHN MARSHALL BOONE
WARRENELL "BOOM" LESTER

BOBBY LEE

FOR LIGHT HEAVYWEIGHT REIGN IN BALTIMORE. Terry Moore's career was winding down and Warnell Boom Lester's was just starting. In fact, this would be Moore's last fight in a career, spanning from 1945 to 1956. In that time, he touched gloves with Holly Mims, Jose Basora, Eugene Silent Hairston, and Rocky Castellani. Included among Lester's opponents from 1954 to 1960 were Bob Satterfield, Bert Whitehurst, Young Beau Jack, Harold Carter, and Ernie Rainbow Knox. Joe Poodles, a Baltimore boxing icon, trained Terry Moore for many of his fights.

A TERRIFIC WELTERWEIGHT. Bobby Lee had an illustrious career from 1945 to 1954. During this time, he fought world champions Kid Gavilan twice, Sugar Ray Robinson twice, Johnny Saxton twice, and Johnny Bratton. He also touched gloves with Terry Moore, Bee Bee Wright, George Benton, and Holly Mims. (Photograph courtesy of Buddy Ey.)

BAFFLED SONNY LISTON. Bert Whitehurst was a tough and clever heavyweight contender from 1952 to 1962. At 6 feet and 189 pounds, he won the Maryland heavyweight championship. He had brighter horizons in the future, meeting world champions Archie Moore, Harold Johnson, Sonny Liston, and Bob Foster. He gave Sonny Liston all he could handle in their two meeting on April 3 and October 24, 1958, although Liston did manage to pull out the 10-round decisions.

ONE OF MACK LEWIS' EARLY CHARGES. Jerome "Jerry" Brewer learned how to box under trainer and later manager, Mr. Mack. After an illustrious amateur career where he beat Billy Richardson, Larry Davis, Jack Wilson, and others, he turned professional in 1960 by fighting Bobby Leggett. He kept active until 1967 as a junior welterweight fighting Billy Gordon, Bud Anderson, Lloyd Marshall, and Genaro Soto.

CHARLES CENTER BOXING CLUB
welcomes you to

BOXING

AT THE CIVIC CENTER

MIDDLEWEIGHTS

JOEY GIARDELLO
Ranked 2nd by World Boxing Association

VS

JOHNNY MORRIS
Middleweight Champion of Pennsylvania
10 Rounds

Monday, Nov. 12th

First Bout 8:30 P. M.

Also: JOHNNY GILDEN vs ANDRE GONZALES
8 Rounds

BOBBY HURT vs JOE SALCI
8 Rounds

TICKET INFORMATION: TU 9-8600 - Good seats on sale
at the Civic Center or any of these advertisers.

RINGSIDE & BOXES $5.00 MEZZANINE $3.00 GEN'L ADM. $2.00
Tax Included

1	2	3	4	5	6	7	8	9	10

See LENNY ROSS at the ELDORADO CLUB
322 W. Baltimore Street

FIRST BOXING MATCH AT THE CIVIC CENTER. Philadelphia's future middleweight champion Joey Giardello kicked off the first show at the Center with an impressive 10-round win over Johnny Morris in front of 6,113 fans on November 12, 1962. (Photograph courtesy of John Gore.)

106

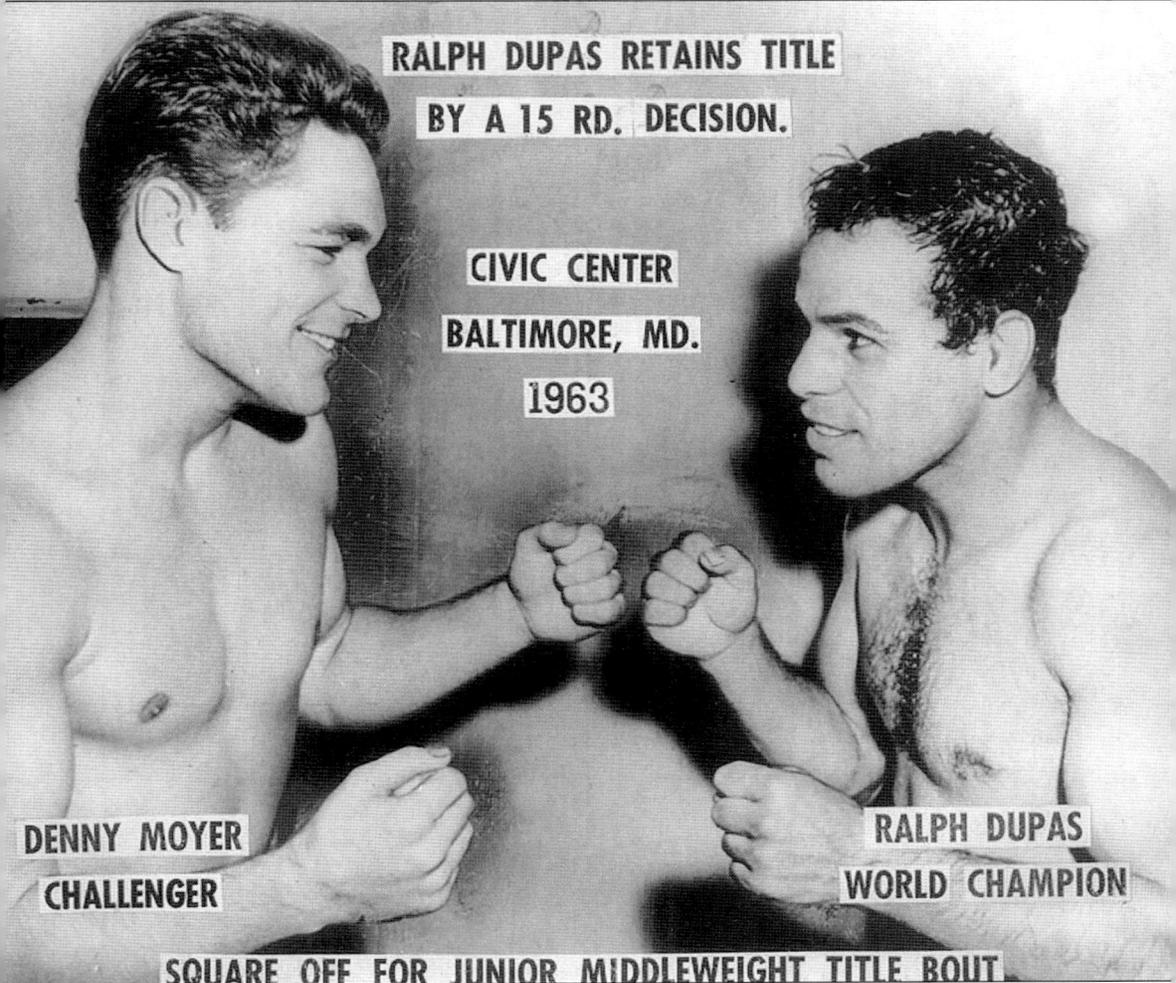

RALPH DUPAS RETAINS TITLE
BY A 15 RD. DECISION.

CIVIC CENTER
BALTIMORE, MD.
1963

DENNY MOYER
CHALLENGER

RALPH DUPAS
WORLD CHAMPION

SQUARE OFF FOR JUNIOR MIDDLEWEIGHT TITLE BOUT.

WORLD JUNIOR MIDDLEWEIGHT FIGHT. Previous titleholder Moyer would lose to Dupas again, this time at the Civic Center on June 17. Both men had long outstanding careers. Moyer met champions Don Jordan, Paddy and Tony DeMarco, Virgil Akins, Emile Griffith, Benny Kid Paret, Sugar Ray Robinson, Nino Benvenuti, and Carlos Monzon. Dupas also met many world champs such as Paddy Demarco, Joe Brown, Joey Giardello, Emile Griffith, and Sugar Ray Robinson. The pictured fight was promoted by famous Baltimore manager Benny Trotta.

ERNIE KNOX

A TRAGIC STORY. Managed by Mack Lewis, Ernie "Rainbow" Knox was a terrific light heavyweight active from 1957 to 1963. Rudy Watkins, Don Warner, and Warnell Lester among some of the men he battled. On October 14, 1963 a black cloud fell over Baltimore. Ernie was knocked out in the ninth round by Wayne Bethea. He never regained consciousness and died two days later. (Photograph courtesy of Robert Carson.)

ELI HANOVER AT STEELWORKERS' HALL. Eli Hanover was a boxer, manager, and promoter from the 1930s to the 1970s in Baltimore. Eli grew up in the Jewish Ghetto area of East Baltimore and had a brief professional career starting in 1939 and ending in 1941 due to wartime service. On September 23, 1965, Eli switched from managing to promoting fights when he presented this Inaugural Professional Boxing Promotion at Steelworkers' Hall on Dundalk Avenue. The fight featured Irish Johnny Gilden winning a 10-round decision over Ricky Ortiz. Eli would spotlight his big shows at the Civic Center such as the Bob Foster versus Mark Tessman light heavyweight championship bout in 1970. In 1974, he changed the site of his large productions to the Capitol Center in Landover, Maryland.

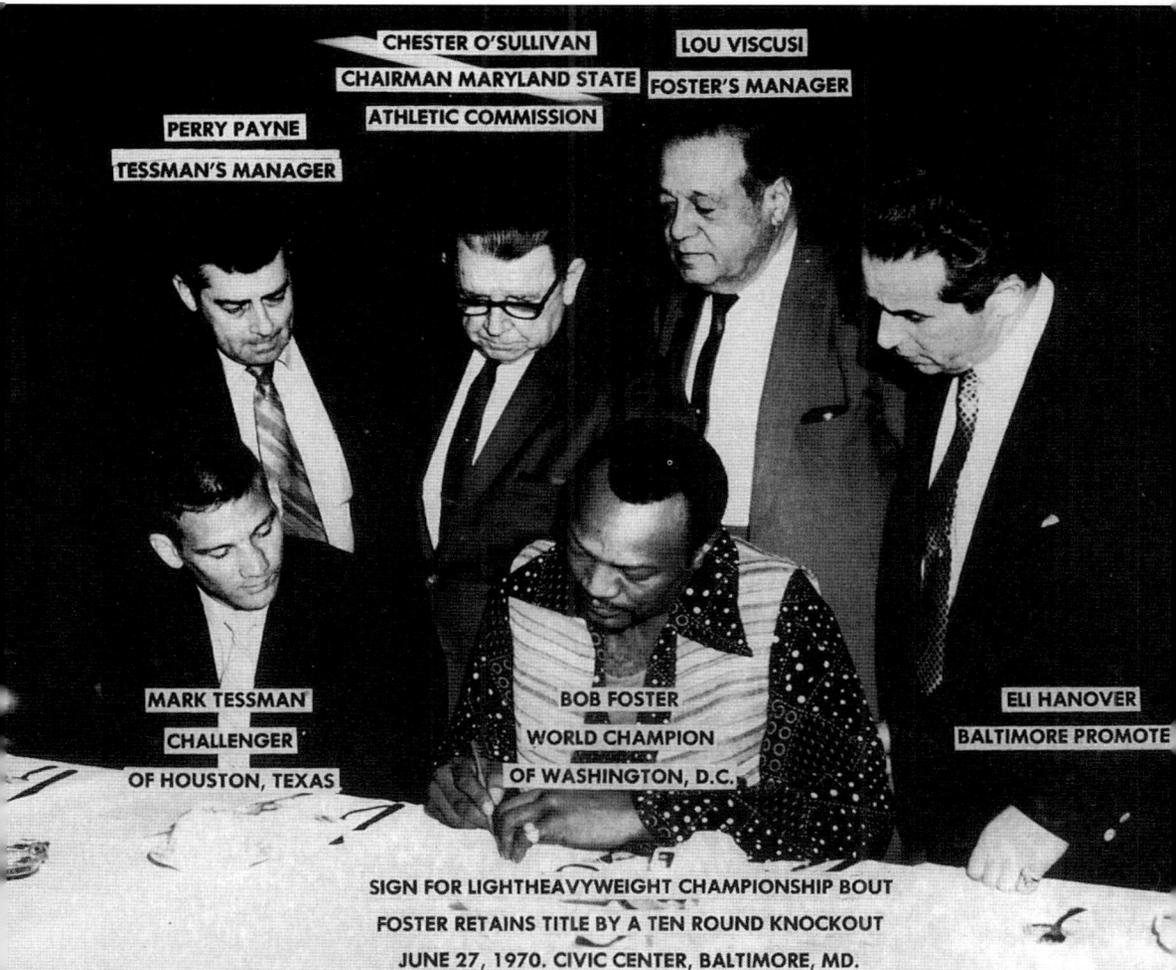

PERRY PAYNE
TESSMAN'S MANAGER

CHESTER O'SULLIVAN
CHAIRMAN MARYLAND STATE
ATHLETIC COMMISSION

LOU VISCUSI
FOSTER'S MANAGER

MARK TESSMAN
CHALLENGER
OF HOUSTON, TEXAS

BOB FOSTER
WORLD CHAMPION
OF WASHINGTON, D.C.

ELI HANOVER
BALTIMORE PROMOTE

SIGN FOR LIGHTHEAVYWEIGHT CHAMPIONSHIP BOUT
FOSTER RETAINS TITLE BY A TEN ROUND KNOCKOUT
JUNE 27, 1970. CIVIC CENTER, BALTIMORE, MD.

Sign on the Dotted Line. Champion Bob Foster knocked out Mark Tessman in 10 rounds on June 27, 1970, at the Civic Center. Eli Hanover was influential in bringing big name boxers to Baltimore during the 1960s and 1970s.

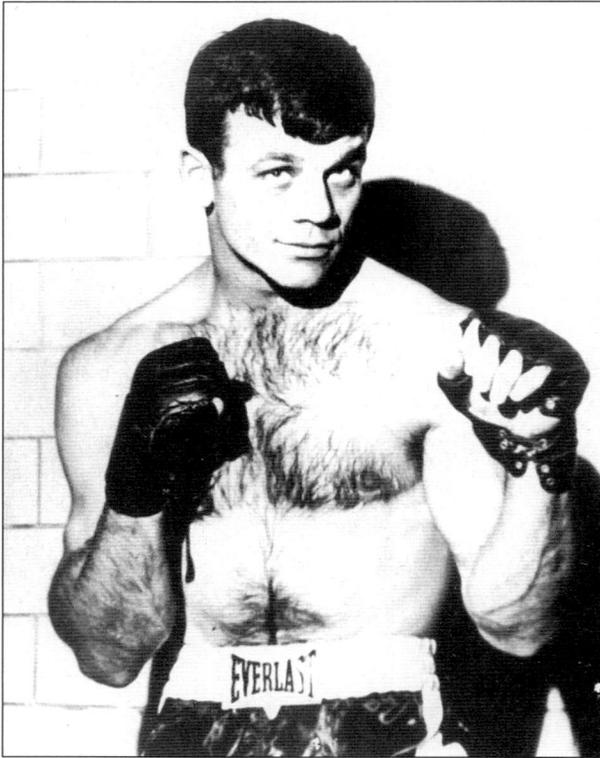

FIGHTING MARINE. First handled by Mack Lewis and later by Terry Moore, Josh Hall began his professional career with a second-round knockout of Johnnie Edwards on May 25, 1967. He continued to fight as a light heavyweight until 1973, meeting a total of 26 opponents. Among the contenders he met were Julio Cruz, Al Bolden, Al Benoit, Lloyd Bozeman, and LeRoy Roberts.

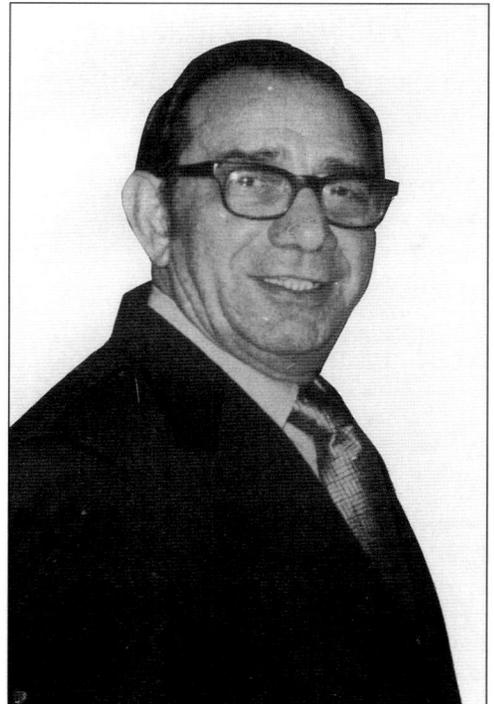

MANAGER AND TRAINER FOR DECADES. Joe DeAngelis was an all around talent when it came to assessing boxing talent. His early days took him back to learning from legendary handlers Sammy Harris and Eddie Ross. Joe managed some big stars from the 1920s to 1970s including the Transparenti brothers Lou, Reds, and Nick; Pete Galiano; Sammy LaPorte; Bobby Chavez; Harry Groves; and Johnny Wilburn. Acting as a trainer, Joe worked with Benny Trotta, Young Raspi, Jimmy Tramberia, and Jimmy Reed.

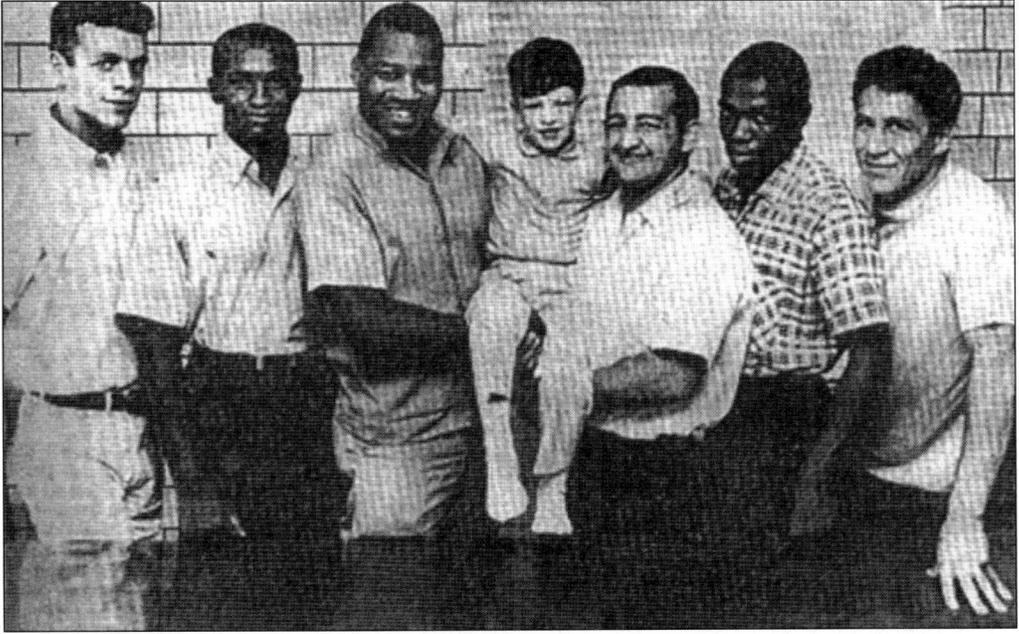

SIX LEGENDARY FIGHTERS. A charity fight card was held at the Civic Center in July 1968. For that show, Baltimore fighters, shown from left to right, Josh Hall, Vern Mason, LeRoy Roberts (Philadelphia native), Dick DiVeronica (New York native), Herbie Lee, and Ralph Palladin all participated.

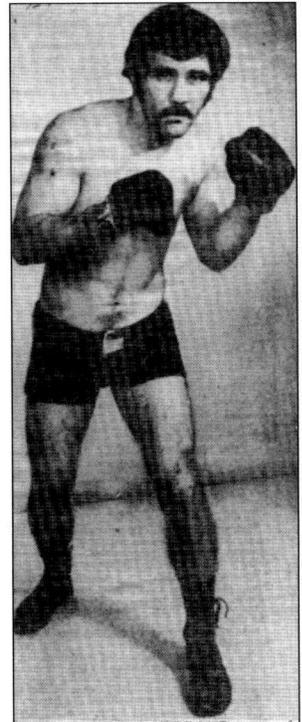

BUDDY RUSSELL BOGGS. Boggs, hailing from Washington, D.C., fought most of his fights in Baltimore. In 1967 during his first year as a professional, he met Vern Mason only to lose in six rounds. However, his welterweight career was a stellar one, meeting the likes of Dave Wyatt, Dick DiVeronica, Percy Pugh, and champion Vito Antuefermo. Vito knocked him out in six rounds in Baltimore on December 5, 1973. Legendary Heine Blaustein served as his trainer.

HARRY LEVENE

Matchmaker:
MICKEY DUFF

PRESENTS

ALL HEAVYWEIGHT TOURNAMENT

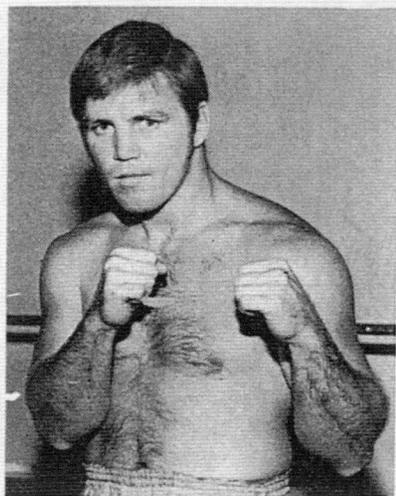

ELIMINATING
CONTEST
FOR THE
HEAVYWEIGHT
CHAMPIONSHIP
OF THE
WORLD

JERRY QUARRY v LARRY MIDDLETON

EMPIRE POOL WEMBLEY

TUESDAY, 9th MAY, 1972

15p

SOUVENIR
PROGRAMME

A CHANCE TO MEET MUHAMMAD ALI. One of Baltimore's premier heavyweights of all time, Larry Middleton lost a ten-round decision by a quarter of a point to Jerry Quarry. By losing this bout, he missed and a chance to meet Ali for the NABF Heavyweight title. Middleton, managed by Mack Lewis, Joe Gamby, and Nick Trotta, was a top contender from 1965 to 1979. He fought Joe Bugner, Ron Lyle, Jimmy Ellis, and Ken Norton. (Photograph courtesy of Leo Dymowski.)

Seven

1973–2003

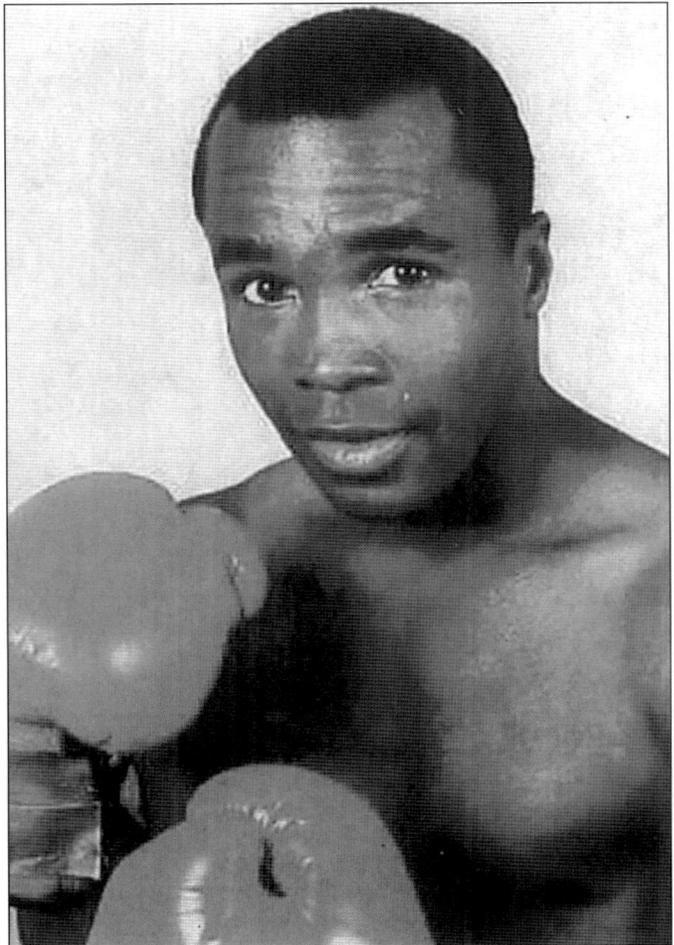

SUGAR RAY. Maryland native Sugar Ray Leonard was named Fighter of the Decade for the 1980s. He won an unprecedented five world titles in five weight classes and competed in some of the era's most memorable contests.

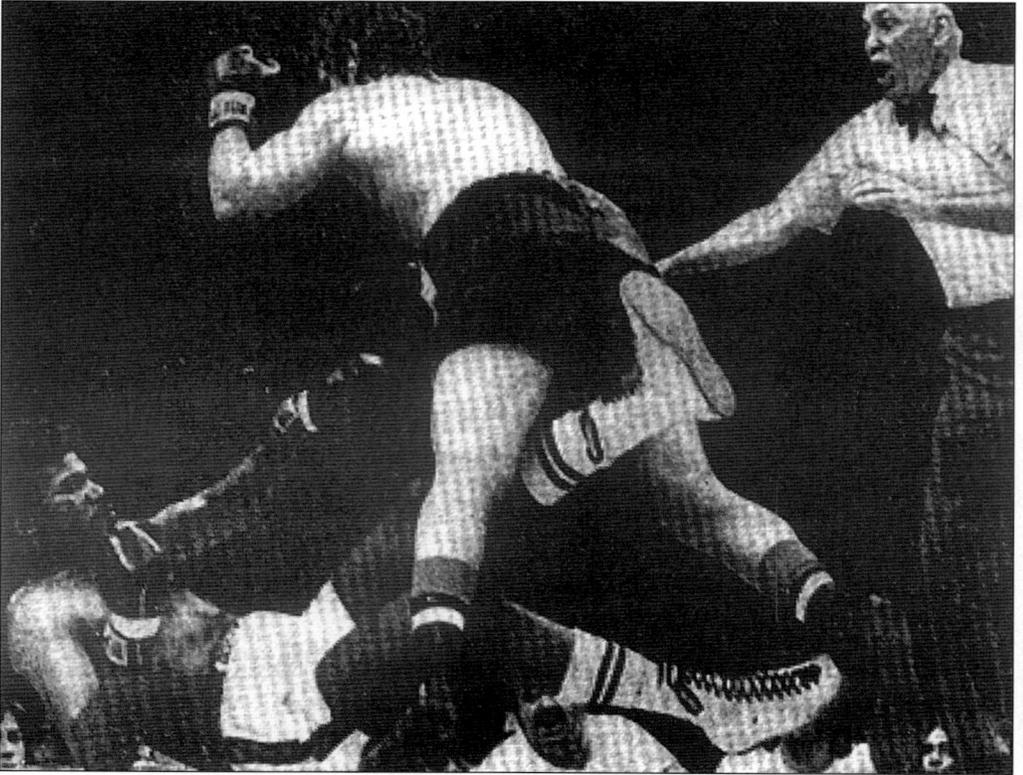

OUCH! Baltimore's Larry Middleton catches Oscar Bonavena in a precarious position during their May 21, 1974 heavyweight match in Baltimore. Oscar would win the 12-round decision.

A GOOD MIDDLEWEIGHT. Lamont Lovelady boxed from 1972 to 1982. He met Alvin Andserson, Leo Kid Saenz, and Bernard Mays. He is best remembered for his September 30, 1975 knockout loss to champion to be Marvelous Marvin Hagler.

A STRONG WELTERWEIGHT CONTINGENT. Natives of Washington, D.C., from left to right, Tim Blue Walker, Johnny Gant, Sparky Wheeler, Avon Little, and Cluster Jackson Faison met some stiff competition in and around Baltimore. James Dudley served as their manager. Walker boxed Saoul Mamby, Ron Pettigrew, and John Cooper. Gant met Dave Wyatt, Adrian Davis, Herbie Lee, Vern Mason, Bobby Hayman, and Hedgemon Lewis. He also fought Angel Espada for the welterweight title on October 11, 1975. This was a fight he lost in 15 rounds. Sugar Ray Leonard knocked him out in 8 rounds at the Capitol Center on January 11, 1979. Wheeler went up against Morris Grant, Johnny Davis, and Floyd Mayweather. Little boxed Billy Bell, Victor Checo, and Hector Diaz. Faison mixed it up in the ring with Jimmy Savage, Floyd Mayweather, and Ron Pettigrew.

A REGULAR AT THE CIVIC CENTER AND STEELWORKERS' HALL. Ronnie McGarvey had a great career, engaging in 36 bouts and winning 33 of them from 1968 to 1978. In 1977, his career peaked when he fought Alfredo Escalera for the WBC Junior Lightweight Title. He was knocked out in the sixth round. Later that year, he defeated Shig Fukuyama in Baltimore via a tenth-round knockout to win the NABF title. He would lose the title in his last fight against Mike Ayala on March 18, 1978.

QUARTET OF FISTIC EXCELLENCE. The below picture features, from left to right, the following :former two-time world champion Harry Jeffra, president of the Veteran Boxers Association Ring 101 Vince Cala, local boxing star of the 1930s Pete Galiano, and past world welterweight champion Kid Gavilan. All pose, sharing a moment at the annual 1976 Maryland Boxing Hall of Fame Dinner and Dance.

BALTIMORE'S SIXTH WORLD CHAMPION. Dwight Braxton, also known as Dwight Muhammad Qawi, was born in Baltimore on January 5, 1953, and spent his first 14 years here before moving to Camden, New Jersey. He debuted professionally on April 19, 1978, in Washington, D.C., fighting Leonard Langley to a 6-round draw. Dwight had many of his early fights in Baltimore, meeting Louis Butler, Johnny Wilburn, and Lou Benson. He stepped into the national limelight when he stopped Mike Rossman in the 7th round of their 1981 fight. Later on that year he won the World Boxing Council (WBC) light heavyweight championship title when he knocked out Matthew Saad Muhammad in the 10th round. He wound up losing a 15-round decision to Michael Spinks on March 18, 1983, for the light heavyweight title. His last fight was a 15-round loss to Evander Holyfield on July 12, 1986. Holyfield became the new World Boxing Association (WBA) junior heavyweight world champion. Dwight has the distinction of being the shortest—just 5 foot 6 3/4 inches—light heavyweight champion in history. He stood almost an inch shorter than 1914 title holder Jack "The Giant Killer" Dillon.

SUGAR RAY'S BIG DAY

BALTIMORE

CIVIC CENTER

SATURDAY · FEBRUARY 5, 1977

THE DEBUT OF SUGAR RAY. Ray Leonard's first professional fight was a successful one, a six-round win over Luis Vega. Prior to this, Ray Charles Leonard captured the 1976 Olympic gold medal in the light welterweight division. (Photograph courtesy of Leo Dymowski.)

A HISTORIC NIGHT. This was taken at the Baltimore Civic Center on the evening of Sugar Ray Leonard's professional debut on February 2, 1977. Standing in order next to Sugar Ray are old-time fighter Nick Bass, Ray's legendary manager Angelo Dundee, and local sportscaster Vince Bagli.

BICENTENNIAL BOXING SHOW
CIVIC CENTER **BOXING** THURSDAY JULY 29
BALTIMORE 8:00 P.M.

MAIN CO-FEATURE BOUTS

JUNIOR MIDDLEWEIGHT

VERNON MASON 10 RDS. **ALVIN ANDERSON**
BALTIMORE, MD. BALTIMORE, MD.

VS VS

LARRY BUTLER **PABLE RODRIQUEZ**
HOLYOKE MASSACHUSETTS PORTLAND, MAINE

6 ROUNDS LIGHT HEAVYWEIGHT / 6 ROUNDS (OTHER STAR) HEAVYWEIGHT

JOHN WILBURN BALTIMORE, MD. / **BIFF "THE TERROR" CLINE** HILLCREST HEIGHTS, MD.

VS / 4 ROUNDS (OTHER STAR)

ROY INGRAM PHILADELPHIA, PA. / **GEO. CHAPLIN** BALTIMORE, MD.

GEN'L ADMISSION $5.00 - $7.00 ★ RINGSIDE $10.00 ★ Tickets at BOX OFFICE

TWO OF MACK LEWIS'S CHARGES. On July 29, 1976, celebrating our Bicentennial, Vern Mason and Alvin Anderson engaged in the main event bouts at the Civic Center. Both came away with victories. (Photograph courtesy of Lew Dymowski.)

Painters Mill Boxing!

REISTERSTOWN ROAD
OWINGS MILLS, MARYLAND

Professional
Boxing Club

MIKE WARREN LASKY
PROMOTER

FRIDAY FIRST BOUT AT 8:00 PM **FEBRUARY 13**

MIKE ROSSMAN
THE JEWISH BOMBER

10 ROUNDS MIDDLEWEIGHTS

VS. CASEY GACIC
THE EXCITING SLUGGER

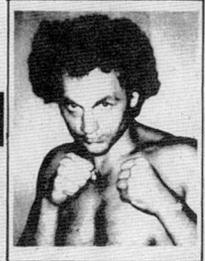

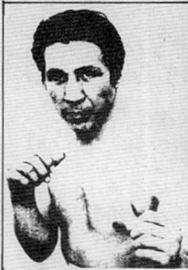

RALPH PALLADIN
BALTO'S FAVORITE...DEFEATED
MIDDLEWEIGHT CHAMPION RODRIGO VALDEZ

10 ROUNDS JR. MIDDLEWEIGHTS

VS. HECTOR PENA
TEXAS JR. MIDDLEWEIGHT CHAMPION

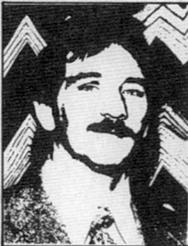

JERRY JUDGE
COLLEGE PARK, MD....KNOCKED OUT
CHUCK WEPNER & FOUGHT GEORGE FOREMAN

10 ROUNDS HEAVYWEIGHTS

VS. HAROLD CARTER
EXCITING KNOCKOUT PUNCHER

Tickets may be purchased at the following locations: Luskin's Dept. Stores ... Ticketron
Locations ... Civic Center ... Hiken's Tuxedo Outlets ... Geoffrey's Men's Shop

OWINGS MILLS FIGHT CARD. Ralph Palladin, a Washington, D.C. native, had many battles in and around Baltimore. On February 13, 1976, he knocked out Hector Pena in 8 rounds. From 1966 to 1978, Ralph met the likes of Dave Wyatt, Johnny Doylan, middleweight champion Rodrigo Valdez, Bobby Watts, and Harold Richardson. The main event pitted future light heavyweight champion Mike Rossman versus Casey Gacic. The result was a 10-round draw. (Photograph courtesy of John Gore.)

TWO BALTIMORE LEGENDS OF THE 1920S. Little Jeff (middle) and Nick Bass (left) had illustrious careers fighting world champions and top contenders. They were frequent visitors at the popular 1970s Palmer House restaurant owned by Tom D'Anna (right). Jeff was quoted as saying a much heavier George KO Chaney "delivered the hardest punch he ever received." In a gym sparring session, Chaney landed a left hand to his body and subsequently broke one of his ribs.

TRAINED BY THE LEGENDARY HEINE BLAUSTEIN. Leo Kid Saenz, a middleweight whose career spanned from 1973 to 1981, fought almost all his matches locally. Emile Griffith, Mustafa Hamsho, Jimmy Savage, and Willie Mack were some of the good men he boxed.

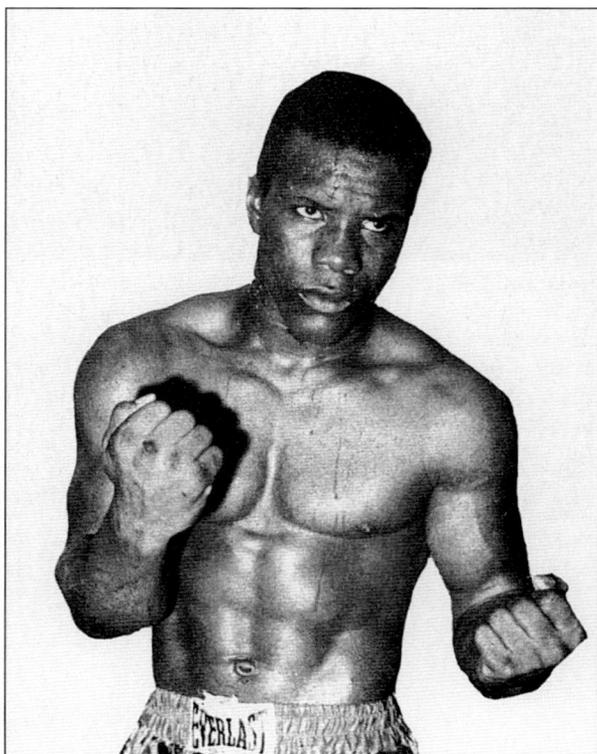

A TOUGH LIGHT HEAVYWEIGHT. Johnny Wilburn, managed by Joe DeAngelis, boxed from 1975 to 1980, meeting many top men, including future champions Michael Spinks, Dwight Braxton, and Eddie Mustafa Muhammad.

A MOMENTOUS DAY. Baltimore's first two different weight class world champion Harry Jeffra is being inducted into the Boxing Hall of Fame at the Roosevelt Hotel, New York City on April 21, 1982.

CELEBRATING A WIN OVER EARNIE SHAVERS. Mack Lewis (far left) celebrates George Chaplin's (far right) win in a ninth-round disqualification over Earnie Shavers on March 1, 1983. George, a Maryland heavyweight champion at the time, had a strong career from 1976 to 1987, fighting among others Duane Bobick, Greg Page, Gerrie Coetzee, Michael Dokes, Gerry Cooney, and Jesse Ferguson.

FIGHTING ABROAD. Baltimorean light middleweight Alvin Anderson spent some time overseas during his career, which lasted from 1967 to 1980. He drew in 10 rounds on this night with Maxwell Malinga in Durban, South Africa, in 1974. Alvin also tangled with Herbie Lee, Angel Espada, and Rocky Mosley. (Courtesy of Lew Dymowski.)

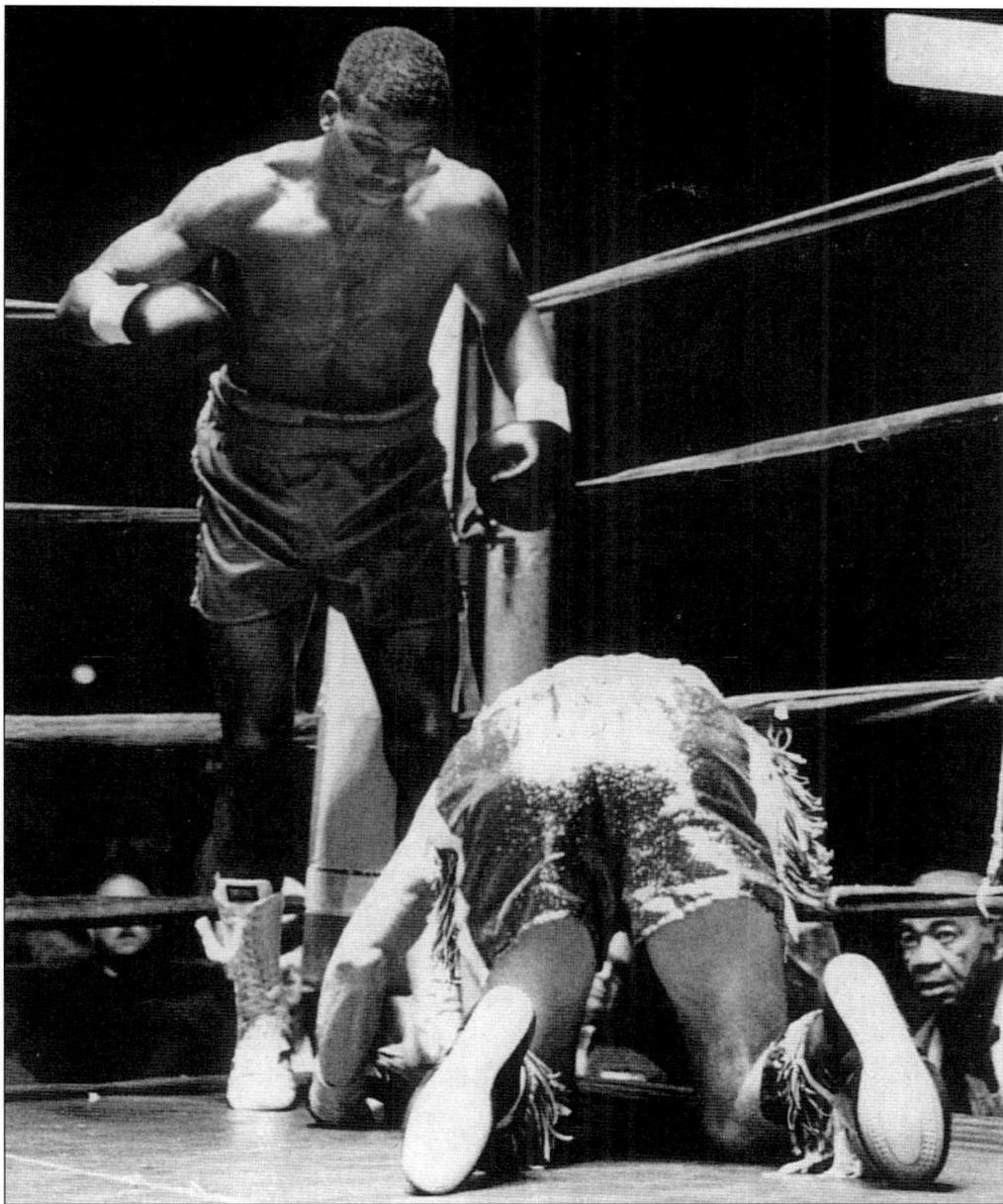

DOWN YOU GO. Vincent Pettway stands over Eddie Van Kirk, both from Baltimore, in the fifth round of their March 4, 1991 fight at the Baltimore Arena. Pettway knocked him out in the next round for the Maryland State Welterweight Title. (Photograph courtesy of Leo Dymowksi.)

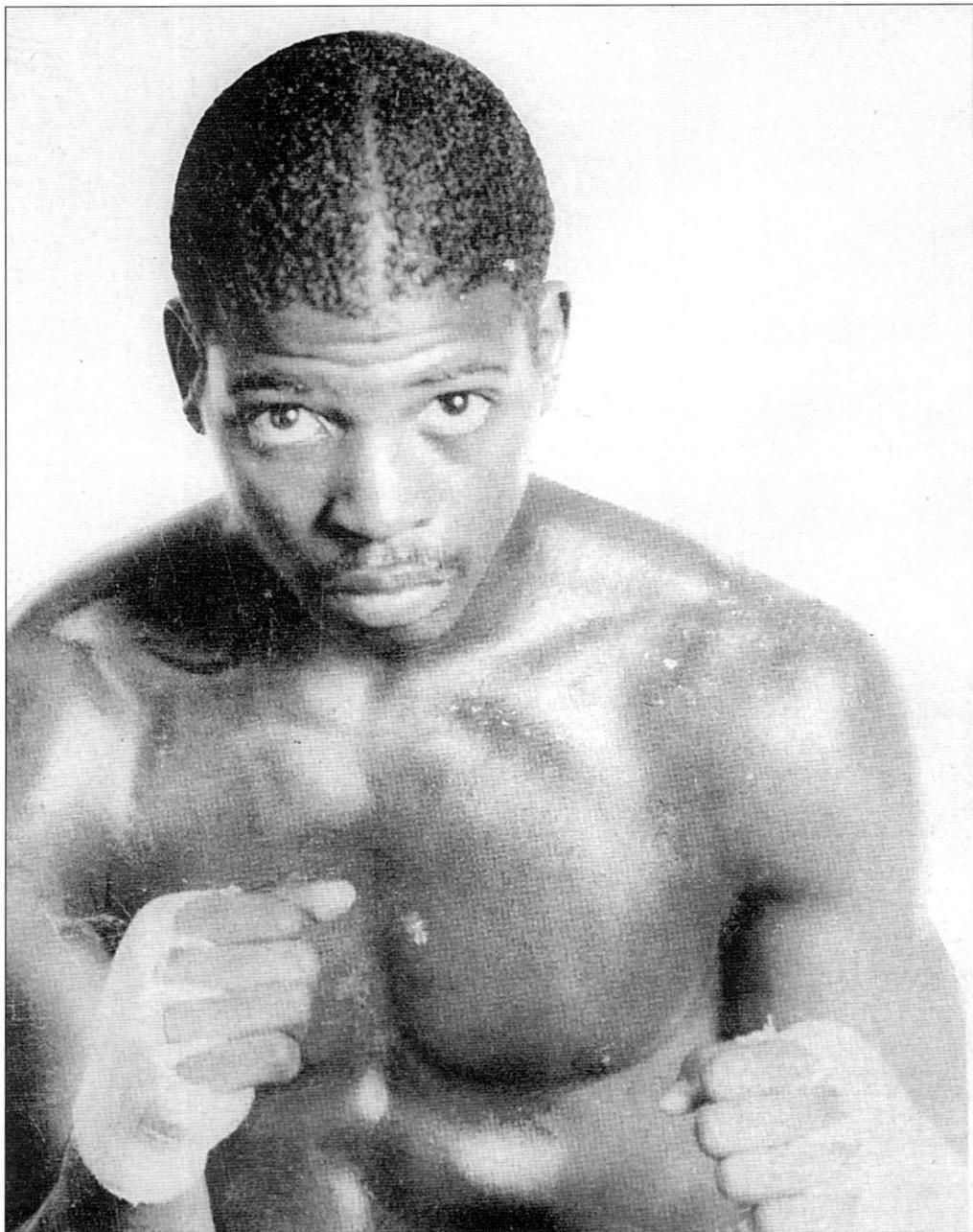

BALTIMORE'S SEVENTH WORLD CHAMPION. Vincent Pettway, shown here in 1989, won a total of 189 out of 200 amateur bouts before turning professional in 1984. He started at the young age of eight while living across the street from his mentor Mack Lewis's gym in East Baltimore. His career culminated when he won the International Boxing Federation (IBF) Light Middleweight Title by a fourth-round knockout over Gianfranco Rosi on September 17, 1994. Vincent was not the only one emotional over the win. Mack Lewis, too, was emotional. He had waited for 50 years for his first champion.

BALTIMORE'S EIGHTH WORLD CHAMPION. Hasim "Rock" Rahman upset Lennox Lewis to win the world heavyweight championship title in South Africa on April 22, 2001, by a fifth-round knockout. This was a title he would relinquish later that year to Lewis in Las Vegas.

PROUD TO BE AN AMERICAN. This May 31, 2001 photo shows U.S. boxing promoter Don King (center) posing with Baltimore's first heavyweight champion Hasim Rahman (left) and David Izon (right) of Nigeria during a press conference in New York City. They were announcing their fight to take place in Beijing, China, on August 5, 2001. A court ruling prevented this fight from taking place due to the fact that Rahman was obligated to fight former champion Lennox Lewis in a return bout. That bout did occur on November 17, 2001, in Las Vegas with Lewis knocking out Rahman in four rounds, thus retaining the heavyweight championship.